Contents

Visions of Illinois

A series of publications portraying the rich heritage
of the state through historical and contemporary works of
photography and art

Published in conjunction with the Chicago Historical Society and the Focus/Infinity Fund of Chicago

Changing Chicago

A PHOTODOCUMENTARY

Preface by Jack Jaffe
Introduction by Walter Rosenblum
Essays by Naomi Rosenblum and Larry Heinemann

University of Illinois Press
Urbana and Chicago

© 1989 by the Board of Trustees of the University of Illinois
Manufactured in the United States of America
1 2 3 4 5 C P 5 4 3 2 1

Library of Congress Cataloging-in-Publication Data

Changing Chicago : a photodocumentary / preface by Jack Jaffe ;
introduction by Walter Rosenblum ; essays by Naomi Rosenblum and
Larry Heinemann.
 p. cm. — (Visions of Illinois)
 ISBN 0-252-01641-6 (cloth). — ISBN 0-252-06083-0 (paper)
 1. Chicago (Ill.)—Description—1981– —Views. 2. Photography,
Documentary—Illinois—Chicago—History. I. Rosenblum, Naomi.
II. Heinemann, Larry (Larry C.) III. Series.
F548.37.C48 1989
977.3′11—dc 19 88-38929
 CIP

Preface

JACK JAFFE

Conventional wisdom tells us that documentary photography is old-fashioned, passé, and of little interest. We are told that a whole generation of photographers—the so-called me generation—want to create artistic pictures but have no interest in what photography does best: tells us about the human condition. Yet the ardor and artistry of the thirty-three photographers represented in the following pages are proof positive that the urge to document photographically is very strong.

The excellent work of Walker Evans, Dorothea Lange, Bill Brandt, Lewis H. Hine, W. Eugene Smith, and Henry Cartier-Bresson, to name only a few, has set high standards that remain valid today and has contributed to a continued interest in documentary photography. As the work of these masters has become increasingly accessible through new scholarship and exhibitions, it has clearly affected the thinking of people in photography today. The Changing Chicago Project is one result of this revived interest in documentary photography. This unique project has provided the opportunity for the publication and exhibition of the work of thirty-three contemporary photographers who continue to pursue high standards in their images of the people and places of day-to-day urban life.

"Changing Chicago" is sponsored by the Focus/Infinity Fund of Chicago, a not-for-profit corporation that I founded in January 1985. The purpose of the Fund is to produce film and still photography projects that have social, artistic, and educational significance with special emphasis on midwestern subjects. In 1986, having completed a photographic documentary project called "Farm Families" with the Art Institute of Chicago, I met with David Travis, the Art Institute's curator of photography, to discuss doing a project that would be an urban equivalent of "Farm Families." David suggested that other Chicago-area museums might participate in such an undertaking as a commemoration of the 150th anniversary of the discovery of photography and the 50th anniversary of the Farm Security Administration documentary project. This seemed to me an ideal way to contribute to the field of photography in this special anniversary year. The idea was presented to Kenneth Burkhart, curator of photography, Chicago Office of Fine Arts, Chicago Public Library Cultural Center; Denise Miller-Clark, director of the Museum of Contemporary Photography of Columbia College; Michael Spock, vice president of public programs, Field Museum of Natural History; and Larry Viskochil, curator of prints and photographs, Chicago Historical Society. Everyone agreed to participate, and "Changing Chicago" was launched.

A planning committee, comprised of the participating curators and exhibition staff, was formed and developed three primary goals for the project. The first is the Changing Chicago Archive, which will be permanently housed in the Prints and Photographs Collection of the Chicago Historical Society; it will be open to scholars and photographers for reference and research, as well as to the general public. This archive will include the exhibition photographs shown at the Society and at the Public Library Cultural Center (the Chicago Office of Fine Arts does not maintain a permanent collection), as well as hundreds of work prints, negatives, and transparencies from each of the project photographers. In addition, a series of taped and transcribed interviews with the photographers and committee members will become part of the archive.

A second goal is the organization of an exhibition at each of the participating institutions, which will open simultaneously in spring of 1989. Approximately 600 prints have been made by the project photographers for the exhibitions, which are organized by the curators and exhibition staff that have served on the planning committee. The photographs exhibited at each institution will become part of that institution's permanent collection (with the exception of the Chicago Office of Fine Arts). A duplicate set of 600 prints will become part of the permanent collection of the Focus/Infinity Fund.

The third goal is this book. *Changing Chicago* is not an exhibition catalog. Although publication of all 600 exhibition photographs under one cover would have been ideal, in the end it proved to be impractical. Publishing five separate catalogs—one for each exhibition—while more feasible, would have presented a fragmented view of the project. Instead of focusing on the exhibitions, this book documents the project, providing a permanent, if partial, record and a sense of the vision and unity of purpose that inspired these thirty-three photographers.

In June 1987, 170 photographers submitted portfolios for review by the planning committee; 33 were chosen on the basis of their artistry and the appropriateness of their project proposals. The committee sought to balance the photographers' varying points of view and subject matter to present both positive and negative aspects of Chicago and the surrounding area—the geographic scope of the project limited photographers to working in Cook County and the surrounding Illinois counties of McHenry, Kane, Will, Lake, and DuPage, as well as Lake County, Indiana. Because ongoing interest and dedication is an important aspect of successful documentary work, consideration was also given to those who were seeking to continue work in progress. Several photographers had been working within a particular theme for several years prior to joining the project. It is satisfying to know that this project allowed them to continue the work they had already begun and inspired others to continue working after the project ended. Of course, it was understood from the beginning that not all of the possible projects in a metropolitan area as large and as complex as Chicago could be done. The Focus/Infinity Fund commissioned the thirty-three photographers to complete their work within a year's time, by late summer 1988.

During the year, efforts were made to enhance interest in the project and encourage the exchange of ideas among photographers and committee members. Three symposia were held in September and December 1987 and April 1988 to bring the photographers together to view their work in progress and to hear visiting scholars and experts speak on the making of documentary photography and its uses. Perry R. Duis, associate professor of history, University of Illinois at Chicago; Dominic Pacyga, professor of history, Columbia College; James Anderson, curator of photographic archives, University of Louisville; William Stott, professor of American studies, University of Texas at Austin; and Walter Rosenblum, photographer, historian, and curator, offered insightful observations and stimulated lively discussions among the project members. Mr. Rosenblum later met with each photographer and offered sensitive critiques and suggestions for their individual projects.

It was an exciting and productive year, and coming to know and work with the many fine people who have participated in "Changing Chicago" made it a very special time in my life. My greatest appreciation goes to the thirty-three photographers who have dedicated countless hours to making the extraordinary photographs for this project.

I wish also to thank the members of the planning committee, with whom I discussed and planned the details of this project during the last two years. Their commitment and enthusiasm helped me overcome the most difficult moments of the project, and working with them gave me that sense of accomplishment one gains only through teamwork. I am particualarly grateful to Kathleen Lamb, coordinator of "Changing Chicago"—her contribution has been critical to the success of the endeavor, and her hard work and devotion are evident in every aspect of the project. My very special thanks go to committee members Ken Burkhart, Janet Kamien (chairperson, department of design and production, Field Museum of Natural History), Denise Miller-Clark, David Travis, and Larry Viskochil.

Coordinating the paperwork for "Changing Chicago" was no small task. For her many tireless efforts and superb organizational skills I am indebted to my secretary, Doris Johnson. Public relations efforts and advice have been expertly handled by Sherry DeVries and Lisa Elkuss of the Field Museum; Marlee Millman and Connie Zonka of Columbia College; Pat Manthei of the Chicago Historical Society; Maureen King, formerly of the Art Institute of Chicago and Ginny Voedisch also of the Art Institute; and Linda Wedenoja of the Chicago Office of Fine Arts, Chicago Public Library Cultural Center.

For his many hours of interviewing the project participants and the resulting tapes and transcripts of interviews, thanks go to Alan Cohen. I also extend my gratitude to Gordon Lee Pollack for his interest and financial support.

The publication of this book is the result of the care and expertise of many people. Richard L. Wentworth, director and editor, University of Illinois Press, showed an eagerness to become involved with the project at an early stage; without his support this book would not have been possible. Russell Lewis, direc-

tor of publications and editor, Chicago Historical Society, played a key role in working out copublishing arrangements. He spent many hours working on the texts, and they are much enhanced by his skillful and sensitive editing. He was ably assisted by Margaret Welsh, editorial assistant at the Society. Tony Porto and Michael Glass masterfully carried out the design.

Lastly, in appreciation of their important contributions to this book, I offer my heartfelt thanks to Naomi and Walter Rosenblum and Larry Heinemann, none of whom I would have had the privilege to meet and work with had it not been for "Changing Chicago."

Introduction

WALTER ROSENBLUM

Shortly before Dorothea Lange died in 1965, she spoke about documentary photography and the new tasks it might accomplish. The Farm Security Administration (FSA) had chronicled the depression, she said, but the government should organize and fund similar projects that would document the customs and artifacts, the hopes and dreams, the rush of life in cities and towns throughout the United States. By providing such a view, sometimes critical and questioning, sometimes inspirational, the images would have significant value for present and future generations.

"Changing Chicago" is such a documentary project. With the inspiration of Jack Jaffe and funding through Focus/Infinity, it has taken shape in a social and cultural climate far different from that of the FSA photographers and reflects the changed sensibilities of the past fifty years. Its roots are in both the classical documentary tradition and a newer vision nourished by barren industrial landscapes, tacky domestic architecture, and unimpassioned crowds. The photographs gathered here look to the past and to the future, embrace tradition and break new ground, encompass coolness and fervor. Indeed, in concept and format this book gathers together the different threads of the documentary genre and reformulates images for today's viewers.

The thirty-three photographers who participated in this unique project made their goal the discovery of the special character of life in Chicago. Each selected an aspect of the city with special resonances that might be orchestrated into an honest, evocative whole. *Changing Chicago* is comprised of portraits, views of healthy social communities, religious and ethnic customs of diverse people, the built environment, and social problems. Through a combination of text and image, through humor, satire, and affection, it revivifies aspects of life in Chicago that may be invisible or that we may see daily but no longer feel profoundly. These photographs show, perhaps for the first time, that Chicago's renowned architecture and its profound social agonies are part of the same pulsating creation that constantly reforms and renews itself.

Changing Chicago includes images that reveal the center of the city as an advanced architectural environment where people work and go about their daily lives (John Kimmich, Tom Petrillo, and Thomas Frederick Arndt); but it is also a city rich in older storefronts and neighborhood buildings (Russell Phillips), distinctive vernacular signage (Patty Carroll and Jay Boersma), and a network of canals and bridges (Rhondal McKinney and Ron Gordon). Many of the images suggest a complex blend of phenomenal activity and quiet dispair: views of the

beaches and parks along the lakefront (David Avison) and ethnic neighborhoods and day-to-day life (Tom Hocker, Stephen Marc, James Newberry, Antonio Perez, and Richard Younker) are juxtaposed with abandoned factories and homes in the desolate towns of northwest Indiana (Bob Thall), with the sterile landscape of upper-class suburbia (Barbara Ciurej and Lindsay Lochman), with the plight of the elderly (Wayne Cable), and with the children in a public school (Jim Iska).

As in most documentary projects, especially those that propose to explore intricate changes in a major urban center, people are the focus of "Changing Chicago." Often anonymous, always captivating, they are shown in the workplace and on the street (Jay King and Jay Wolke), attending fairs and festivals (David Dapogny and Dick Blau), at baseball games (Tom Harney), and in their own neighborhoods and homes (Kerry Coppin, Antonio Perez, and Marc PoKempner). Some engage in hard labor (Susan Crocker and Kathleen Collins), while others participate in society functions and entertainments (Peter Hales). Several photographers, in the classic documentary tradition, chose to follow their subjects closely, to depict their lives in depth and reveal the individual character of the people of Chicago. The problems urban women and children face become especially palpable when we enter into their schools and homes (Angela Kelly and Meg Gerken) or look on as they seek to assert their authority and control their lives (Melissa Ann Pinney).

Within the context of architecture and street life, the detailed images of particular people give *Changing Chicago* a special quality—as though, in viewing a theatrical scene from a comfortable distance, we are suddenly forced to take account of the drama's profound effect on the players. The diversity of photographs corresponds to our experience of urban life itself: we come to know some people intimately, others less well, and the majority as figures in the background. Unlike our everyday experiences, which are often capricious and unstructured, people and places and their interrelationships assume sharper form and greater intensity in *Changing Chicago*.

Pictorial factors are crucial elements in forming meaningful visual statements. Anyone dealing with a documentary project must sooner or later answer questions about the quality of the images: What gives individual photographs their special character? What invests them with liveliness and makes them captivating instead of dull? Theme and subject play a part, of course, but imagination, intuition about the moment of exposure, and a sense of empathy or a social point of view are of prime importance. How the picture is put together—its architecture, so to speak—is also significant: where the photographer stands, what is included, how the light clarifies or obscures, what mood is created—this is what transforms the stuff of reality into compelling images. Rich in information and enlightening as a body of work, the photographs in *Changing Chicago* are deeply moving, individually and collectively, because the photographers have found the means of integrating all these factors into a profound statement about a particular urban experience.

Documentary Photography: A Historical Survey

NAOMI ROSENBLUM

The resurgence of interest in documentary photography toward the end of the 1970s has been accompanied by a reappraisal of its function and effect. Critics, historians, and even some photographers have questioned past precepts governing documentary practice and have suggested new guidelines for dealing with the complex social problems and interrelationships that such documentary works seek to reveal. "Changing Chicago," a documentary project that looks back to the Farm Security Administration (FSA) photographers and classical documentary photography for its inspiration, brings the full force of this debate into focus and raises two central questions: Can photographers today document social and economic problems in the same manner as photographers did in the first half of this century? What role does documentary photography have in the United States? Before considering both the renewed interest and what some have termed a "loss of faith" in the genre,[1] a retrospective look at the role of the photograph in social discourse might illuminate the nature of social documentary photography and, in particular, clarify the thinking behind "Changing Chicago."

In its infancy, photography was perceived as a mechanical process, obedient to laws of nature rather than human whim. Pictures that resulted from "sun-writing" were assumed by many to be factual descriptions of the real world, "*infinitely* more accurate in . . . representation than any painting by human hands."[2] Faith in the innate truthfulness of the camera image shaped its acceptance as "evidence"—a role that eventually became a significant aspect of the documentary purpose. In time, the apparent accuracy and truthfulness of the camera image led to its wider utilization in industrialized nations. Politicians, colonizers, urban developers, social scientists, journalists, and reformers all realized that photographs might serve with greater effect than handmade drawings as visual evidence, whether the aim was to keep accurate records, publicize "good works," educate the public, or effect a combination of these goals.

During the second half of the nineteenth century, middle- and upper-class individuals began to collect camera images of working people (usually in the small *carte* format) to advance social goals. These endeavors sometimes were limited to keeping historical archives, and sometimes they had more active aims. The interest in pictorial representations of work and workers reflected the growing concern over the negative effects of industrialization and urbanization during the middle years of the nineteenth century.[3] The prosperous British manufacturer Sir Benjamin Stone envisaged a library of photographs of traditional social

customs (in his native country and abroad), among which the provincial dress and implements associated with rural work—then being displaced by advancing industrialization—would be saved for the historic record.[4] London barrister Arthur Munby used small-format *carte* photographs of British working-class women as evidence in his campaigns to demonstrate that they enjoyed better health than idle middle-class women.[5]

One of the earliest portrayals of working people was a project undertaken in Scotland in the mid-1840s by the highly regarded team of David Octavius Hill and Robert Adamson. Little is known of Hill and Adamson's intentions in photographing working fishermen and fisherwomen of the village of Newhaven, but it appears that the two men undertook the project as a means to raise funds to improve the decking and tackle of the boats used by the subjects.[6] Perhaps a distant forerunner of later socially motivated documentary photography in intent, stylistically the project was consistent with Hill and Adamson's painterly handling of the Scottish gentry, who were their customary sitters. Employing the calotype process, which gave the portraits an agreeable softness, the photographers of the Newhaven men and women created the first idealized camera portraits of members of the working class.[7]

A portrait project of London's poor in the late 1870s shared Hill and Adamson's objective of raising money for a "cause." Initiated by Dr. Thomas Barnardo, an evangelical minister who deemed it his duty to rid the city of its large population of indigent homeless youngsters, the project had two purposes: to keep records of the more than 50,000 individuals who passed through the juvenile homes set up by Barnardo and to provide publicity for ongoing efforts to fund his work.[8] The photographs taken for the record have the look of uninflected documents (similar in nature to the portraits of "criminals" advocated by Alphonse Bertillon in France), while those intended for fund-raising emphasized emotional values and played on the sympathy of the viewer through the adroit management of pose and expression. Accused in his time of running a photographic scam by making his subjects appear to be in worse condition than they actually were, Barnardo claimed that photographic truth was general rather than specific—that the images were intended to dramatize the problems of a class of people rather than of particular individuals.

The use of photographs to publicize state policy on diverse social issues began in the 1850s. One such early effort—a record of the historic architecture of France, known as the *Mission héliographique* (which actually had its origins before photography)—was meant to promote French nationalism.[9] Documentation of the Imperial Asylum at Vincennes by Charles Nègre,[10] which many consider a precursor of later government-sponsored undertakings, attested to the concern for social problems experienced by the working class—in this case, accidents suffered by those employed in national industries. The rigidity of pose in these photographs resulted from the primitive state of photographic technology, which for a sharp image required that subjects remain fixed in one position for the length of the exposure, and the fact that the intent of this imperial commission was to suggest that the asylum enjoyed a regimen of peace and order. Later

depictions of social programs initiated by both imperial and republican authorities demonstrated that this particular compositional style remained an important factor in projecting similar concepts about the role of authority in dealing with social problems.[11]

From its inception, photography has been closely bound up with urbanization. Called upon to record the phenomenal growth of cities in the advanced nations of the West during the nineteenth century, it provided images of both physical and social transformations. The earliest such sustained project, initiated by Napoleon III and his administrator Baron Haussmann, availed itself of the services of Charles Marville, who "systematically documented areas slated for . . . demolition . . . [and] new public amenities and modern structures."[12] Ridding Paris (or any city) of its decaying structures and turning it into a center with the most advanced public amenities obviously had significant human implications, yet few people appear in Marville's views; when they do, they are incidental to the main purpose of the image, which was to show as clearly as possible the need for new structures no matter what the immediate human consequences. Like those of the *Mission héliographique*, Marville's images were placed in archives, although publication may originally have been intended.[13]

Recording the appearance of buildings and streets slated for demolition for the edification of future generations suggests an ambivalence toward the past that was characteristic of mid-nineteenth-century European cultural attitudes. This outlook marked Thomas Annan's commission in 1868 to photograph a particularly foul slum in Glasgow's central district. The photographs reflected the desire of the City of Glasgow Improvement Trust "to have a record of 'many old and interesting landmarks'" that might serve to document an area about to be demolished.[14] The original impetus may have been nostalgic, but the Improvement Trust, aware of the pressing need for better housing for the "labouring classes," provided information (not included in the albums of photographs) about sanitary and health matters, thus lending the project a social as well as an antiquarian dimension. As in Marville's work, the emphasis remained fixed on the physical structures; the crumbling walls, dank alleys, and open sewage sluices in these carefully composed views still testify to the indignity of living in such surroundings.

In the United States, photographs in support of slum clearance projects were not initiated until the late 1880s. Instead, photographers and real estate interests used camera images to popularize urban growth. Before 1870 the architecture of various eastern cities was documented by the firm of Southworth and Hawes in Boston; by Victor Prévost (a French emigré) in New York; and by James DeBourg Richards and James McClees in Philadelphia. As might be expected in a nation without a historic urban culture, governing bodies and developers in the new cities of the West—San Francisco in particular—supported photographic images that revealed "the urban environment as a dynamic, constantly improving world"[15] rather than as a place where change would wipe out cherished monuments. By the late nineteenth century, images of urban development reflected advances in photographic techniques and processes as well as developments in

grand urban architecture. One example of this trend was the *Chicago Art Portfolio*, published in 1894 by S. B. Frank, which emphasized both the holistic character of the city and the monumental character of its important public and private buildings.

A spur to camera documentation was provided by the increase in literacy among urban dwellers. Publishers employed graphic, and later photographic, illustration to enliven written offerings in the reading material aimed at this group. At first, drawings in magazines such as the *Illustrated London News, Le Journal Illustré*, and *Harper's* were often based on photographs, but the invention of the half-tone engraving process[16] made possible the reproduction of actual camera images and stimulated a new respect for photographs as evidence in campaigns for social reform.

Even before the introduction of half-tone reproduction of photographs, the camera image had been called upon to confirm written information about the working poor. The first conscious application occured in 1851, when Henry Mayhew's *London Labour and London Poor*[17] appeared with illustrations of diverse traders and working people; for the most part, the engravings were based on daguerreotypes (photographs on metal plates) commissioned from a fashionable London portraitist.[18] In the translation from camera image to artist's drawing, the "London poor" became little more than stiff figures set apart from their background, yet the images did add a degree of authenticity to the sociological texts based on Mayhew's interviews. The combination of popular writing and visual evidence was meant to refute the idea that the working-class poor represented a danger to more comfortably situated Londoners. As a result of the book's success, a pattern was established for the major social tracts that appeared in England and the United States throughout the remainder of the century.

Conceived in a similar vein, *Street Life in London* followed in 1877, with photographs reproduced by a semimechanical process called Woodburytype and inserted onto the pages of written material.[19] Reproducing the full range of tonalities and all the background detail of the original images by Scottish photographer John Thomson, these illustrations offered the viewer a sense of authenticity that far outstripped that of engravings. While Thomson's views of street life complemented the lively written material advocating reform, the compositional formality also tended to counter the specter of a militant and threatening working class emerging in Britain during the 1870s.

Faith in science and technology allied with a belief in the good intentions of the educated segments of society inspired social reformers on this side of the Atlantic with a high regard for photographic documentation of social injustices. In the United States between 1888 and 1915, this concern was encouraged by systematic efforts on the part of Progressive reformers to bring to light the inequities of the capitalist industrial system. Indeed, reformers eventually saw the combination of accurate reporting and authentic image as the most persuasive tool for informing *and* invoking action on a variety of social problems.

How the Other Half Lives, the first significant publication embodying this powerful combination, appeared in 1888, first in periodical form and then as a

book.[20] Its author and photographer, Jacob A. Riis, a journalist who had himself suffered privations as an indigent immigrant, sought authentic visual evidence to dramatize his reports of slum conditions and substandard workplaces, which he made public in illustrated lectures as well as in print.[21] As the book's title indicated, Riis considered himself and his literate audience part of the half whose efforts might make living conditions for the lower class less onerous. Despite his own class and ethnic biases (which are painfully obvious to contemporary readers), the force of Riis's vision cannot be denied. The photographs supplied a sobering corrective to the romanticized illustrations found in earlier religious tracts about social conditions and to popular works of art on the same theme.[22] Their strength lay in the fact that, beyond being "records" of actuality, they encapsulated Riis's indignation about social conditions.

Riis was among the outspoken reformers in the United States who recognized that poverty resulted from alternating periods of prosperity and depression in the urban-industrial economy rather than from solely personal inadequacy—a perspective that came to rely on scientific tools for the measurement, recording, and control of all aspects of social existence. Just as photographic systems were expected to provide evidence of criminal "types," so, in Riis's view, would photographs of housing conditions provide incontrovertible evidence of the relationship between substandard living conditions and antisocial behavior. His expectations that an educated and aroused middle class would pressure authorities to correct unhealthy or unjust conditions of living were realized in part by the enactment of new tenement construction codes and the razing of the worst slum areas around Mulberry Bend, which he documented. After seeing Riis's photographs, a Chicago reform minister, Rev. Jenkins L. Jones, suggested that photographers in that city turn their cameras on the homes of the poor and then exhibit the work publicly so it might be seen by all.[23]

Reformist objectives of the era are exemplified in a series of images by the well-known magazine photographer Frances Benjamin Johnston of the Hampton Institute in Virginia. Earlier, Johnston had photographed children working in mines and factories but without much empathy for them or their problems. In an 1899 project, however, she arranged her subjects to reflect the rationality and order basic to the institute's educational program, which prepared the children of former slaves and American Indians for the job market. She focused on actual tasks—reconstructing a staircase, learning mathematics—and bathed the subjects of her balanced compositions in clear, even light. Although unpublished at the time, the photographic prints were shown in Paris in 1900, where they may have suggested to affluent viewers that racial problems in the United States were being adequately handled through educational means.[24]

Progressive Americans considered education to be the single most effective means to defuse potentially volatile social situations, yet concepts of individual dignity also flavored their endeavors to alter public perceptions about the underclass. Among photographers, this concern derived in part from the humanist ideas and imagery of English naturalist photographer Peter Henry Emerson.[25] Respect for the dignity of those on the bottom or at the fringes of industrial society

eventually became a basic canon of the documentary style. It illuminated the photographs of a community of Gullah blacks on St. Helena Island, South Carolina, in the early 1900s by Leigh Richmond Miner and was visible in the images of American Indian tribal life by Edward S. Curtis and by Andrew Vroman, in Doris Ulmann's portrayals of rural mountain folk and blacks in the 1920s and 1930s, and in all of Lewis W. Hine's portraits of working people. Indeed, by the 1930s it had become a hallmark of the social documentary style.

Around the turn of the century, as photographers began to document social problems in a more conscious and planned fashion, other approaches to depicting social themes emerged, made possible by the invention of hand-held cameras and dry film in sheets and rolls. Professional photographers—many of whom, like Eugene Atget, brought passion to the seemingly mundane task of documentation—increasingly provided antiquarians, architects, and archivists with records of the built and natural world. Simplified technology also enabled amateur photographers to casually depict aspects of urban street life; among this diverse group were the patrician Italian count Guiseppe Primoli, the English journeyman printer Paul Martin, and the thoroughly middle-class American Alice Austen. The animation evident in their largely unstudied images filtered into professional photographic practice, in particular via images intended as magazine illustrations, and eventually affected socially significant themes, to become another element in the complex documentary style that emerged in the 1930s.

With the reform movement in full flower and periodical journals competing for readers during the first decade of the twentieth century, photographs assumed even greater importance both as illustration and as evidence. Socially concerned groups in the United States recognized that images of immigration, housing, health, work conditions, and child labor not only would authenticate investigative reports but would humanize the subjects, thus narrowing the perceived gap between the largely immigrant industrial working class and the native-born American middle class. This perception lay behind the photography of Hine, who was committed to the dual objectives of providing evidence and arousing compassion.[26] In his earliest photographic project—a depiction of immigrants from eastern and southern Europe arriving at Ellis Island—he emphasized the essential humanity of those the Progressives regarded as "new Pilgrims" but other native-born Americans saw as the illiterate dregs of Europe. Indeed, in his efforts to place his subjects within an acceptable context, he not only sought out moments that expressed common human emotions but titled the images to suggest values acceptable to most Americans.[27]

A later project, undertaken at the behest of a group engaged in the first comprehensive sociological investigation of Pittsburgh, one of the nation's premier industrial cities, convinced Hine that documenting social ills not only would afford him a meaningful and economically viable career but was necessary for the proper functioning of the American system. From 1908 through 1917, his work illustrated the Pittsburgh Survey and other publications; it was also used for education and fund-raising in the bulletins of the National Child Labor Committee, was made into slides for lectures, and was mounted on display panels for

national exhibitions. In short, Hine's images allowed an unknowing public to become aware of "the deadening effects of industrial labor, . . . [through] a vivid history of weary faces, exhausted and often crippled bodies."[28] He achieved this objective by going beyond the description of factual situations, fusing in a single image accurate sociological data, aesthetic considerations, and profound empathy with his subjects, embracing feeling as well as fact. Later generations of documentary photographers, in particular a number of those involved in the FSA project, were inspired by Hine's example in their portrayals of individuals affected by the drought of 1930.

Progressive Era social policies came to an end as the United States prepared to enter World War I, and while Hine's images of work found historical use during the 1920s in various social study publications,[29] the boom in industrial production and the emphasis on individual initiative during that expansive decade mitigated against the support of social programs requiring camera documentation. Instead, as manufacturers, advertising concerns, and magazines employed greater numbers of photographs to publicize products, Hine turned to making portraits of skilled workers at their jobs, selling some of the images to industrial and trade journals and eventually securing a commission to photograph the construction of the Empire State Building, which enabled him to continue his portrait of the skilled sector of the American working class.[30]

This portrayal of diverse aspects of working-class existence had analogues in Germany. As early as 1898, Berlin photographer Waldemar Titzenthaler produced a group of images of skilled industrial workers with the tools of their craft. A later series by Helmar Lerski consisted of close-ups of workers' faces, dramatically illuminated but lacking in context.[31] A more inclusive project, with greater ideological and social dimension, was undertaken by August Sander before World War I and then resumed in the 1920s. "Man in the Twentieth Century," as Sander called the work, was intended not just to portray individuals but to reveal "social anatomy" through physiognomy.[32]

Documentary photography expanded and flourished in the United States during the mid-1930s under the New Deal government of Franklin Delano Roosevelt. As in the earlier Progressive Era, public authorities confronted by tears in the social fabric during the Great Depression endeavored to educate and change policy through the use of word and image. Because of its flexibility and low cost (compared with motion pictures), the still photograph, on exhibition and reproduced in print media, was regarded as an ideal means to achieve these goals. Between 1935 and 1945, many federally supported agencies included photography as a resource, among them the Works Progress (later Work Projects) Administration (WPA), the Rural Electrification Administration (REA), the Tennessee Valley Authority (TVA), and the Office of War Information (OWI). In addition, private organizations, notably the American Red Cross, supported photographers in the field to document their aid projects. There is little question, however, that the project organized by the Historical Section of the Farm Security Administration (part of the Department of Agriculture) has come to exemplify documentary photography's most forceful expression and to stand as a model for

future projects;[33] it also has been central to much of the current criticism of social documentation.

Nearly all of the elements of past documentary work—that is, the respect for authenticity, sympathy for those portrayed, and an effort to organize fact and feeling into a visually arresting image—were assimilated into the documentary genre as it evolved in the FSA project. In their own time the photographs provided a visual record of a vanishing rural culture; they depicted people afflicted by circumstances over which they had no control, and they attested to the activities of public authorities. A selected group of images, used in print media and accompanied by descriptive or evocative texts, were meant to arouse feelings that might lead to social action. Some were sent around the nation to serve as propaganda for federal programs and as examples of photographic art expression. Many were portraits, but even in those in which no people are present the photographer's overriding concern was with human affairs. The vast majority of FSA images—of vernacular architecture, popular artifacts, traditional customs, and celebrations— were archived for use by later generations.

Altered in subtle ways by the different individuals who participated in the FSA project, the style of 1930s documentary photography nevertheless derived from a cohesive ideology.[34] For Walker Evans, who has been considered the quintessential documentarian by some authorities, the genre consisted of "a stark record . . . [of] actuality untouched,"[35] a philosophy with which those employed on the project agreed in principle, although their means of expressing "actuality" differed from individual to individual. For instance, before making an exposure, Arthur Rothstein waited until his subjects wore an appropriate expression, one which he felt gave "a factual and true scene."[36] Dorothea Lange selected what she considered her most truthful portrayals from a series of exposures; she believed that the now-famous image of a migrant mother and children, which became the icon of the FSA project, encapsulated a general truth in a more compelling manner than others in the same series. Similarly, because Ben Shahn was specifically committed to arousing action through his images, he argued that factual visual records of erosion, for example, were insufficient inducements to action, whereas images that appeared to truthfully sum up the human consequences of erosion might invoke public indignation. For a number of participants, the stark record had to serve a larger truth, thus echoing ideas put forth by Barnardo in the 1870s.

All the FSA photographers understood that the choices they made—the selection of subject, vantage point, and moment of exposure, the nature of the illumination, and the final cropping—altered reality. The very act of transposing a segment of real time in real color into monochrome (or colored dyes)[37] on a two-dimensional surface contradicted efforts to limit the photographic image to an exact record or to maintain that it was a completely objective rendering of reality. The special character of FSA photography lay not only in the visual summary of the appearances of rehabilitation camps, tornado cellars, and provincial architecture and artifacts, as helpful as such images might be for social historians, but in the force of feeling that resonated through many of the images, notably those that have become "American cultural icons."[38] The strong emphasis on "living experi-

ence, which was meant to arouse viewers to the need for government intervention,[39] was motivated by ideological concepts as well as the very real human concerns felt by individual photographers who believed that social change was possible and desirable.

In conjunction with sensitivity to pictorial architecture, this empathy transformed description into sensation. In the FSA project, documentary style required, as it had for Hine and to a lesser extent Riis, the congruence of form and feeling to make its image of actuality seem important. But unlike these earlier figures, the FSA photographers incorporated to a far greater degree a sense of the momentary and transient. Lange (working with a Rollei) and Shahn (using a Leica) were especially sensitive to fleeting gestures, facial expressions, and body movements that revealed heightened emotional states. Frequently, this sense of a transitory moment captured by the camera suggests that the viewer is witnessing episodes from "real life" rather than images calculated to inform and arouse. Similar attitudes informed the work of those engaged in urban photography during the 1930s and early 1940s, although for the most part their projects were less well organized.[40] The WPA sponsored a number of documentary works in the various art and public construction programs under its aegis in cities across the nation; other projects depicted street life and activities in these localities.

One exception to the random nature of such ventures was a project initially conceived by Berenice Abbott but carried out under WPA auspices. Its title, "Changing New York," may seem especially relevant to this publication, but its objectives differed considerably. Abbott and her collaborator, writer Elizabeth McCausland, were attracted by the confrontation between past and present visible in the city's architecture: in one image of buildings on East 48th Street in Manhattan, a modern International-style glass-brick façade built in 1934 by William Lescaze is contrasted with an adjacent 1860 brownstone; in another, the construction of Rockefeller Center forms the background for the Gothic-style Collegiate Church of St. Nicholas (no longer in existence). Using a large-format view camera, Abbott concentrated on commercial, public, and private buildings, seeking, in the manner of Atget, to reveal the pulse of the city through its inanimate structures, while McCausland's text added the historical information required of this "document."[41] Unlike *Changing Chicago*, with its many portraits of individuals of differing class and ethnic origin, this portrayal did not focus on the inhabitants (when present at all, they are largely anonymous). However, Abbott's work did inspire a specialized genre of publication of city imagery, and over the next fifty years numerous photographic works dealing with architecture and street scenes in (among others) Chicago, Minneapolis, New York, Pittsburgh, and San Francisco appeared.

Working-class life in urban slum neighborhoods became a compelling theme for photographers concerned with the social environment during the depression years. Arnold Eagle and David Robbins produced a document, entitled "One Third of a Nation," for the WPA, while members of the Photo League, an organization active in New York City from 1936 until 1950, depicted this subject matter in more random fashion. In the late 1930s, league members set out to

provide truthful images of people in their environment; for example, the Harlem Project, on which Aaron Siskind, Morris Engel, and Jack Manning worked. Recognizing also that the medium had inherited an aesthetic as well as a descriptive legacy, members championed what they called "honest" photography—that is, visually compelling images that dealt directly with real life but were free in their techniques and processes from the aesthetic effects and trivial subject matter condoned by pictorialist camera clubs.[42]

Initially, the Photo League had been allied with a radical international worker-photographer movement that had emerged in the early 1930s in Europe. Other than in Great Britain, worker-photographers were concerned mainly with providing visual reports for radical left journals and clubs, for which they held a "proletarian eye" to be essential.[43] In contrast, the British undertaking—a documentation of working-class life in the towns of Bolton and Blackpool, entitled "Mass-Observation"—shared some of the goals and characteristics of the FSA project, although its emphasis was on creating a social history archive rather than arousing viewers to action.[44]

The need to make a visual statement about the nature of social existence, asserted so forcefully by the FSA documentary project, came to be shared by the American photographer Paul Strand. Initially a part of the Stieglitz circle—the source of his passionate commitment to photographic artistry—Strand became aware of the relationships between people, their history, and their culture through the reformist cultural climate engendered by New Deal politics. In 1945, after ten years of making documentary films on contemporary political issues, he began to work on a series of publications in which still images in combination with texts would reveal the specific character of diverse provincial societies.

Like August Sander's work of the 1920s, where the viewer was guided through a "systematic inventory of society," Strand meant his images—for example, of the island culture of the Hebrides or of the agricultural town of Luzzara in Italy—to be viewed in a preordained manner within the context provided by the book's text.[45] While Strand's high aesthetic standards may seem at odds with what generally is thought of as documentary style, his preference for social themes clearly connects him to that tradition.

Interest in social documentation continued sporadically into the 1950s, but the sense of commitment to a purposeful social ideal was dissolving in the aftermath of World War II. An ambitious enterprise organized by Roy Stryker (former FSA functionary) for Standard Oil of New Jersey was meant to inform the public about the production and consumption of oil in the United States while at the same time altering commonplace perceptions of the company as "tainted" by greed and corruption.[46] The hundreds of thousands of images produced by the eleven experienced documentary photographers formed a vast archive, but while rich in sociological information, the individual images did little to stir sympathy and change opinions. An endeavor to portray the architectural heritage of Chicago, sponsored jointly by the Chicago Area Camera Club Association and the Chicago Historical Society, begun in the 1950s and still ongoing, had no such vaunting ambitions. Its goal, possibly unique at the time, was to provide an eviden-

tiary record of domestic architecture, interiors, and customs that would be of future use, especially to social scientists. It, too, did little to further the aims of social documentary photography.

As government involvement in social change became less popular, funds for documentary projects were increasingly difficult to obtain. Nevertheless, a small number of individual photographers continued to be influenced by documentary style, whether they were commissioned by private agencies or publications or were working on their own. For example, W. Eugene Smith, assigned to provide photographs for a history of Pittsburgh, aspired instead "to create a portrait of a community, . . . scanning the . . . intricate web of social, economic, cultural, and political forces that make up a major industrial city."[47] On his own, former Photo League activist Walter Rosenblum carried on the prescriptions of his youth by electing to spend ten months in Haiti, concerning himself with difficult social conditions and their effects on people. While entirely different in style, both projects centered on people, signifying the profound interest in the human condition on the part of the photographers—an interest nourished more by the temper of the period in which they came to maturity than by the era in which they were now working.

Younger photographers coming of age in the late 1950s reflected a different social pulse. They took their cues from the counterculture that had emerged after the Second World War to question the ideas and values engendered by rampant consumerism and racism and, eventually, by the unpopular war in Vietnam. Some were attracted to the ironic depiction of the American national ethos, exemplified by the work of Robert Frank. In contrast to the concern by, for example, Hine, Lange, and Shahn for those disadvantaged by circumstances, Frank, like other photographers who left Europe for the United States during the 1930s and 1940s,[48] regarded ordinary activities, such as displays of patriotism and the national love of automobile travel, with sardonic humor and bewilderment. From his more distanced perspective, he revealed a sense of alienation among working-class people that appealed to young photographers, although not to the traditional intellectual establishment. *The Americans,* Frank's book of photographs of his cross-country trip, elicited sharp criticism for its disparagement of themes many Americans considered sacred.

Other photographers active in the 1960s were involved in depicting the confrontations between various sectors of society for the periodical press. As a result, their attitudes toward image making were conditioned less by classic documentary concepts than by the demands of photojournalistic practice. The use of documentary images in magazines has to some extent erased the boundaries that differentiate the two practices; however, while FSA photographs appeared in *Life* and *Look*, their overall purpose was broader than that served by picture journalism. Picture magazines attempted to distill what was considered newsworthy (from the point of view of publishers whose revenues came from advertising as well as subscriptions) in a limited number of captioned images for those unwilling to read extensive texts on complex issues. Editors usually were not interested either in evoking action or maintaining archives of social fact, both basic precepts

in documentary photography; nor were they interested in arousing sympathy for individuals caught up in circumstances over which they had no control. Rather, their purpose was to invite interest in the picture story itself.

Although by the 1960s the cultural temper had turned gritty, and humanist sentiment in visual imagery had become suspect as a means of sentimental voyeurism on the part of the more affluent toward the underclass, a number of documentary photographs of these years seem tinged with the same passionate intensity, if not the same idealism, that had informed the work of the older generation. Two examples are Bruce Davidson's photographs of a Hispanic neighborhood in East Harlem and of subway riders in New York, and Danny Lyon's communities of motorbike riders in the Midwest and prisoners in Texas.[49] In common with earlier documentary work, these images reached the public in the form of picture books with varying amounts of supportive texts, their purpose being to illuminate rather than evoke action.

During the 1960s and 1970s, the photographic scene was transformed. A flourishing art market awakened museums and collectors to the many kinds of photographic expression, including commercial, photojournalistic, and artistic. University art departments and professional schools, notably the relocated Bauhaus in Chicago (the Institute of Design), increasingly turned out photographers who regarded the medium as a form of individual expression as well as a means of livelihood; they worked in a multitude of formats and styles and were aided by technological advances in color and by instant imaging systems. An abundance of photographic books of all kinds—monographs, histories, and documentations (usually self-generated rather than commissioned)—accompanied and advanced the boom in the value of photographs as commodities.

At the same time, film and video reporting took over the informational functions previously performed by documentary still images. As television replaced picture magazines as a source of news, the role of the image became more central and, paradoxically, less significant. Because of its ephemeral nature (and later its seductive color), the video image did not have to maintain the same standards of visual lucidity as still photographs, while the constant bombardment of images tended to make individual still photographs seem static and inconsequential. Besides affecting how the public regarded camera images, TV news programs in particular changed public reaction to momentous events. For example, President Kennedy's assassination and its aftermath, and images of the grisly war in Southeast Asia seen nightly on TV screens, began to seem less real, less awful than they actually were. Surrounded by fictional entertainments featuring violence and mayhem and by fictional images advertising the good life available through the acquisition of consumer goods and services, real and unreal became fused in the public mind, weakening feelings of human and civic concern. As a result, documentary photographers, especially those working in black and white, were faced with a crisis of attention: how to make visually arresting images of substance that would invite the interest of viewers rendered insensible by image overload.

Beyond this problem, the idealism that had initiated and sustained the social documentary projects of the Progressive and New Deal eras became a subject of contention as the intellectual community reconsidered past phenomena in the light of changing conditions in the political sphere, in the art market, and in art theory. One point of debate centers on the relationship of the photographer to the subject and raises questions about exploitation and sentimentalization. According to one group, the problem photographers face is "how to generate an empathic response without sliding into sentimentality or romanticism" or "converting" those depicted "into symbols."[50] A related argument is that those who are the subjects of documentary photographs are being exploited because the usually middle-class photographer is voyeuristically prying into the private lives of the less privileged.[51] Actually, this admonition against the invasion of privacy was first raised during the Progressive Era by well-meaning middle-class social workers. Hine's answer—still apt today—was that the positive value to society of truthful images that brought about "social uplift" (as reform measure were then called) outweighed considerations of individual privacy.[52]

Another issue raised in this debate is the role aesthetics should play in determining documentary style. According to some critics, the photographs historically selected as paradigms of the style (by Stryker, by the photographers, by museums, by the art market) have for the most part been well composed, even beautiful images. This quality renders them suspect in that the vast number of documentary photographs made under the aegis of government agencies in the 1930s actually were "unstudied, informal, or spontaneous . . ."; such images are more authentic, it is claimed, because they have not been processed by "the dubious machinery of high culture."[53] In this view, the "veracity" of documentary images, once considered more objective than fictional narratives, is mediated by some idea of aesthetics and so should not be assumed to duplicate reality.[54] Other voices assert that documentary photographs not only "represent a small and highly selective sample of the real world" but often are influenced by the desire on the part of the photographer to "make art," which thereby "unsuits the photographs for use as evidence."[55] In sum, these critics feel that the artistic component of the documentary style contravenes the documentary purpose.

In calling for a "re-invention of documentary photography" that avoids "universalized timeless statements" (associated with outmoded humanism), today's critics of the classic documentary style suggest that emotionally charged images invent their meanings and corrupt the quest for social change, a point of view contradicted by the history of documentary photography. When they demand that the genre question its own "authoritative voice while simultaneously trying to find the photographic forms consistent with its social and political critiques,"[56] they ignore the fact that most of the significant documentary photography projects of the past grew out of and were conditioned by the reform programs they amplified. They were meant to sway public opinion as well as offer evidence, whether initiated by public or private agencies or by individual photographers. These undertaking fused visual lucidity—that is, art—and social ideology within a

culture that considered the individual worthwhile and the improvement of conditions necessary in order for society to function rationally. In consequence, the images actively embodied "the convergent aims of giving information and showing respect for communal life."[57]

Because the prevailing ideology in the United States during the past twenty-five years has supported, at least in theory, privately initiated rather than federally directed cultural programs, government support for photography has taken the form of grants from state and federal agencies to individuals. In France, however, under a nominally socialist government, a group of photographers found direct government support for a documentary project whose stated purpose was to fuse elements of FSA practice with that of the *Mission héliographique* (the 1850s portrayal of architecture and monuments commissioned by the French government). Aimed at depicting changes in the French countryside and suburbs caused by uncontrolled industrialization, the images by the fifteen photographers employed by La Mission Photographique de la DATAR included factory buildings and large-scale apartment complexes erected in once-provincial suburbs, railroad cuts, waste areas, office interiors, and the like. While they revealed the uneasy conjunction of modern industrial development and traditional buildings, few of the photographers concerned themselves with people; those who did portrayed them simply as one element in the new industrialization. In an effort to make the photographs available in a form other than exhibition and publication (a paperback edition of work in progress appeared in 1985), 35mm transparencies of selected images were to be placed in libraries throughout the nation. As had been true in the United States earlier, changes in the political climate in France brought the project to an end after only a few years of activity.

Despite the privatization of cultural life in the past few decades, there has been a recent resurgence in the United States of photographs concerned with ongoing problems in society. Usually initiated by the photographer and supported either by the individual, by grants, or in some cases by union funds, the purpose of these documentary projects about working people—coal miners (Earl Dotter), agricultural workers (Reesa Tandy and Roger Minick), hospital employees (Georgeen Comerford), and illegal immigrants (Ken Light)—usually is to illuminate specific issues in the hope that an aroused public will exert its political will. Other recent documentary photographs have made visible aspects of ecological disaster, the transformation of the landscape by large-scale industrial and urban construction, and the effects of manufacturing nuclear energy and materials, with similar, if not as clearly formulated, goals in mind. In spite of differences in style from earlier documentary work, many of these projects carry forward the spirit of the classic documentary genre through their socially motivated vision and goals, their desire to inform *and* evoke feeling about individuals and communities.

The Changing Chicago Project is documentation of a somewhat different nature. With its focus on human experience, which it seeks to place within a context determined by the particular geography and past history of the city of Chicago, it shares the aims of the classic social documentary mode. It also draws upon elements present in early architectural documentations through its inclu-

sion of urban structures, surrounding landscape, bridges, factories, and waterways. But even as it probes these sometimes grand, sometimes shabby façades as they present themselves to the casual eye, it is not oriented toward specific action on social issues. Rather, it aims to shape a sense of the actuality of life through a vivid interplay of architecture, artifact, events, and people. In its conjunction of visual statements that are cooly informative with others that are satirical, celebratory, and inspiriting, and through its inclusion of instructive and lyrical texts that deal both with the city and its imaging, the project seeks to honor past traditions, reflect present concerns, and forge a new and broader role for documentary photographs.

NOTES

1. See Peter B. Hales, "Landscape and Documentary: Questions of Rephotography," *Afterimage*, Summer 1987, 10.

2. Edgar Allan Poe, "The Daguerreotype," reprinted in Alan Trachtenberg, ed., *Classic Essays on Photography* (Leete's Island Books, New Haven, Conn., 1980), 38. For a less-positive view of the medium's representational accuracy, see Lady Elizabeth Eastlake, "Photography," reprinted in Beaumont Newhall, ed., *Photography: Essays and Images* (Museum of Modern Art, New York, 1980), 81.

3. A number of photographs depicting working people were made in the 1840s by Fox Talbot on his estate at Lacock Abbey, but it was not until the appearance of cheaper processes and smaller formats that working people could order portraits of themselves. The new methods also encouraged the production of commercially salable images of the working class, many of which appealed to the curious traveler. William Carrick, working in Russia, and Eugenio Manoury, in Peru, were but two of the numerous commercial photographers whose images of peasants and street vendors appealed to tourist collectors. Some portrait businesses, exemplified by that of Heinrich Tonnies in Aalborg, Denmark, presented a range of local occupations, thus providing a social portrait, although the maker may not have had this end in mind. Besides photographers, painters Ford Maddox Brown, Jules Breton, and Gustave Courbet (among others) addressed this theme.

4. See Bill Jay, *Customs and Faces: Photographs by Sir Benjamin Stone, 1838-1914* (Academy Editions, London, 1972).

5. See Michael Hiley, *Victorian Working Women: Portraits from Life* (Gordon Fraser, London, 1979).

6. See Colin Ford, "Introduction," *An Early Victorian Album* (Alfred A. Knopf, New York, 1976), 36.

7. Lady Eastlake referred to the Hill and Adamson portraits as "Rembrandt-like"; Eastlake, "Photography," 91.

8. See *The Camera and Dr. Barnardo* (Barnardo School of Printing, Hertford, England, n.d.). Besides retraining in mission homes, children were sent to Canada to work as servants for British farm families.

9. Under the aegis of the *Commision des Monuments*, which stipulated itineraries, five photographers traversed the country, returning with more that 300 negatives depicting the condition of important buildings and monuments. Because the aims of the commission were mainly archival, the works were not publicly exhibited, frustrating early champions of photographic documentation who had looked upon the project as an opportunity both for individuals and the medium to demonstrate their capabilities. See André Jammes and Eugenia Parry Janis, *The Art of French Calotype* (Princeton University Press, Princeton, N.J., 1983), 54-56.

10. Little is known about the origins of the project; for the fullest information, see *Charles Nègre, Photographe, 1820-1880* (Editions de la Réunion des Musées Nationaux, Paris, 1980), 264-72.

11. For instance, the carefully arranged figures of famine victims photographed in India in 1899 by Raja Deen Dayal for the ruler of Hyderabad imply order imposed on social chaos from above. Similarly, when Jacob Riis photographed the young inmates of an orphanage in New York City, he arranged them in a neat, symmetrical half-circle to emphasize the rational character of the good works undertaken by authorized charitable institutions.

12. Maria Morris Hambourg, "Charles Marville's Old Paris," *Charles Marville, Photographs of Paris* (French Institute, New York, 1981), 7-9.

13. Ibid., 9.

14. From the introduction by William Young to the 1900 photogravure edition of Annan's Glasgow views, quoted in Anita Ventura Mozley, "Introduction," *Thomas Annan: Photographs of Old Closes and Streets of Glasgow, 1868-1877* (Dover Publications, New York, 1977), vi.

15. Peter B. Hales, *Silver Cities: The Photography of American Urbanization, 1839-1915* (Temple University Press, Philadelphia, 1984), 91.

16. The half-tone process, first patented by Frederick Ives in 1881, translated the tonal values of the photograph into a microscopic code of discrete dots that could be read as continuous tonalities. See Naomi Rosenblum, *A World History of Photography* (Abbeville Press, New York, 1984), 451, for a brief survey of photomechanical printing methods; for a more detailed account, see Estelle Jussim, *Visual Communication and the Graphic Arts* (The Bowker Co., New York and London, 1974).

17. Henry Mayhew, *London Labour and London Poor,* was first published in 1851 in two volumes as a compendium of newspaper articles and was reissued in 1861, 1862, 1864, and 1865 with additional material. See Peter Quennell, ed., *Mayhew's London* (Bracken Books, London, 1984).

18. Richard Beard started a daguerreotype studio in 1841 and sold franchises throughout England.

19. *Street Life in London,* text by Adolphe Smith, photographs by John Thompson [sic] (Benjamin Blom, New York and London, 1969). The work originally was published in twelve monthly parts, priced so that working people could afford it. Adolphe Smith [Headingly] was a journalist who served as official interpreter for the International Trades Union Congresses from 1886 to 1905.

20. Jacob A. Riis, *How the Other Half Lives* (Charles Scribner and Sons, New York, 1890). The original edition contained artist's engravings from photographs and photographic reproductions in half-tone. A reprint edition (Dover Publications, New York, 1971) contains 100 photographs, all in half-tone, from the collection of the Museum of the City of New York.

21. For a discussion of how Riis used the images, see Hales, *Silver Cities,* 164; see also Maren Stange, "Gotham's Crime and Misery: Ideology and Entertainment in Jacob Riis's Lantern Slide Exhibitions," *Views,* 8, no. 3 (Spring 1987), 7-11.

22. The most notable social tract to appear before Riis's work was Charles Loring Brace's *The Dangerous Classes of New York and Twenty Years Work among Them* (1872). John George Brown gained an ample income from the sale of paintings of the children of the working class, known as "street arabs."

23. See Ferenc M. Szasz and Ralph H. Bogardus, "The Camera and the American Social Conscience," *New York History,* 55, no. 4 (October 1974), 433.

24. Invited by the United States Commission to the Paris Exposition as a delegate to the International Photographic Congress (Alfred Stieglitz was the other U.S. delegate), Johnston brought along a collection of the work of women photographers; her own photographs of Hampton Institute were shown in the United States section of the exposition. See Toby Quitslund, "Her Feminine Colleagues: Photographs and Letters Collected by Frances B. Johnston in 1900," *Women Artists in Washington Collections* (University of Maryland Art Gallery, College Park, 1979); see also *The Hampton Album* (Museum of Modern Art, New York, 1966).

25. Emerson, a British medical man turned photographer, published his ideas about the relationship between art and reality in *Naturalistic Photography for the Students of Art* (Sampson, Low,

Marston, Searle and Rivington, London, 1889); the work appeared in a third edition (Scovill and Adams Co., New York, 1899). Emerson photographed the rural poor of East Anglia, emphasizing their stature and individuality.

26. For a discussion of Hine's background and relationship to John Dewey's concepts of education and his development of a rationale for camera documentation, see Alan Trachtenberg, Walter Rosenblum, and Naomi Rosenblum, *America and Lewis Hine* (Aperture, New York, 1977).

27. An immigrant mother and child was called "Ellis Island Madonna"; immigrants photographed on a stairway received the title "Climbing into the Promised Land."

28. Alan Trachtenberg, "Ever the Human Document," *America and Lewis Hine,* 128.

29. In 1925 Rexford Guy Tugwell and his assistant, Roy E. Stryker (both eventually connected with the FSA project), used many of Hine's images to illustrate a textbook on American economic history. See Maren Stange, "The Management of Vision: Rexford Tugwell and Roy Stryker in the 1920s," *Afterimage,* March 1988, 6-9.

30. This was published in a slim volume for youthful readers. See Lewis Hine, *Men at Work* (Macmillan, New York, 1932).

31. Lerski (born Israel Schmuklerski in Strasbourg), an actor and theatrical photographer, worked in Milwaukee, Wisconsin, before returning to Germany; his still photographs of German workers date from between 1928 and 1931. See *Helmut Lerski, Lichtbilder* (Museum Folkwang, Essen, 1982).

32. Allan Sekula, "The Traffic in Photographs," *Art Journal,* 41, no. 1 (Spring 1981), 18. A selection of the portraits was published as *Anlitz der Zeit,* consisting of sixty images with preface by Alfred Döblin (Transmare, Munich, 1929). In his introduction, Döblin asserts that Sander's physiognomic approach will lead to an understanding of sociology.

33. There is an extensive bibliography of works on the FSA Historical Project, the agency that employed the photographers, processed the film, and maintained the archives. For a recent publication that puts the FSA work into the context of other New Deal photographic projects, see Pete Daniel, Merry A. Foresta, Maren Stange, and Sally Stein, *Official Images: New Deal Photography* (Smithsonian Institution Press, Washington, D.C., 1987).

34. For a discussion of the ideas of the participating photographers, see Hank O'Neal, *A Vision Shared: A Classic Portrait of America and Its People, 1935-1943* (St. Martin's Press, New York, 1976).

35. Quoted in William Stott, *Documentary Expression and Thirties America* (Oxford University Press, New York, 1973), 269.

36. Quoted in ibid., 61. In a famous incident Rothstein moved a cow's skull to photograph it again; at the time his argument was that he was representing the truth of the situation (the effect of the drought) by moving it to a different location.

37. Seven hundred kodachromes taken between 1939 and 1942 by Jack Delano, Russell Lee, Marion Post Wolcott, and John Vachon were discovered in the collection of the Library of Congress in 1978. See Ellen Handy, "Farm Security Administration Color Photographs," *Arts Magazine,* 58, no. 5 (January 1984), 18; Andy Grundberg, "FSA Color Photography: A Forgotten Experiment," *Portfolio,* July-August 1983, 53-57.

38. Handy, "Farm Security Administration Color Photographs," 18.

39. An anecdote included in Stott makes the point that Lange's pictures eased the appropriation of $200,000 of relief money. See Stott, *Documentary Expressions and Thirties America,* 226.

40. See Merry A. Foresta, "Art and Document: Photography of the Works Progress Administration Federal Art Project," and Sally Stein, "Figures of the Future: Photography of the National Youth Administration," *Official Images,* 92-107, 148-56.

41. Berenice Abbott and Elizabeth McCausland, *Changing New York* (E. P. Dutton & Co., New York, 1939); reprinted as *New York in the Thirties as Photographed by Berenice Abbott* (Dover Publica-

tions, New York, 1973). Having made Atget's acquaintance in the last year of his life, Abbott was able to arrange for the purchase of his negatives and prints after his death in 1927; eventually this material was acquired by the Museum of Modern Art, New York.

42. See Anne Tucker, "The Photo League," *OVO Magazine,* 10, nos. 40/41 (1981), 3-13.

43. Edwin Hoernle, "The Working Man's Eye," reprinted in David Mellor, ed., *Germany: The New Photography, 1927-1933* (Arts Council of Great Britain, London, 1978), 48.

44. See Humphrey Spender, *Worktown People* (Falling Wall Press, Bristol, England, 1982).

45. Starting with *Time in New England,* on which he worked with Nancy Newhall, Strand worked with a writer or editor to select appropriate texts to present a cohesive idea about the society he photographed: with Cesare Zavattini on *Un Paese,* Basil Davidson on *Tir a M'hurain* and *Ghana: An African Portrait,* and James Aldridge on *Living Egypt;* the only work in which text selections were left entirely to writer Claude Roy was *La France de Profile.*

46. Stephen W. Plattner, *Roy Stryker: U.S.A. 1943-1950: The Standard Oil (New Jersey) Photographic Project* (University of Texas Press, Austin, 1983), 12-13.

47. William S. Johnson, ed., *W. Eugene Smith: Master of the Photographic Essay* (Aperture, Millerton, N.Y., 1981), 149.

48. Two examples are John Gutmann, who arrived in the United States in 1934, and Lisette Model, who came in 1937. Gutmann's street views are full of sardonic humor, while Lisette Model's portraits made on New York's Lower East Side are much less sympathetic than those by native-born Photo League members working in the same milieu at the same time. In the postwar period, Model's vision became influential, in particular, on the work of Diane Arbus.

49. Bruce Davidson, *East 100th Street* (Harvard University Press, Cambridge, Mass., 1970); Davidson, *Subway* (Aperture, New York, 1986); Danny Lyon, *Conversations with the Dead* (Holt, Rinehart and Winston, New York, 1969).

50. Martha Rosler, "Some Contemporary Documentary," *Afterimage,* Summer 1983, 13-15. The first full-length publication to raise this issue was Stott, *Documentary Expression and Thirties America;* Stott holds that Lange's images were sentimental symbols while Evans's were of real individuals.

51. Reviewing an exhibition by Walter Rosenblum, critic Andy Grundberg used the buzzwords of this position, referring to sentimentality and "optimism" and noting that the photographer "is a white middle-class New Yorker," taking as subjects the "black descendants of slaves." See "In Haiti: Photographs by Walter Rosenblum, 1958-1959," *New York Times,* August 12, 1988.

52. Lewis W. Hine, "Social Photography: How the Camera May Help in Social Uplift," *Proceedings,* National Conference of Charities and Corrections, June 1909, 50-54.

53. Nancy Roth, "Redefining the Vernacular," *Afterimage,* March 1986, 4-5.

54. Neil Seiling, "The New Old Documentary," *Afterimage,* March 1985, 3, 20.

55. Howard Becker, "Do Photographs Tell the Truth?," *Afterimage,* February 1978, 9-13.

56. All quotes from Deborah Bright, "Many Are Called, Few Are Chosen," *Afterimage,* Summer 1985, 13.

57. Max Kozloff, "Where Have All the People Gone?," *The Privileged Eye* (University of New Mexico Press, Albuquerque, 1987), 203.

My City in a Garden

LARRY HEINEMANN

Let me say at once that I am Chicago born and raised. Although I'm involved in a love-hate relationship with this city, and although I've looked for other places to live—San Francisco comes immediately to mind, as does the Olympic peninsula in Washington State—somehow there has never been a sufficiently powerful reason for me to leave. I've never quite figured that out. San Francisco is built on the San Andreas Fault (and I've had enough surprises in my life, thank you), and the Olympic peninsula—well, it's a very isolated place and I seem to be a city boy. When all is said and done, however, it's the lake, I think, that keeps me here. The lake is a genuine terrain feature, like the Rocky Mountains that loom west of Denver, rising out of the high plains; like the hills upon which San Francisco is built, or the Manhattan skyline—a manmade terrain to be sure.

Chicago, a city in a garden, is truly magnificent when seen from the lake—a vantage point I did not enjoy until I was well into adulthood. By the same token, what can be uglier than the plain, lusterless gray asbestos siding on the buildings in any neighborhood after an early spring rain—the buildings gleaming and filthy, still moist with runoff, and the air chilly to boot. What other city would elect a man like Harold Washington and then rankle mightily with his administration, yet venerate him in the fashion of Richard J. Daley and after his death pack the city council gallery and throw money by the handful, chanting, "Deal, deal," when his successor was chosen at four o'clock in the morning. Chicagoans, who seem always blunt and robust in our tastes, tend to view politics as a hack business, a wild and raucous blood sport.

Any city is more than its buildings, of which Chicago is abundantly blessed. Our architectural heritage is the envy of many a metropolis, and we have exported brilliant, as well as shameless and pathetic, ideals. Whoever and whatever we are, it is the special spirit of the people that makes us so. Consider this: We are a city yet young. The first Europeans, French traders and trappers, began coming here in the seventeenth century to scratch around among the Indians for furs. Our first permanent citizen, Jean Baptiste Point du Sable, arrived just after the turn of the nineteenth century, to set up a trading post. Living here then must have been a very hard dollar, and no doubt du Sable lived in a crude log cabin chinked with mud to keep out the "Hawk." What do you suppose Paris looked like 150 years after its foundation? Or London? Or Moscow? Or New York? People have been coming to Chicago ever since. From ports of entry in New York and San Francisco, immigrants have made the willful, conscious choice to move on, to move inland. To

this place. We are an amalgam, and people are still coming here, stirring the pot—and you can almost read on their faces the relief of having escaped oppression and poverty.

My own family, my great grandfather, his wife, and his children, came here from Bavaria (to escape conscription, let it be said) in the later part of the 1800s. It seems that wherever political oppression or the destruction by war or soul-deadening poverty overwhelmed a people ("What have we got to lose?"), they gathered to themselves whatever riches they possessed and whatever else they could carry and *moved.* It happened because of the Potato Famine in Ireland and political suppression in Imperial Russia; Chinese coolies came for the railroad construction jobs with the Union Pacific; and it is happening today—from Central and South America, Pakistan and Persia, the Middle East and Southeast Asia. People are still coming looking for the Main Chance, the promise (and the fantasy) of work and the opportunity to start over, start clean.

Think for a moment what a person has to give up to come here: a homeland and a culture, kin as far as the eye can see, a bloodline of ancestors that worked the same rice paddies for a thousand years and whose very ashes enrich the soil. People came here *motivated;* they came here tuned for the work it would take to build a city from a marshy wetland—build it and *re*build it, good, bad, and indifferent. Never mind for a minute that the work might not have been here when they arrived, or that starting up from nothing is *very* hard (but better than starving or being lynched in a pogrom). Never mind that some people arrived with pockets bulging, coming here to cash in. Never mind that the "opportunity" might have turned into a kind of grasping opportunism—or at the very least a hard scrambling that can grind a person down and after forty years of honest work leave you with nothing more than beat-up hands, bad eyes, and a bend in your back. If we are a city still young, then we are also a city still in search of itself, still full of a "frontier" mentality—anything goes, pardner.

The lake is certainly part of our character, both a source and resource, for what would Chicago be without the lake? It is where much of our weather comes from, of course, from "lake effect" snow in winter to the quintessential phrase that describes our summer weather—"cooler near the lake." (The "Hawk"—the biting wind that comes howling inland from the lake's close-packed ice in winter—is a wet, penetrating chill that goes straight to the bone through the most carefully layered clothes.) Seeing the city's skyline from a boat a couple miles out on the lake is a wonder—at night the place seems to glow and sparkle. But get beyond the bubble of the skyline, out into the neighborhoods, where sometimes a person can look at the sad, other panorama of bungalow rooftops and two-flats and be moved to remark that this is a face only a mother could love. Driving back to the city after a two-week vacation, there is nothing more depressing than seeing the pall of poison air that hangs over us, air that is killing us by inches.

If this is the city that works (for such is the myth we have contrived for ourselves), this is also the city of park district payrollers whose idea of work is six guys watching one guy lean on a shovel while a driver naps behind the wheel of his pickup with the bill of a Bears cap over his eyes. If this is the city that pays its

workers the astonishing gratuity of a "prevailing wage" (What honest pride is there in that?), this is also the city in which there is no more depleted or wearisome or depressing a sight than a two-car subway train at eleven o'clock at night—homebound working stiffs exhausted and pale from such a simple thing as getting home in one piece. At such times Chicago seems lowdown, mean and ugly; at such an hour it doesn't much matter what work you do, whether you work with your back or your hands or your head or on your feet. A couple of years after Harold Washington's milestone election as mayor, a New York friend of mine asked me if Chicago was still the "city that worked"—he didn't much believe it, especially after the death of Mayor Daley. I told him the question was not whether the city "worked"; the question was who would work. This year we're still working that out.

Political hacks and grasping opportunists have always been part of the landscape—there are obscure parks and unavoidable public buildings, boulevards, and streets aplenty named after them. If the city has winked at the clever theft of ward-heelers and developers, its crooked cops and crackpot aldermen, it has also given abundant recognition (but not money) to its scrupulously honest and forthrightly compassionate progressives. I once heard a TV reporter tell of some alderman's brother-in-law cashing in with an enormous insurance contract—or something like that—and the guy dutifully rattled off the facts with the flat expression of rhetorical astonishment, as if he had never heard of such a thing in all his born days. Then the anchorman asked in all seriousness (with an equally staged and straight-faced naïveté) if this were an instance of out-and-out criminal fraud or just another example of "ordinary" clout? What a question, and what a natty distinction to be made. Alphonse Capone, that famous used-furniture salesman, must have turned over in his grave.

All of this makes me think of Carl Sandburg's often-quoted poem "Chicago," regarded now as a sorry old cliché. Everyone knows the first couple of lines,

> Hog butcher of the World,
> Tool Maker, Stacker of Wheat,
> .
> City of the Big Shoulders:

But can anyone recite the rest?

> They tell me you are wicked . . .
> And they tell me you are crooked . . .

It is a litany of vice, bristling with verbs. Farther on Sandburg makes his point:

> Come and show me another city with lifted head singing so
> proud to be alive and coarse and strong and cunning.

That sort of definition seems as true today as in 1914, when the poem was first published.

If we are a city in a garden, then where *are* the gardens? Down in Grant Park, across the boulevard from the big hotels. In the neighborhood parks, which bloom with trash—broken glass and charcoal ashes and beer can pull tabs—the objects of aggressive and purposeful neglect. At Wrigley Field—a genuine ballpark, mind you—where we are astonished by its air and spaciousness (forget for a

moment that the Cubs haven't won a pennant since 1945). Or in Comiskey Park (notice the word "park"), another venerable old edifice, this one named for Charles Comiskey, as notorious a skinflint as George Halas (What was it that Mike Ditka, another hard charger, said of Halas, may he rest in peace: "He threw nickels around like manhole covers."), whose flinty, parsimonious contempt for his players is often spoken of as a direct cause of the Black Sox Scandal of 1919.

The skyline rises, sparkling and tawny, glittering, along mile after mile of lakeshore—a silhouette that is the envy of many a city in this world (How many great artists and architects have come from this neck of the woods?)—and back of that a vast, dreary sprawl that seems to deaden the light with a kind of brick that might just be made of cinders and seems to suck any good and positive impulse right out of you. Is there anything more ugly and dispiriting than block after block of vacant land on the West Side or the South Side dumps, where methane flames burn from tiny spouts, dumps that seep toxic poison with every soaking rain? Is there anything more beautiful or more morose than the silhouette of the curbside trees against the pinkish glow of the alley lights?

If we are a city on the make—as Nelson Algren said; he wasn't complaining, he was bragging—we are also a smugly satisfied city, wanting nothing to change, willing to fight anyone who does insist on progressive change—screw the other guy, let him get his own (*if* he can), Chicago ain't ready for reform (even as it changes before our very eyes). We have always been a city and a people of contrasts, with every notch filled in between. Wild, almost easy money—folks almost throwing money at you—on the one side, conniving, grasping selfishness on the other, and in between the decent, honest working stiffs trying with every muscle in their backs to make ends meet and keep the dogs away from the door as well as the endless, mind-numbing failure (no matter how hard you try).

The city's unofficial motto may be "I will!" but we are plagued with laziness and institutionalized ineptitude of a kind that prompted Education Secretary William Bennett to call Chicago schools the worst in the country. Granted we have nowhere to go but up, but good God they're pitiful! And on the subject of mottoes, wasn't it Mike Royko's suggestion a number of years back to change the motto on the city's seal from *Urbis in Horto* (city in a garden) to "Where's mine?"

In Chicago we honestly brag about our grasping, sneering opportunism; at the same time, we smile and share. We are a people who stay up half the night, sitting on front stoops and stairways (waiting for the house to cool), drinking beer and listening to jazz and blues and street musicians; at the same time, we are a people who go to bed early, locking ourselves in for fear of our very lives. We are a people who revel in street parties, tangy red wine, and robust good fun; and we remember and venerate Richard J. Daley (and his flat, white-bread imagination), whose idea of a party was the St. Patrick's Day Parade—now there was a man who gave us much and took much away. Let us not forget that it was Daley's city that Martin Luther King, Jr., called the most segregated city in the country. King left, shaking his head no doubt, astonished by the mean-spirited ferocity of the city's racism. It was only after his murder that black political awareness awoke and

flourished, producing Harold Washington's election—yet another large ripple of change. (Nineteen sixty-eight will be remembered for many things.)

If we define ourselves by the great characters who hang their hats here, what are we to make of the amalgam: the Chickenman who strutted on State Street; Studs Terkel with his checked shirt and great mug; Irv Kupcinet and his running monologue of irrelevant, gossipy news; Ronnie the Fan of the Wrigley Field bleachers; Mike Royko with his street savvy and his savage, ironic, "up yours" wit; Harry Carey and his slurpy style of calling a game, not to mention his terrible, lovable singing; "Fast Eddie" Vrodolyak, who hasn't brought in an election in ten years; the Happy Bus Driver, who sings and spouts Scripture; Jane Byrne, a real sad sack; Walter Payton, whose astonishing grit and great heart made us all wonder at his accomplishment and poise, a man with the grace and smarts to quit when he was ahead; the guy with the empty gas can hustling tourists for enough money (by the dollar) to get to Hammond, giving us his own brand of hard street theater, pure Chicago, what a way to make a buck; street musicians (How many years did we have to wait for them?); Jehovah's Witnesses; loafers passing a bottle in a wrinkled brown paper bag; old-fashioned babushkas, bent-backed, limping along on two bad ankles, hauling the family's groceries home in those plastic shopping bags; and women cops (makes you wonder what the world is coming to).

From Hedgewisch to Norwood Park and Edgebrook, from Rogers Park and Juneway Terrace to Ashburn and Evergreen Park, we have come to this place, yesterday or 150 years ago, and we call it home. We live in tidy brick "Chicago-style" bungalows handed down from father to son, tinderbox two-flats that go up like heads of kitchen matches, cardboard boxes draped with plastic drop cloths on Lower Wacker Drive, and elegant, manicured high rises that you couldn't bring down with dynamite. Then, too, many of us have come to envy and despise gentrification, a prettifying that jacks the prices out of sight and makes us look like a Jersey suburb—just ask a New Yorker what *that* means!

We are the city of peace and quiet, opportunity, sky's-the-limit ambition (as if the gold nuggets were lying on the ground and all you had to do was shovel them up and drop them into sacks). We are here because our families are here; because this is as far as our bus fare would take us and our imagination or energy won't take us any farther; because the work we love is here; because we don't have the wherewithal to pack up and leave (so we're stuck); because we've tried New York and then Zurich and then Hong Kong and came here on a whim but stayed because of the good nature and bright minds of the people we've met; because the pickings are *easy*; because the music suits our bodies and the way we dance; because the overtime is so sweet; because we'd be crazy to leave; because we're here and we have to make the best of it; because, damn it all, we love the place; because when we run in the park, what could be more invigorating or enriching than watching the sun rise big and round and hot out of the lake, lighting the city with all its love of life, grace, and warmth—lighting as well all the crackling ambition, abundant hope, good, warm, sexy, glad-to-be-alive feelings, outright thievery and chicanery and sheer laziness, and monumental deals large and small.

The Photographs

Thomas Frederick Arndt

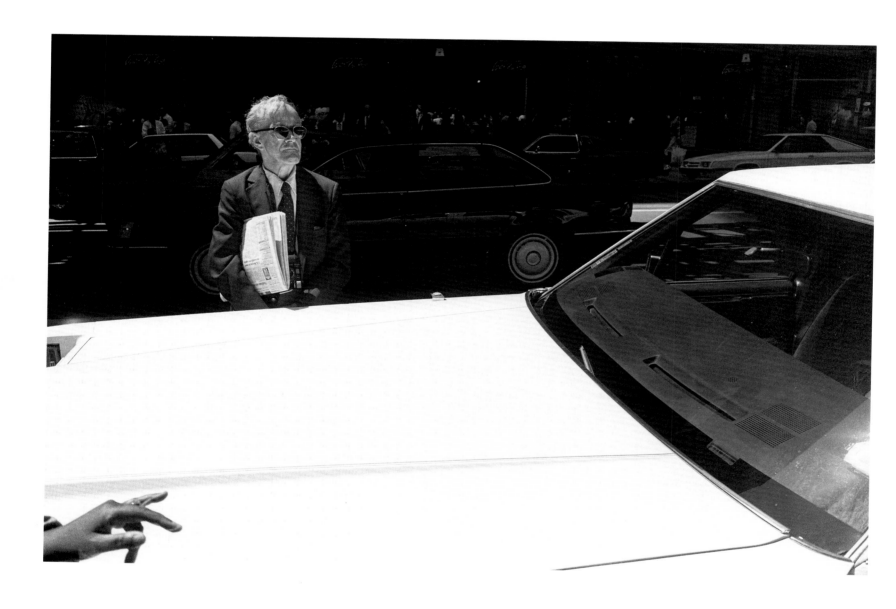

Wabash Avenue and Monroe Street, 1987

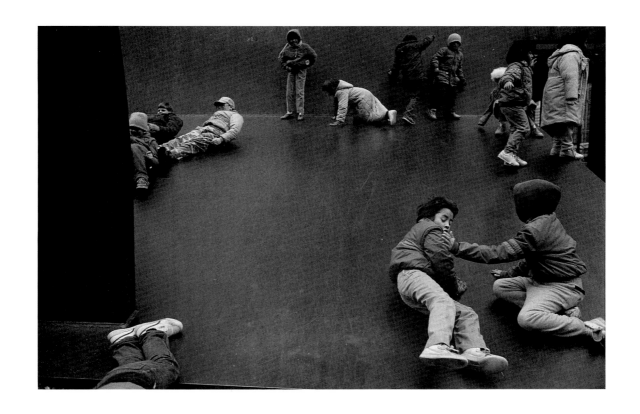

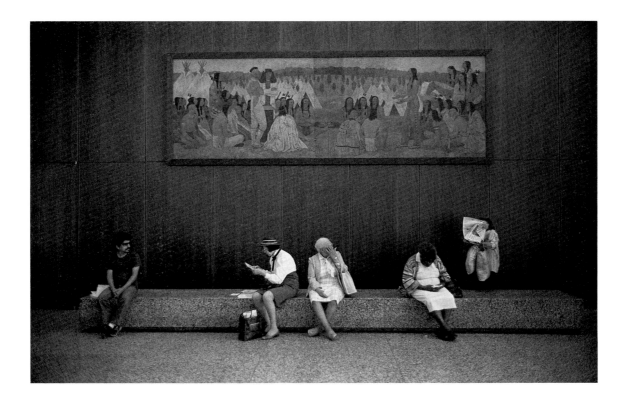

THOMAS FREDERICK ARNDT

Daley Plaza, 1987
Loop Post Office, 1987

27

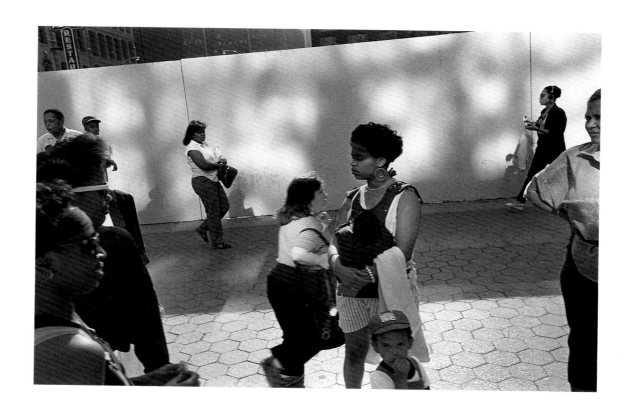

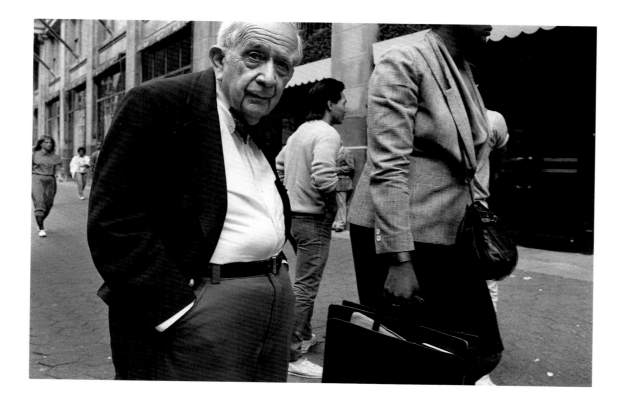

THOMAS FREDERICK ARNDT

State and Adams streets, 1987
Marshall Field's, State and Washington streets, 1986

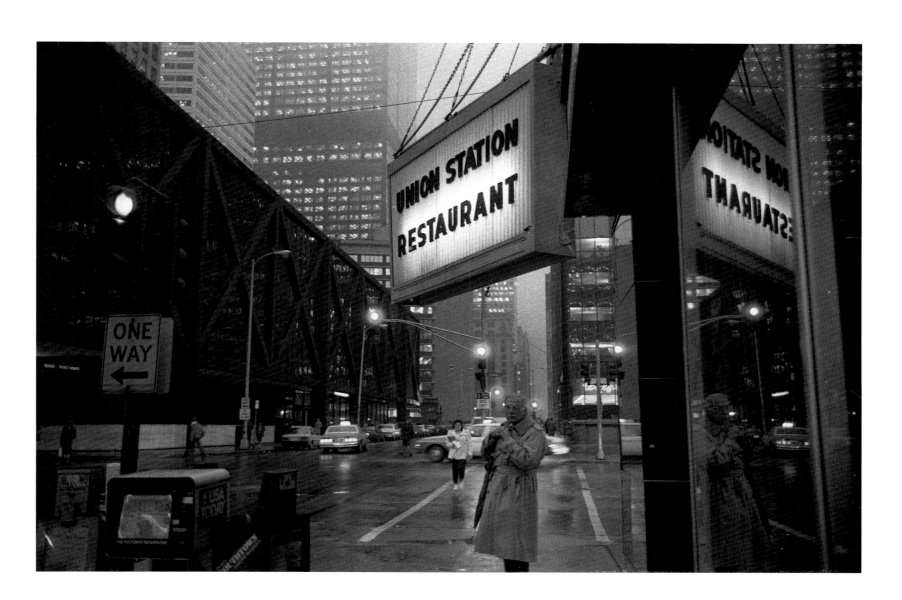

THOMAS FREDERICK ARNDT

Near Union Station, 1986

David Avison

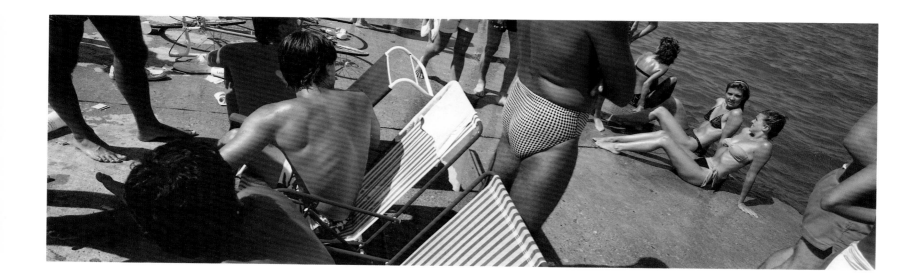

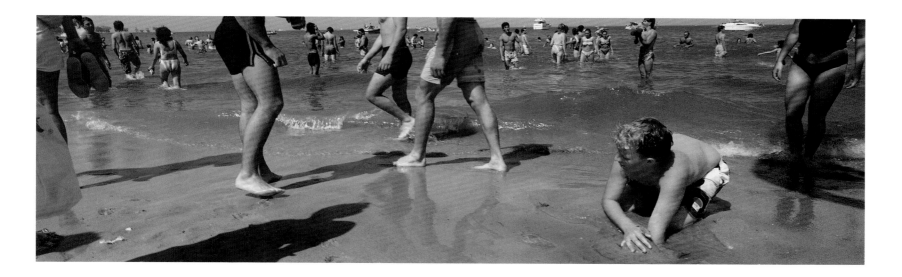

Oak Street Beach, 1987

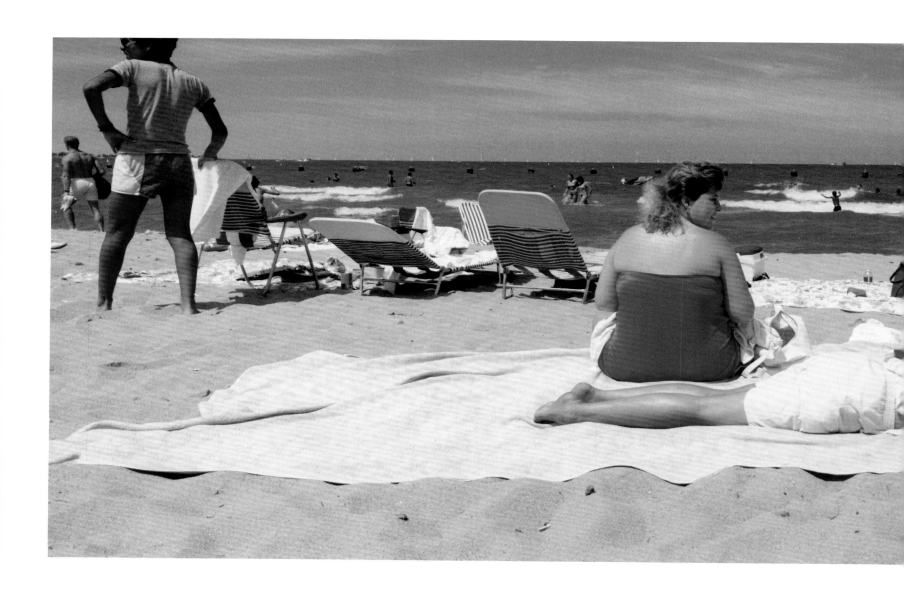

DAVID AVISON

North Avenue Beach, 1987

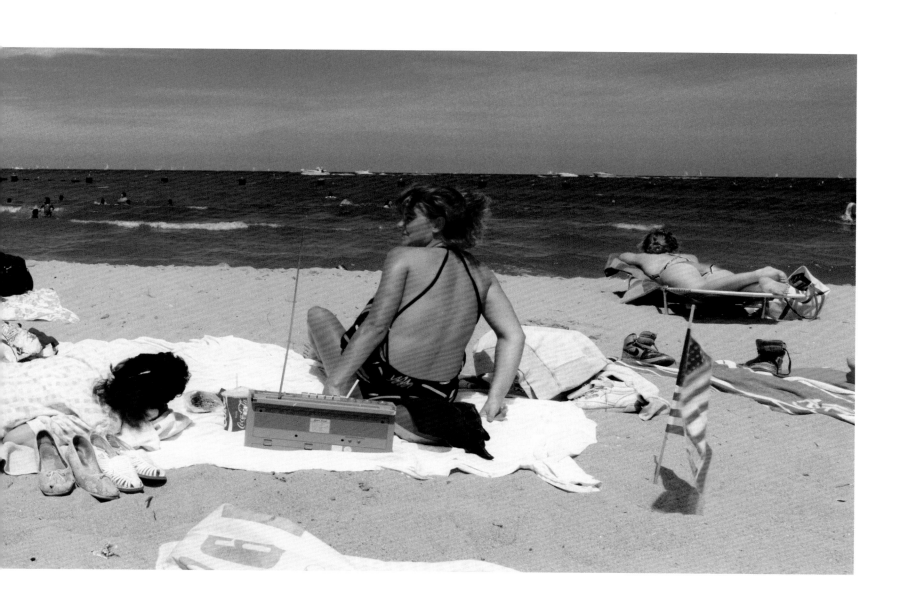

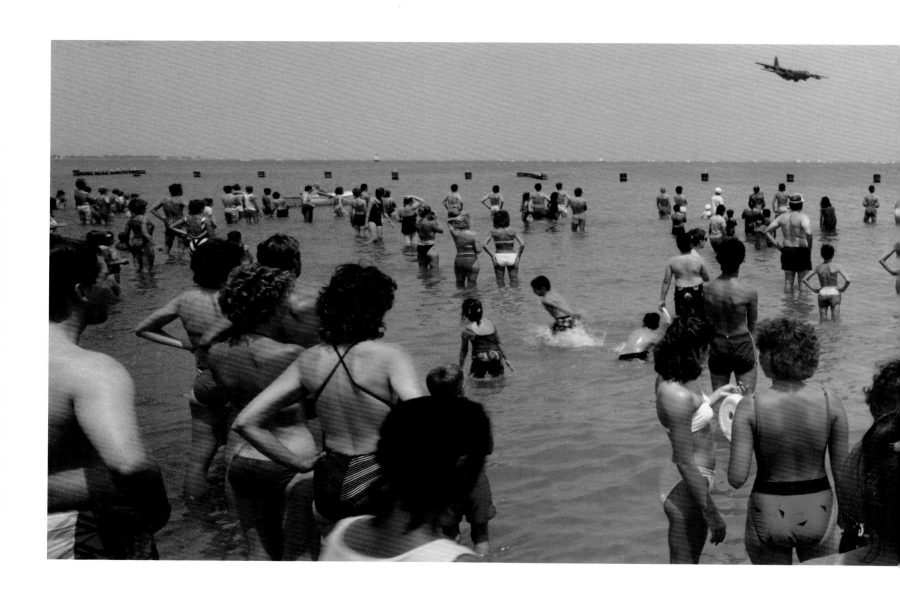

DAVID AVISON

Air and Water Show, North Avenue Beach, 1987

34

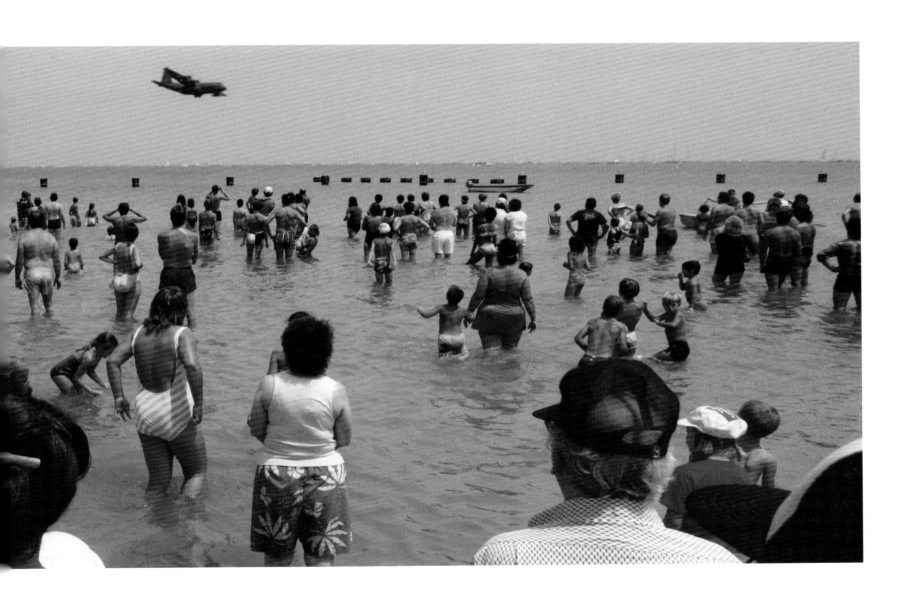

Dick Blau

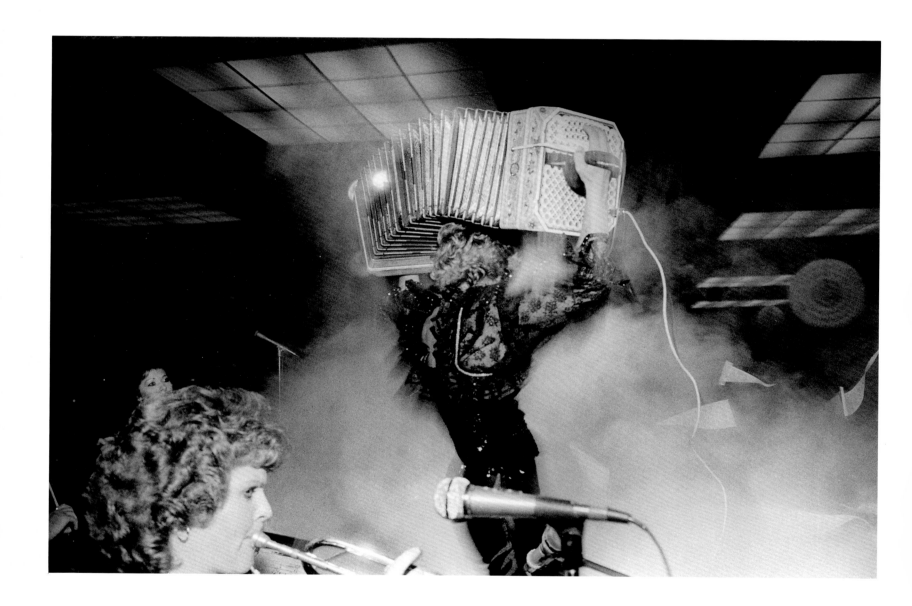

DICK BLAU

Renata and girls, International Polka Association Festival, Ramada Inn, Rosemont, 1983

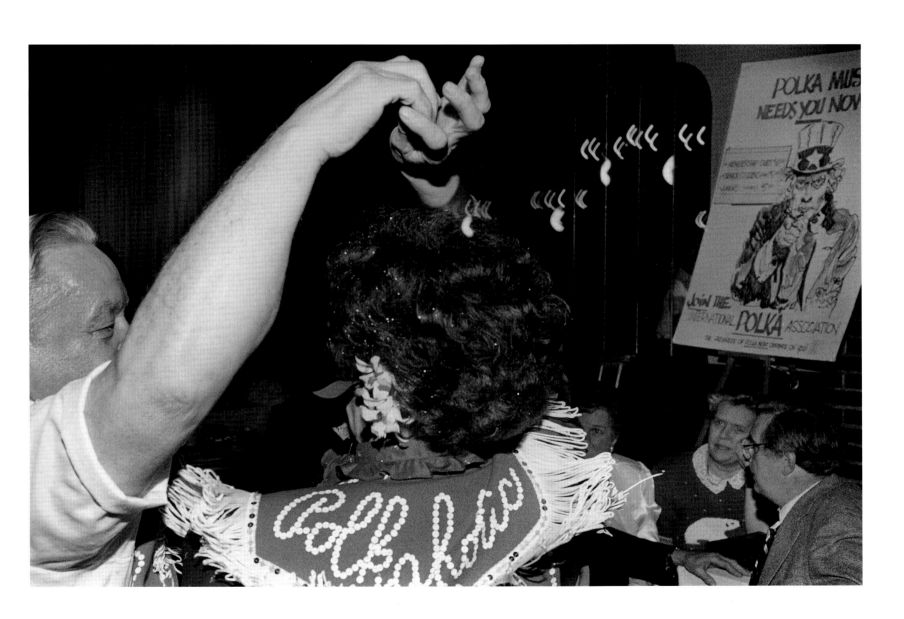

DICK BLAU

Polkaholics, Chicago Festival of Polka Bands, Glendora House, Chicago Ridge, 1988

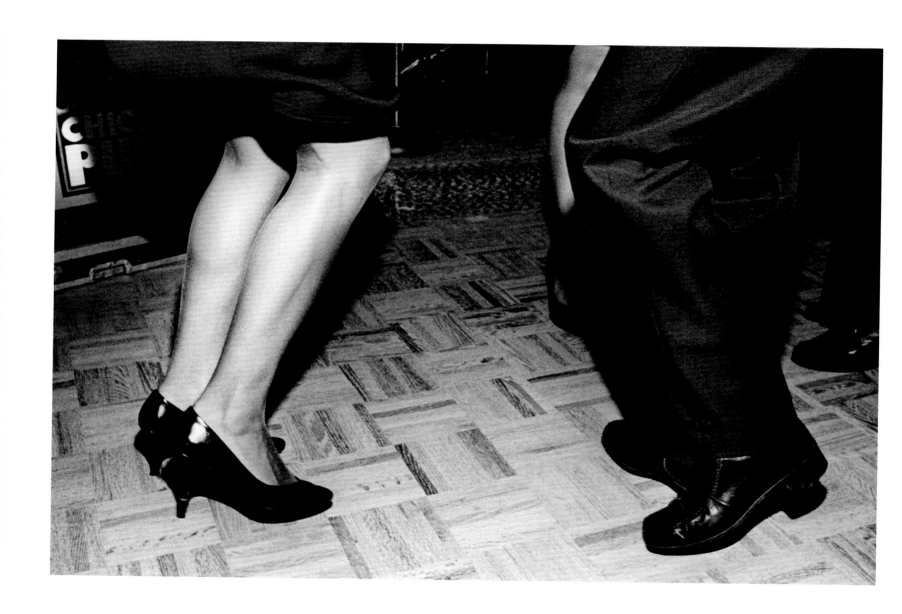

DICK BLAU

Dancers, Chicago Push Fan Club, Johnny Huzny's Personality Lounge, 1987

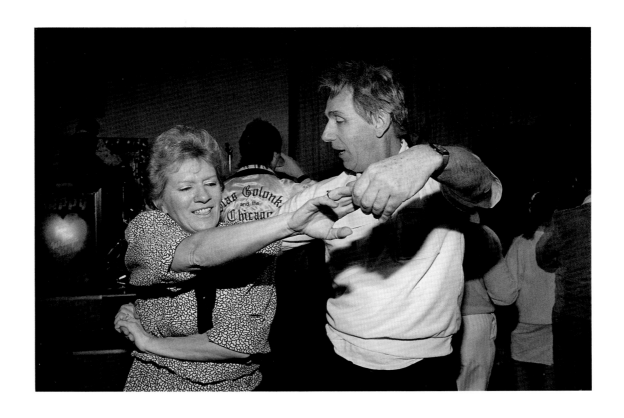

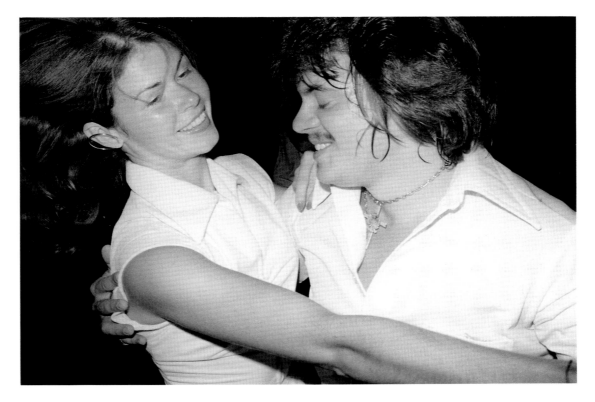

DICK BLAU

Chicago Festival of Polka Bands, Glendora House, Chicago Ridge, 1988
Dancers, International Polka Association Festival, Ramada Inn, Rosemont, 1983

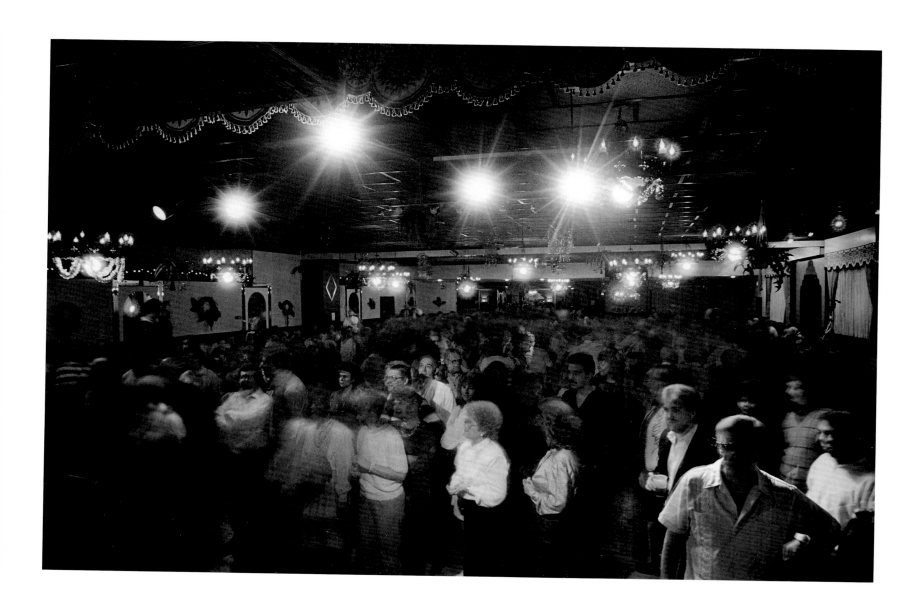

DICK BLAU

From the bandstand, Chicago Festival of Polka Bands, Glendora House, Chicago Ridge, 1988

Jay Boersma

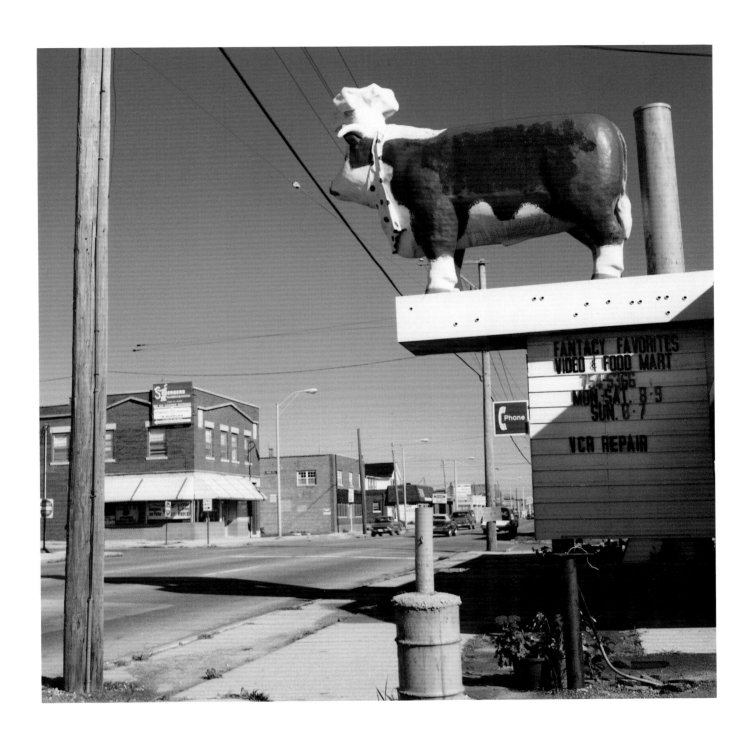

"Fantacy" Favorites Video and Food Mart, Chicago Heights, 1987

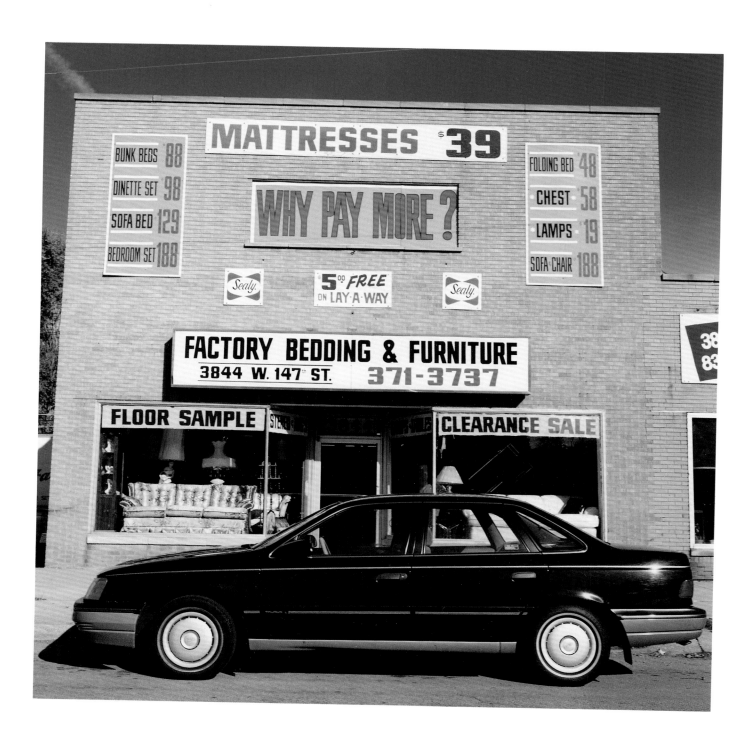

Factory Bedding and Furniture, Midlothian, 1987

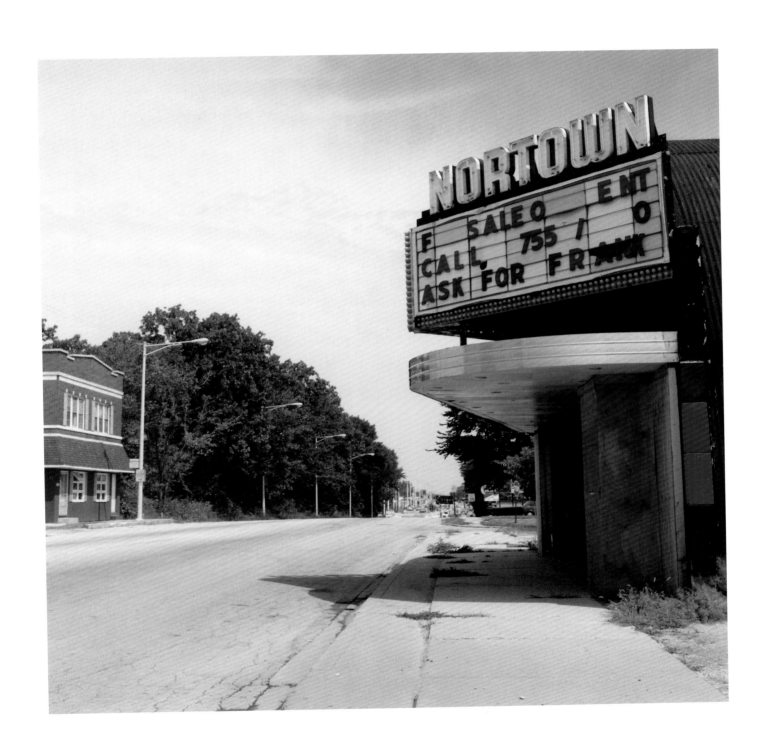

JAY BOERSMA

Nortown Theater, Halsted Street, Chicago Heights, 1987

43

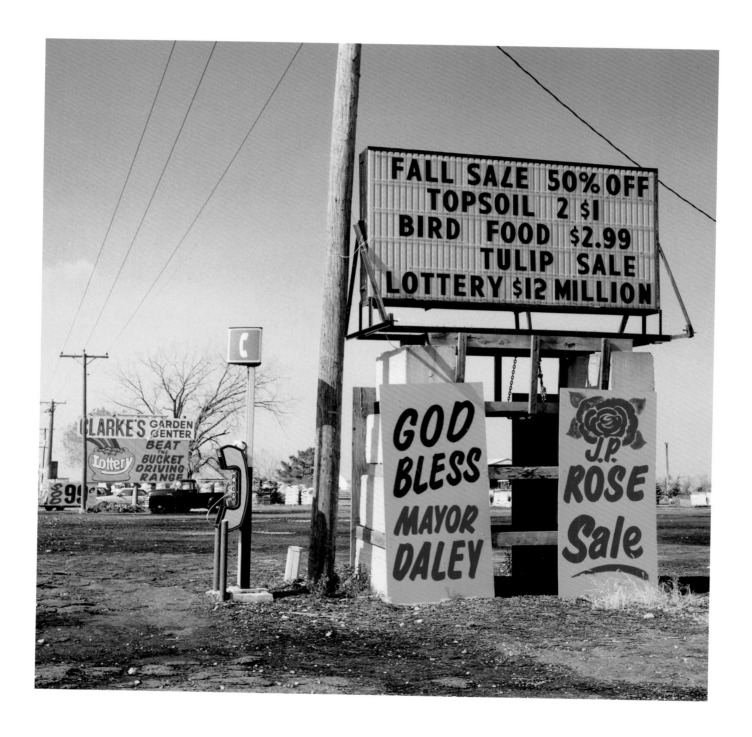

JAY BOERSMA

Clarke's Garden Center, Chicago Heights, 1987

44

Wayne Cable

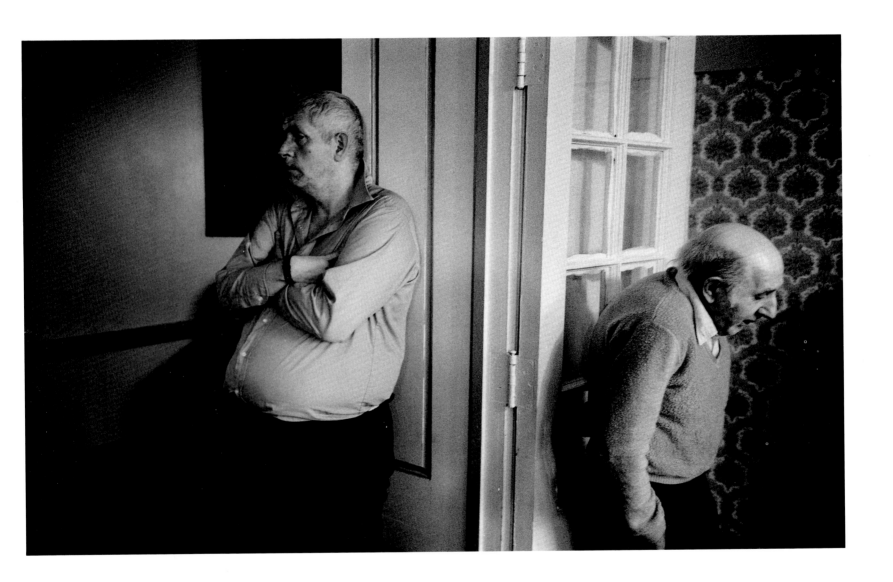

WAYNE CABLE

Waiting for dinner, Arlington House, 1988

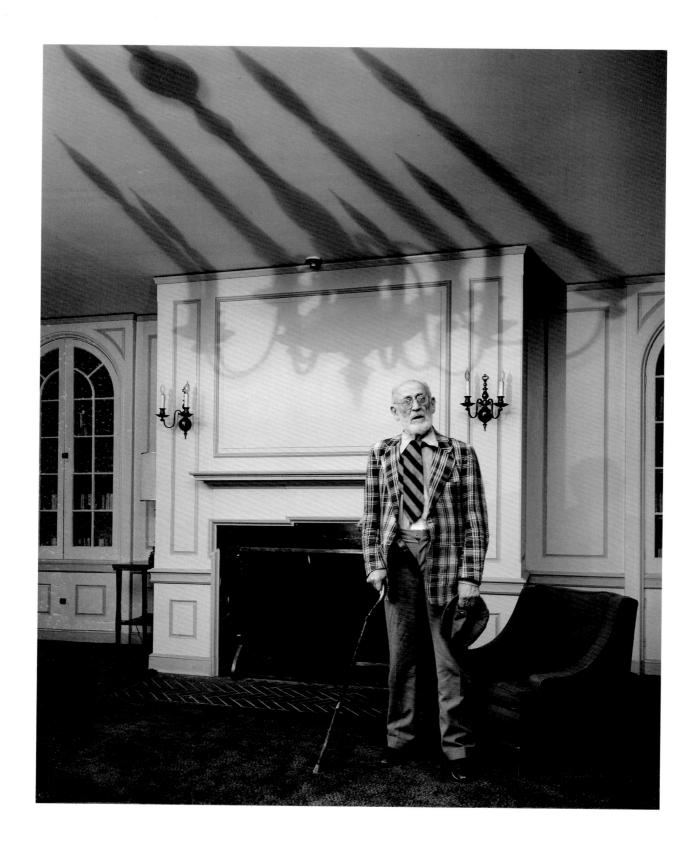

WAYNE CABLE

Resident of Arlington House, 1981

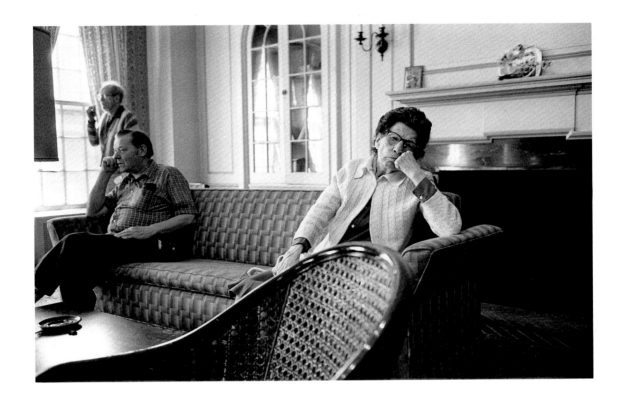

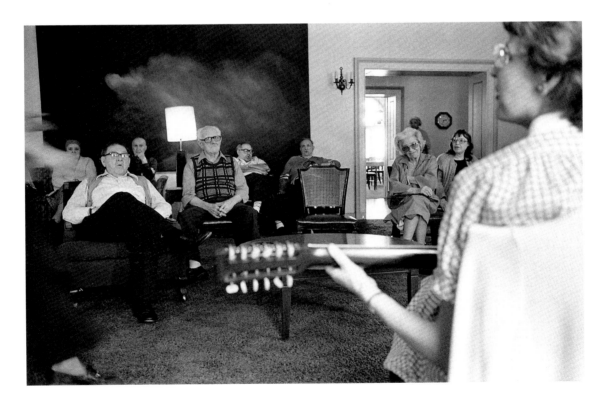

WAYNE CABLE

"Thanks for the Memories," music performance, Arlington House, 1988

"Sweet Georgia Brown," music performance, Arlington House, 1988

47

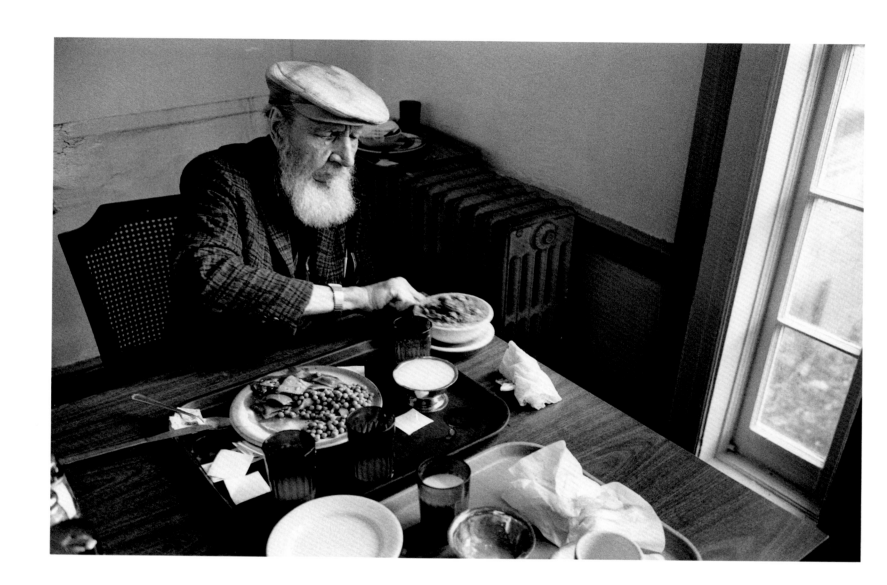

WAYNE CABLE

Arlington House, 1988

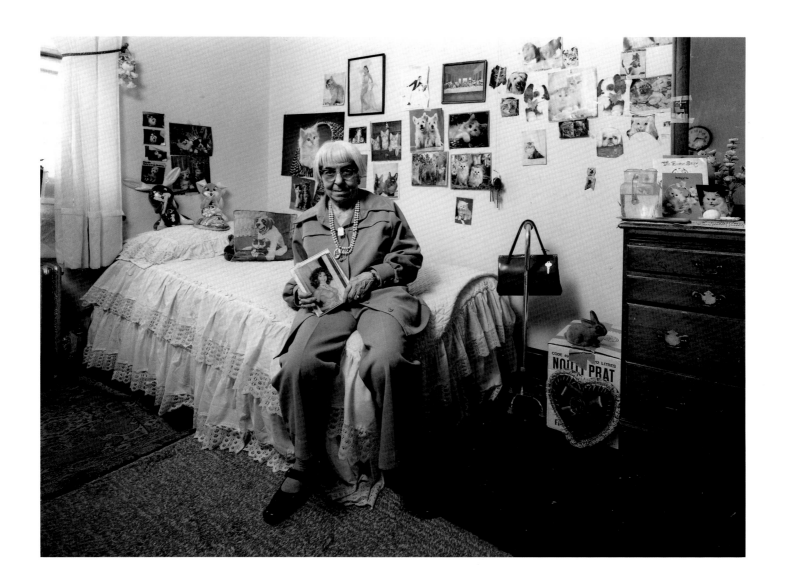

WAYNE CABLE

Resident of Arlington House, 1981

Patty Carroll

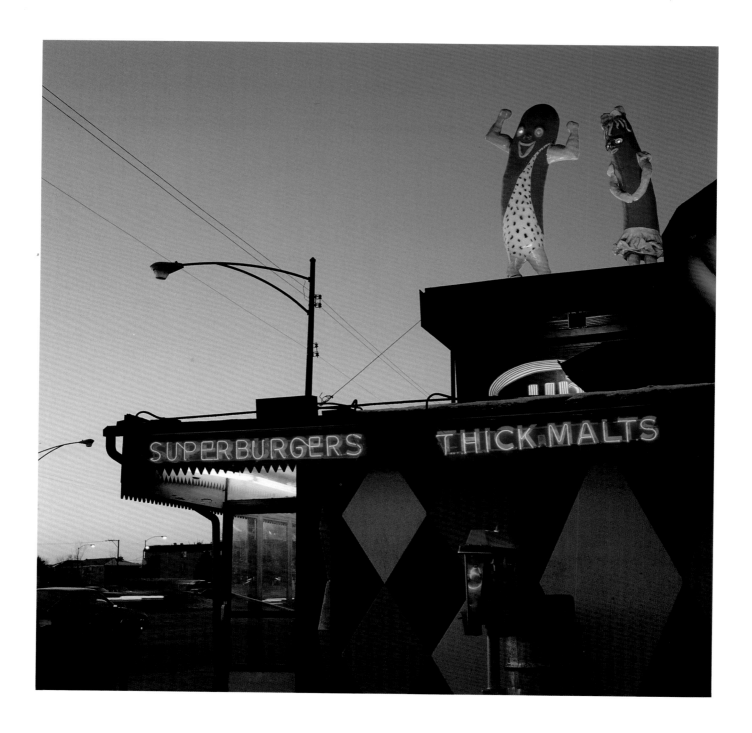

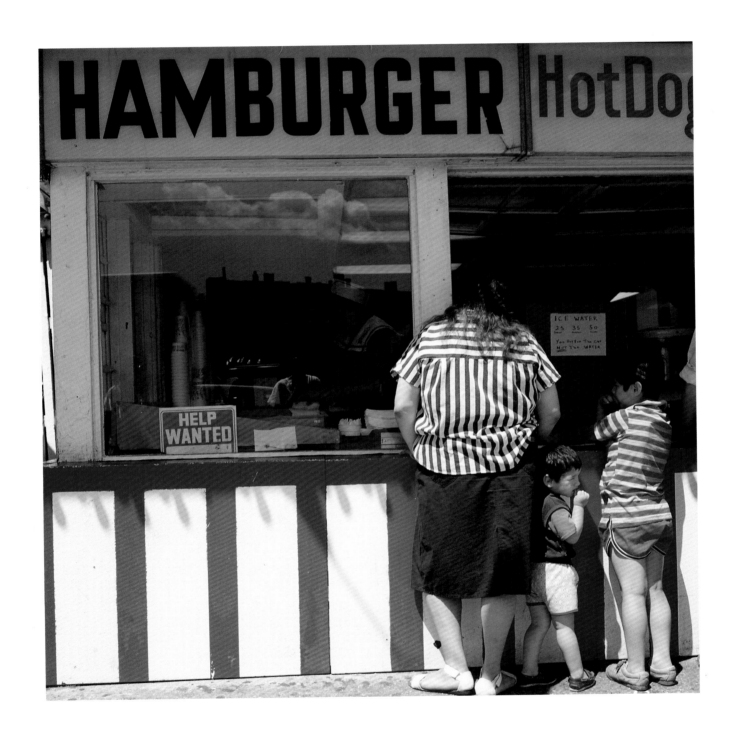

PATTY CARROLL

Duk's, Ashland and Chicago avenues, 1987

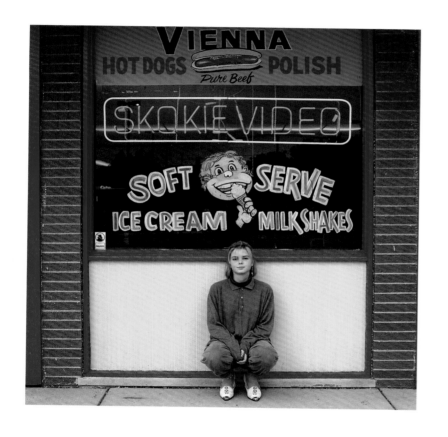

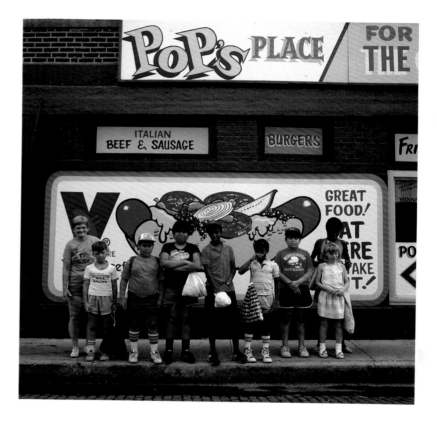

PATTY CARROLL

Skokie Video, Dempster Street, Skokie, 1987
Pop's Place, Morse and Glenwood avenues, 1987

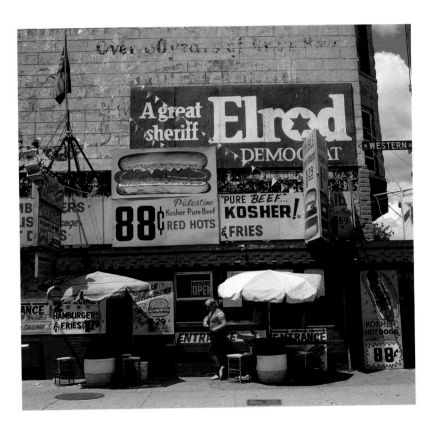

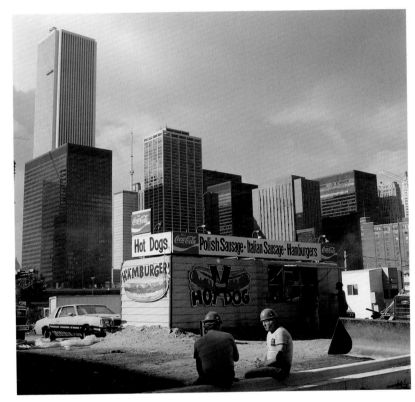

PATTY CARROLL

Diana's Hot Dogs, Milwaukee and Western avenues, 1987
Hot dog trailer, Illinois Street, 1987

53

Barbara Ciurej – Lindsay Lochman

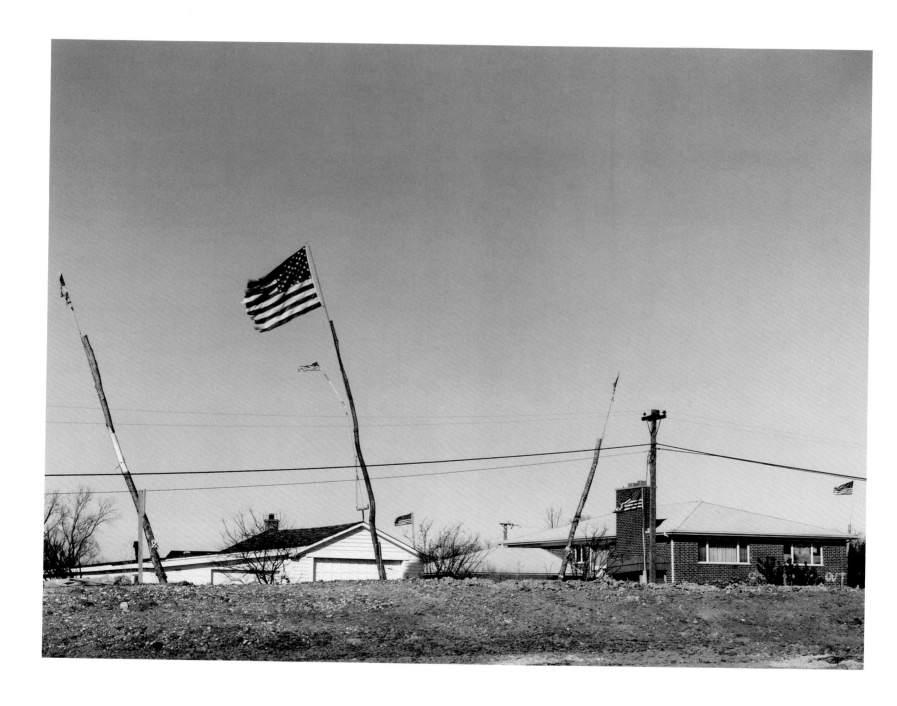

Home with American flags, Deerfield, 1988

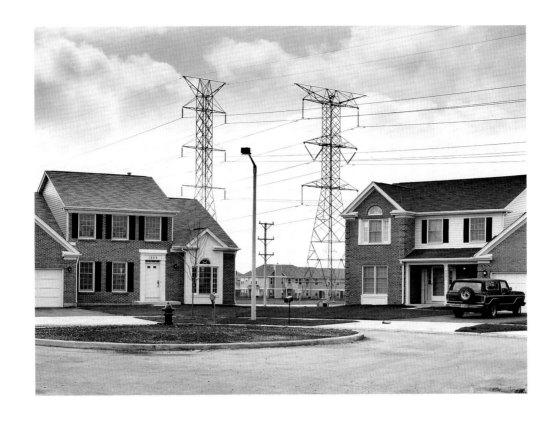

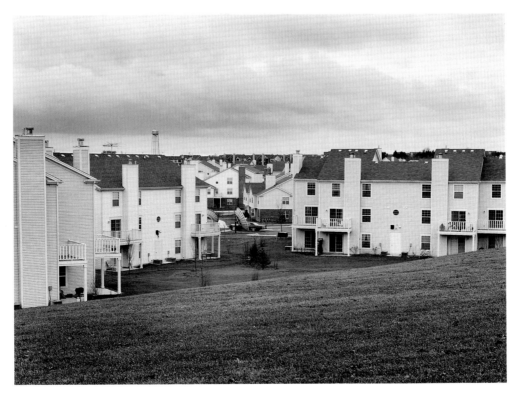

BARBARA CIUREJ — LINDSAY LOCHMAN

Homes with high-voltage towers, Buffalo Grove, 1988
Garden Glen Luxury Manor Homes, Hoffman Estates, 1987

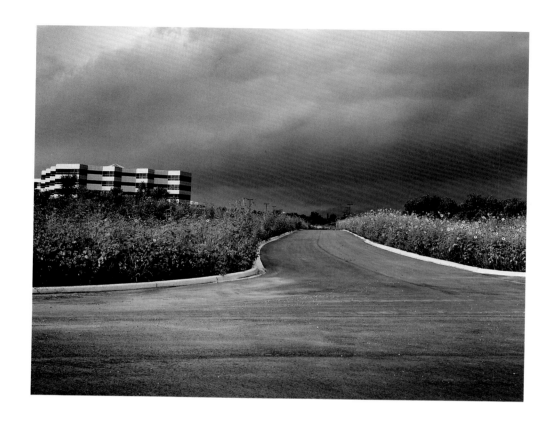

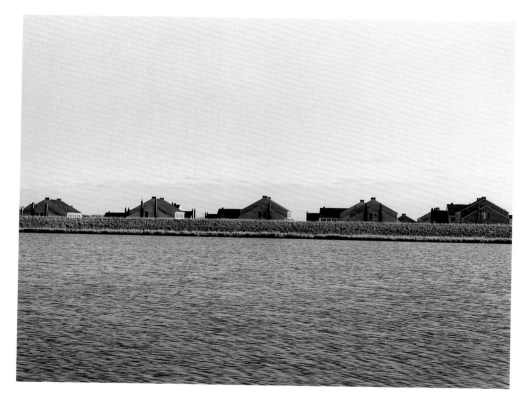

BARBARA CIUREJ — LINDSAY LOCHMAN

Corporate tower in storm, Oak Brook, 1987

College Hills homes, Palatine, 1987

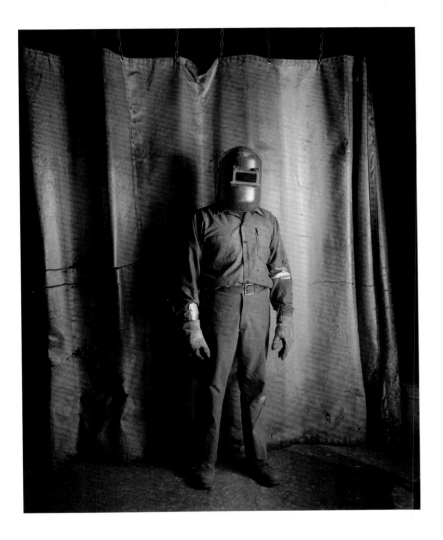 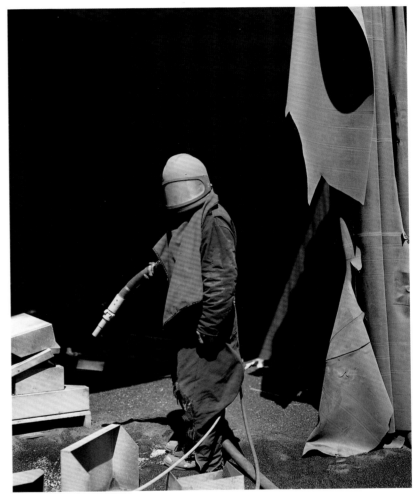

KATHLEEN COLLINS

Set-up man, Chicago Boiler Company, 1988
Sandblaster, Chicago Boiler Company, 1988

Kerry Coppin

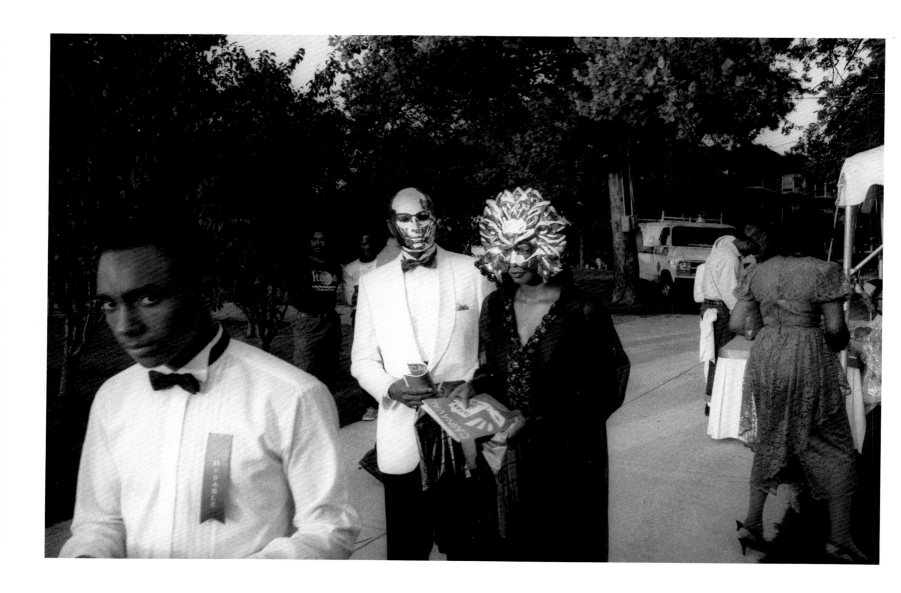

Second Annual Carnival Ball, DuSable Museum of African American History, 1987

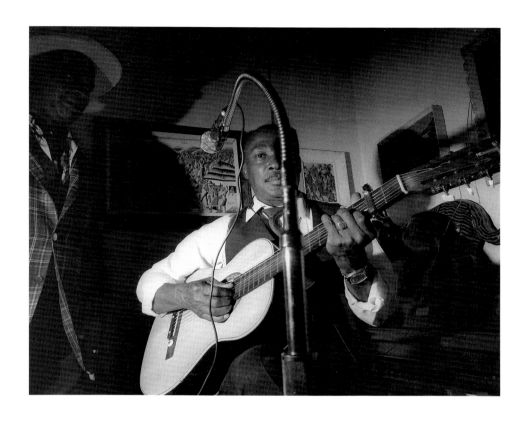

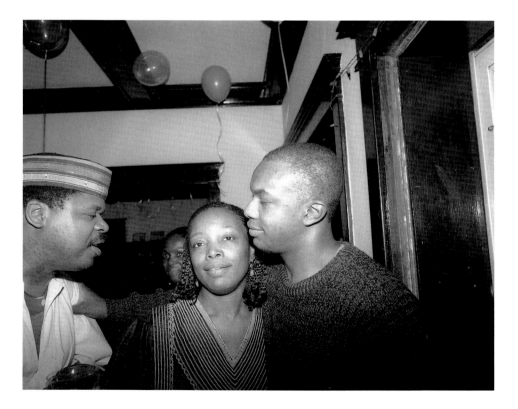

KERRY COPPIN

Opening reception at Nicole Gallery, 1987

Surprise birthday party, South Shore residence, 1987

63

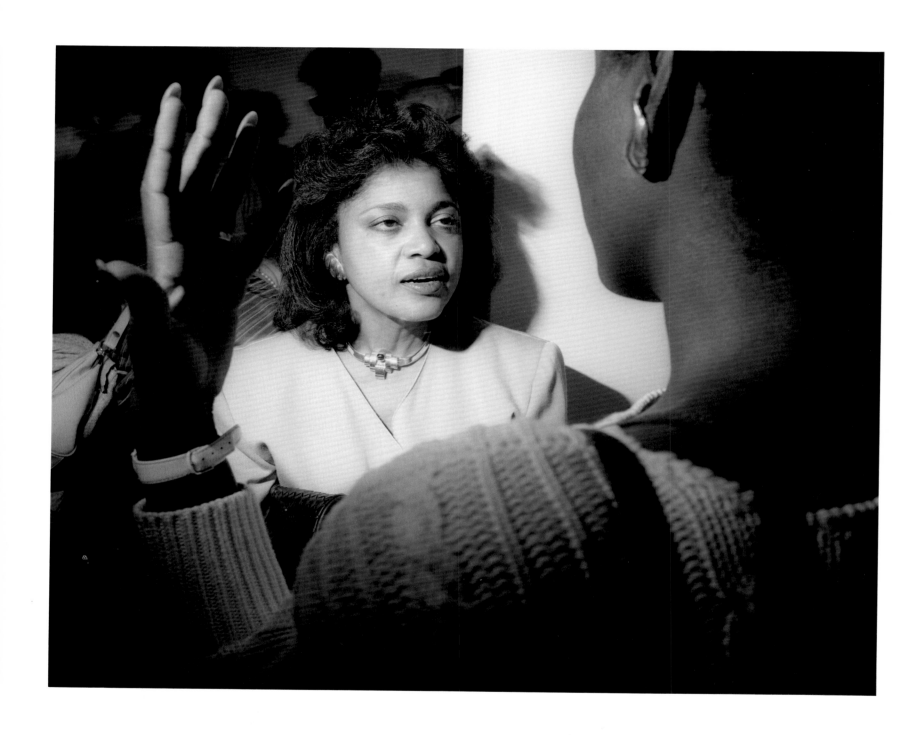

KERRY COPPIN

Opening reception at Isabel Neal Gallery, 1987

Susan Crocker

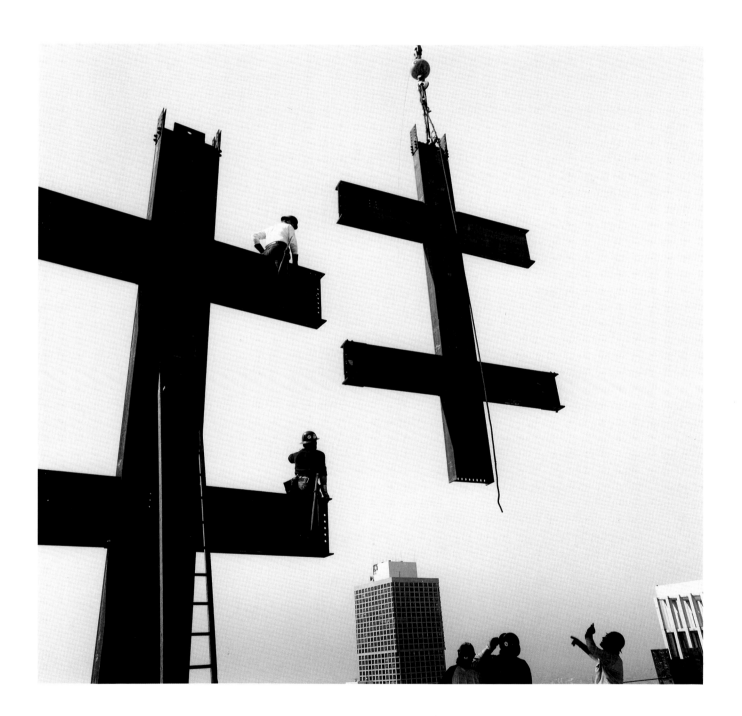

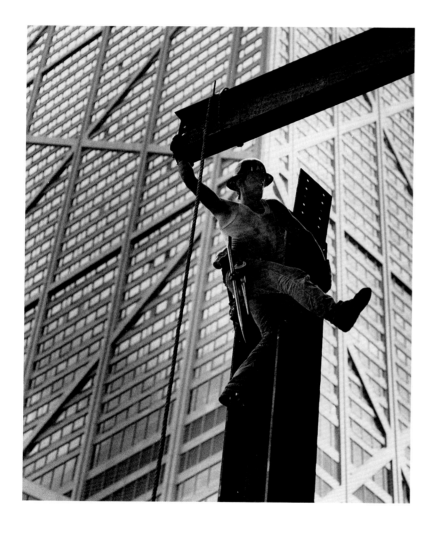
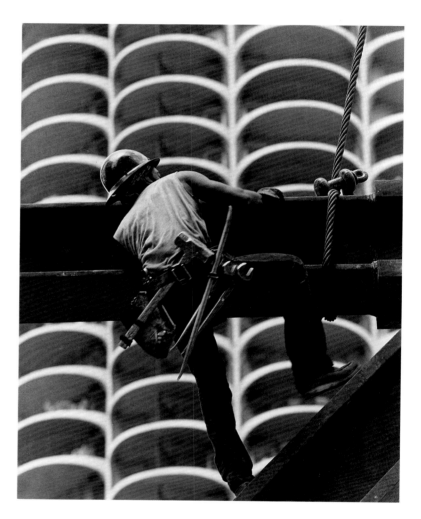

SUSAN CROCKER

Ironworker acrobat, 900 N. Michigan Avenue, 1987
Ironworker wrestling a beam, 35 W. Wacker Drive, 1987

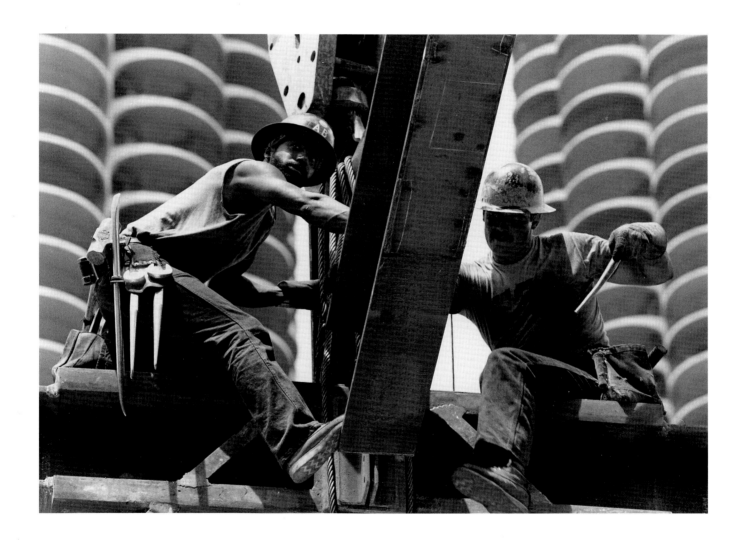

Ironworker placing a beam, 35 W. Wacker Drive, 1987

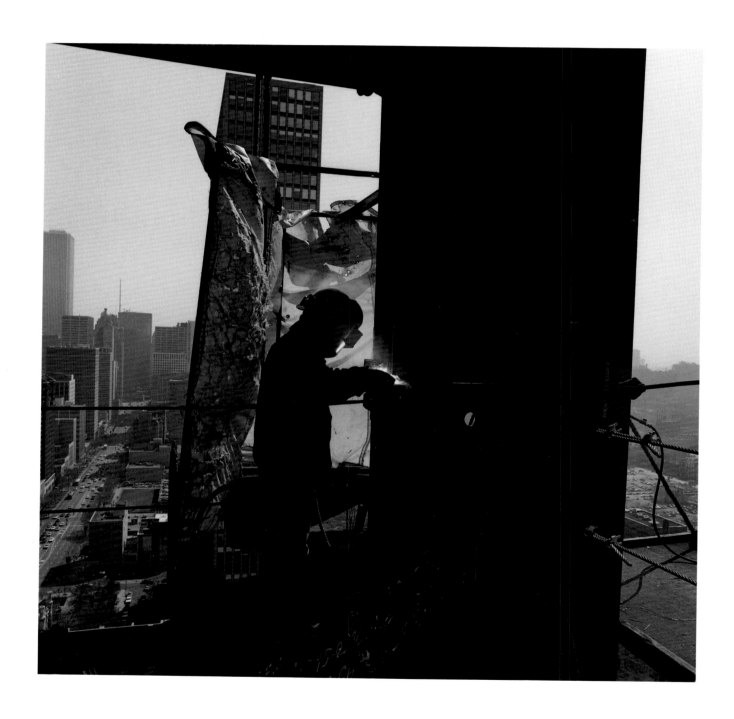

SUSAN CROCKER

Ironworker welding a joint, 900 N. Michigan Avenue, 1987

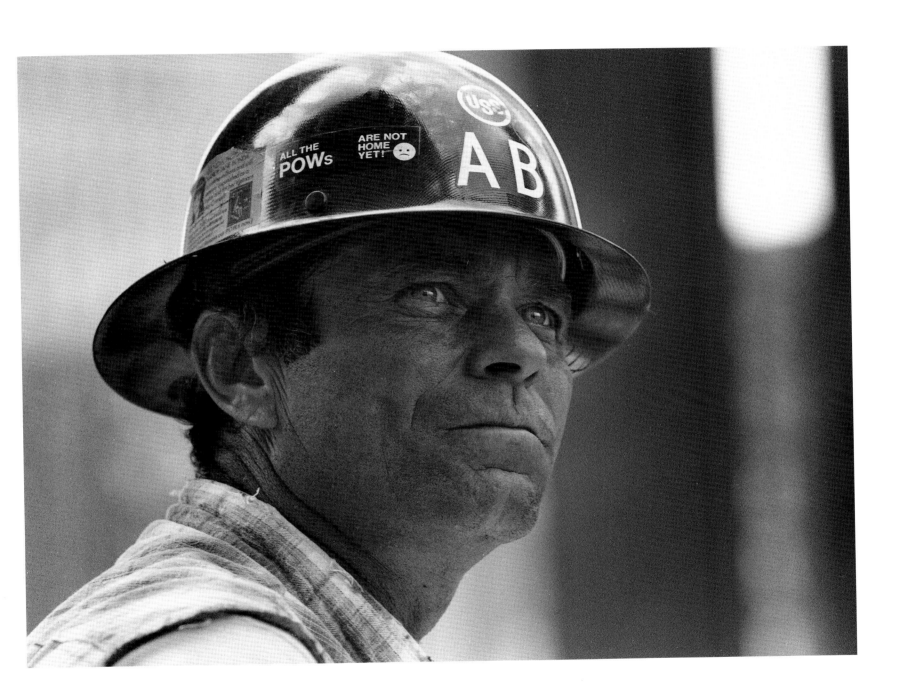

SUSAN CROCKER

Foreman of raising gang, 35 W. Wacker Drive, 1987

David Dapogny

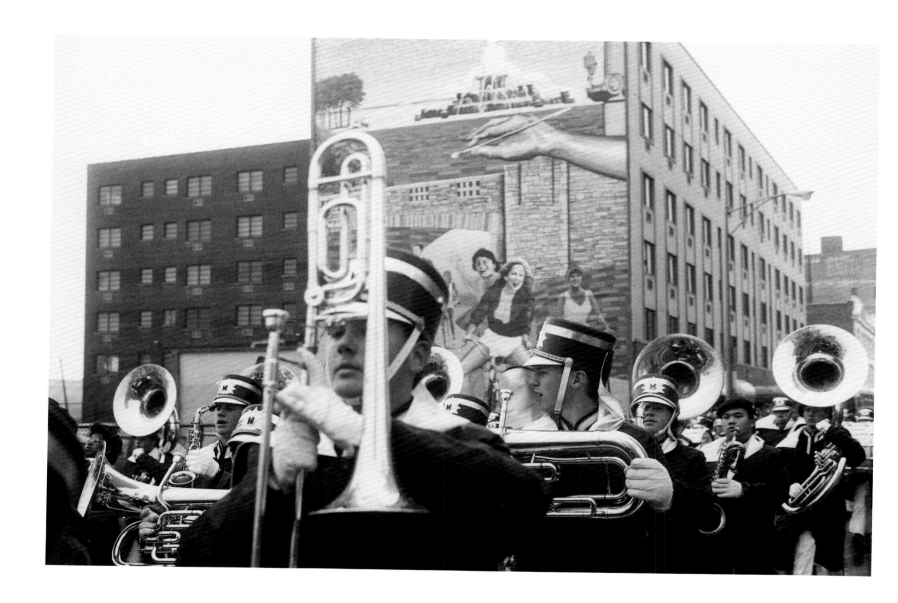

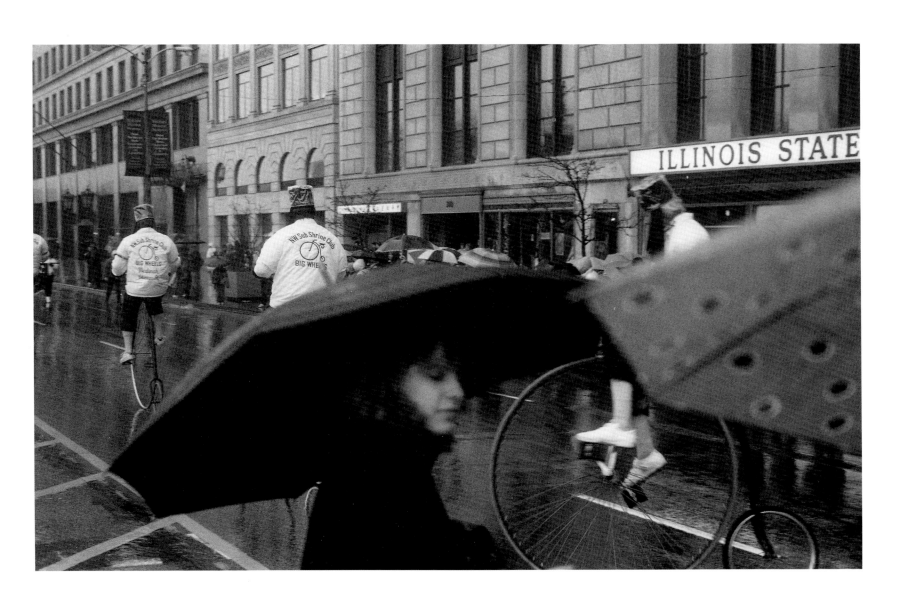

DAVID DAPOGNY

A spectator and the Shrine Antique Bicycle Club, McDonald's Christmas Parade, Michigan Avenue and
Jackson Boulevard, 1987

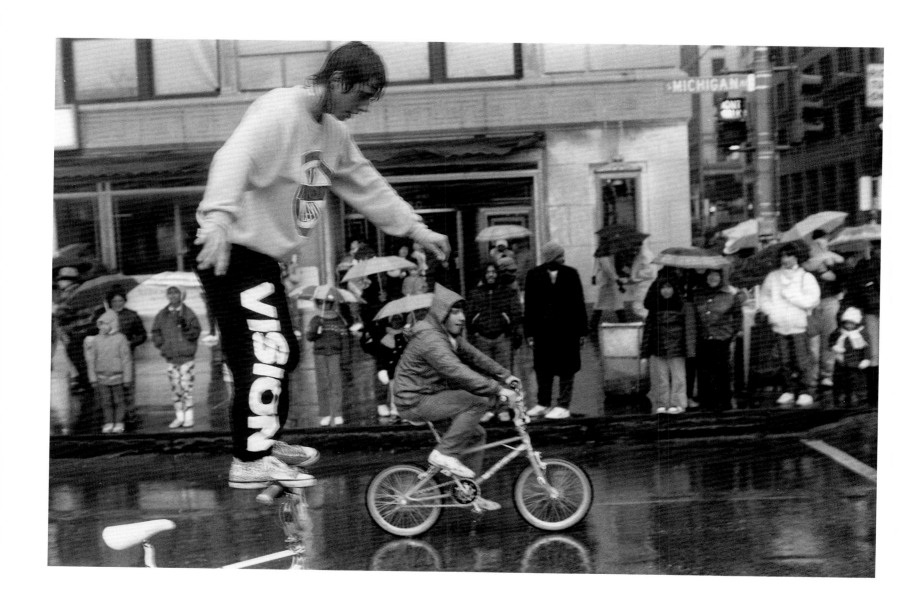

DAVID DAPOGNY

Trick bicycle riders, McDonald's Christmas Parade, Michigan Avenue at Jackson Boulevard, 1987

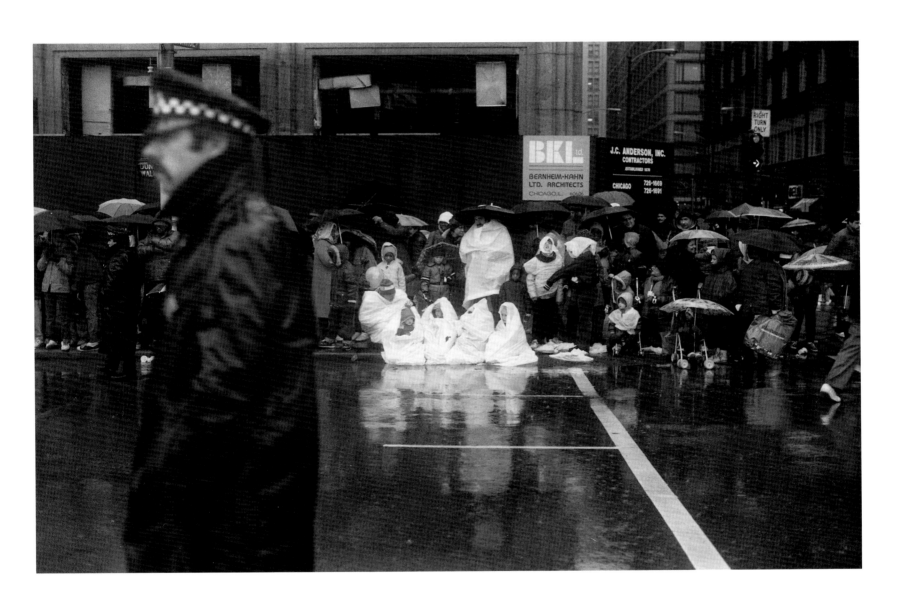

DAVID DAPOGNY

Parade and spectators, McDonald's Christmas Parade, Michigan Avenue at Monroe Street, 1987

Lloyd DeGrane

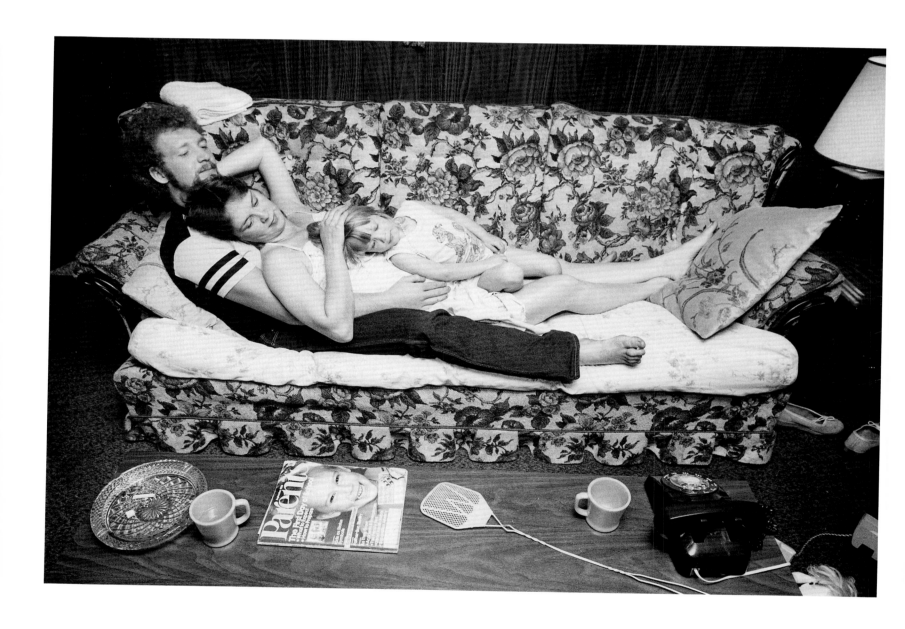

Television family, rural Lake County, Indiana, 1986

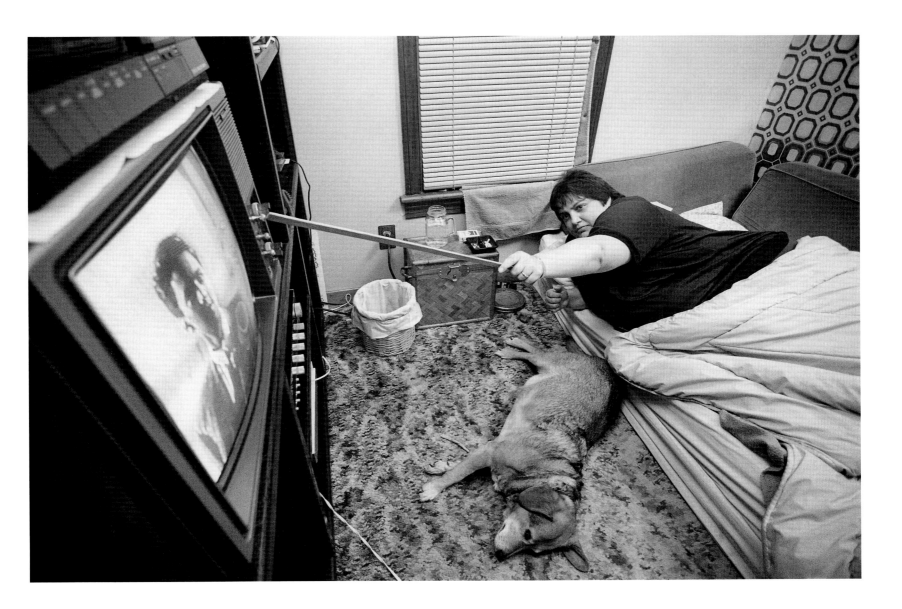

LLOYD DEGRANE

Television viewer switching channels with on-off stick, south Chicago, 1987

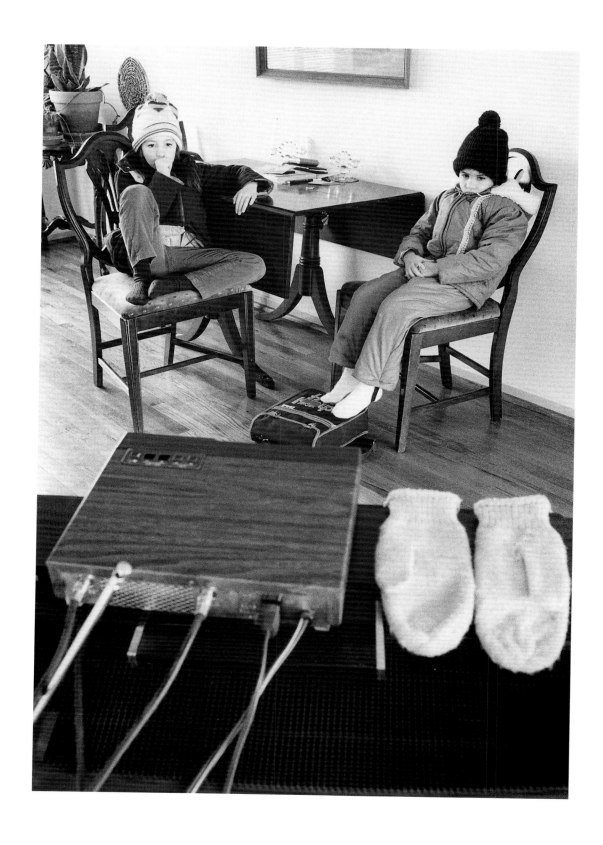

LLOYD DEGRANE

Children watching TV, Park Forest, 1985

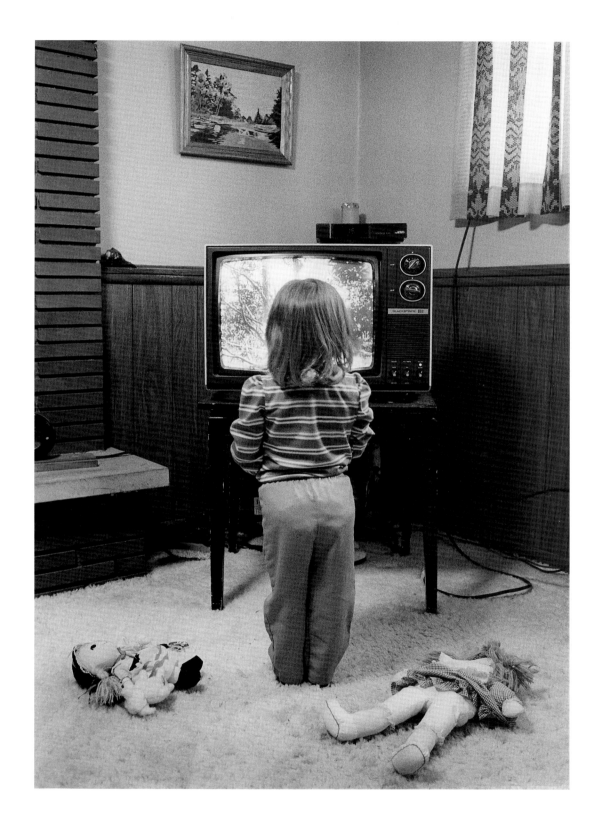

LLOYD DEGRANE

Child watching TV, Calumet City, 1986

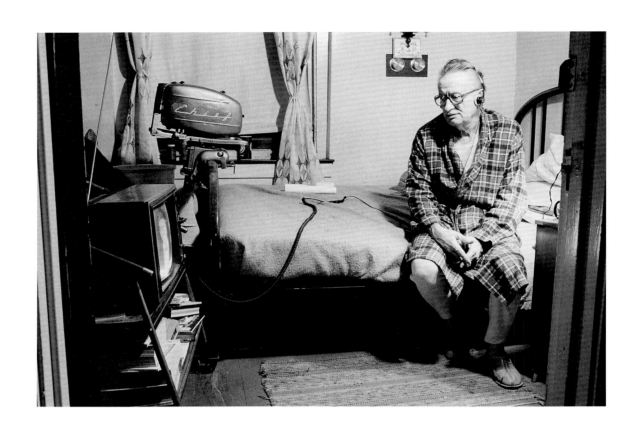

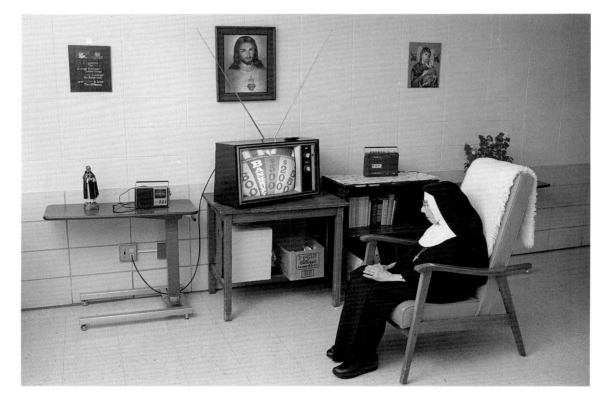

LLOYD DEGRANE

Boarding house resident, Pullman, 1986

Sister Maxima and "Wheel of Fortune," Frankfort, 1988

Meg Gerken

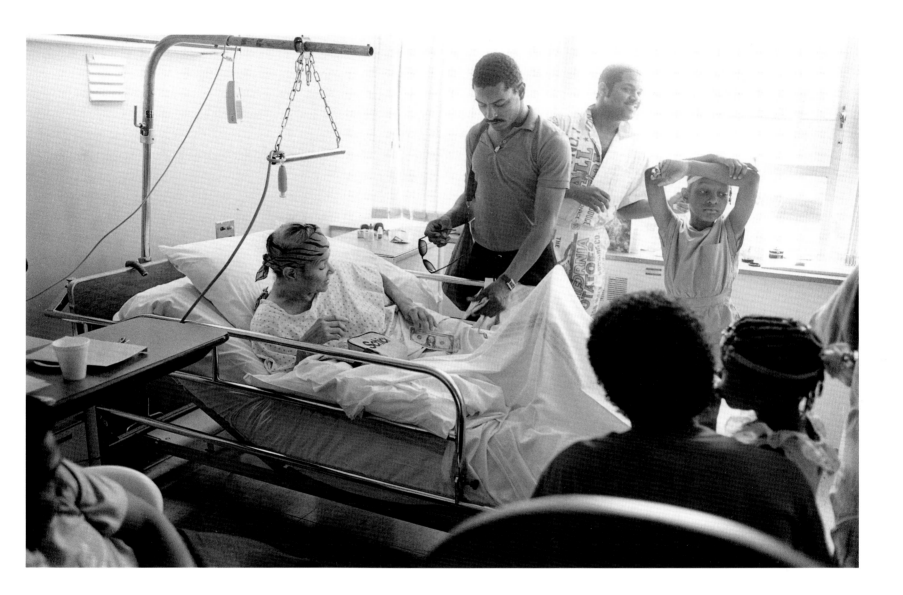

Lorine and family at Michael Reese Hospital, Mother's Day 1987

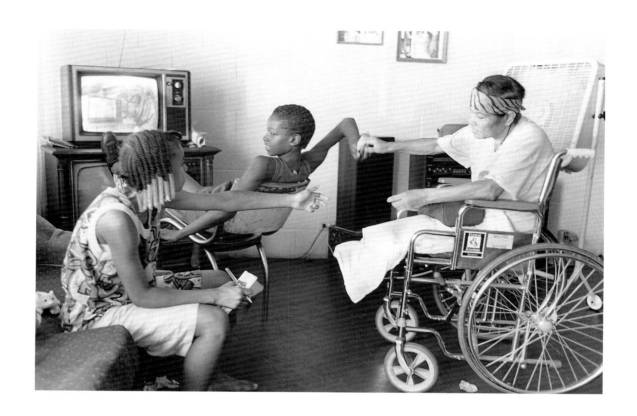

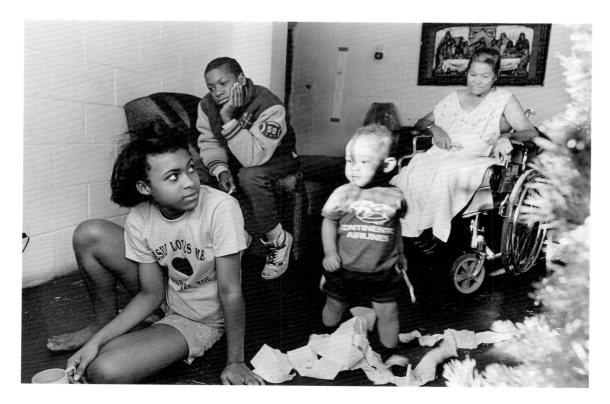

MEG GERKEN

The grocery list — Shalanda, Tremaine, and grandmother Lorine, Henry Horner Homes, 1987
Gathered in front of the VCR — Shalanda, Tremaine, Ivory, and Lorine, Henry Horner Homes, 1987

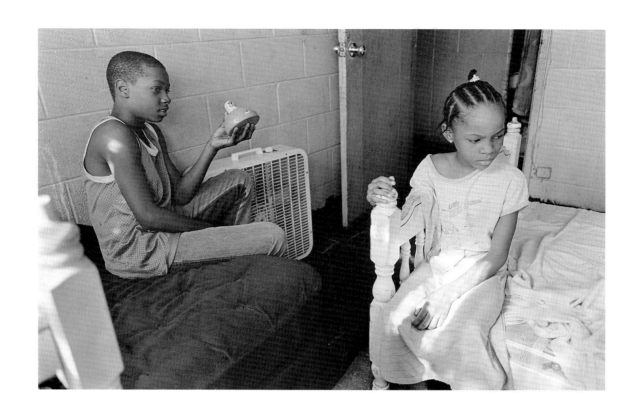

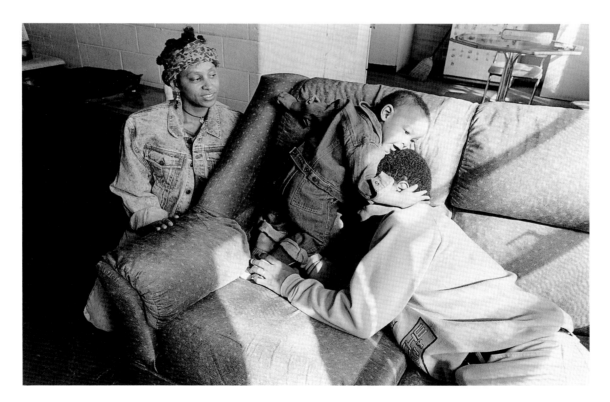

MEG GERKEN

Cousins Tremaine and Kita, Henry Horner Homes, 1988
Jean, her grandson Ivory, and her brother Mac, Henry Horner Homes, 1988

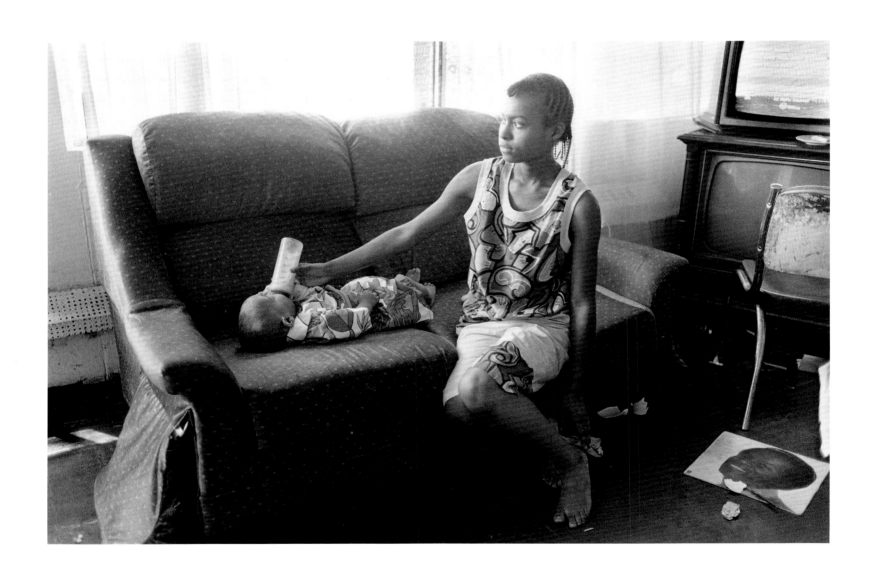

MEG GERKEN

Shalanda and her cousin's son Ivory, Henry Horner Homes, 1987

Ron Gordon

Torrence Avenue Bridge sequence, 1987

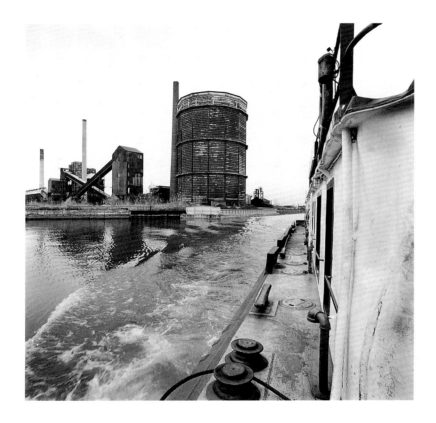 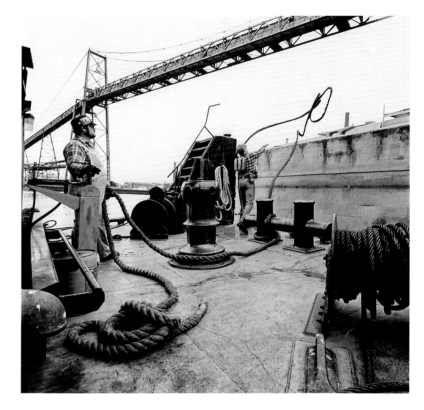

RON GORDON

Grain elevator along the Calumet River, 1987
Crew of the tugboat *Desplaines*, throwing rope to a chemical barge, 1987

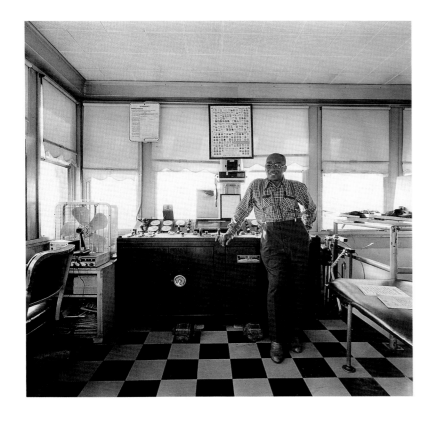
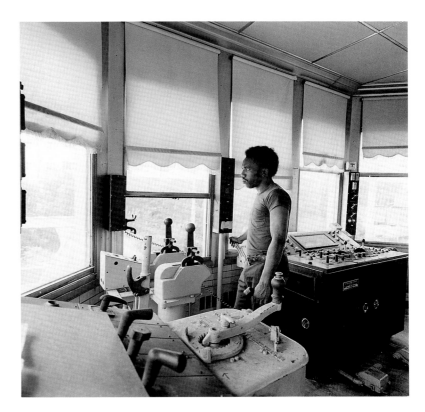

RON GORDON

Bridge tender, 95th Street Bridgehouse, 1987
Roving bridge tender, 95th Street Bridgehouse, 1987

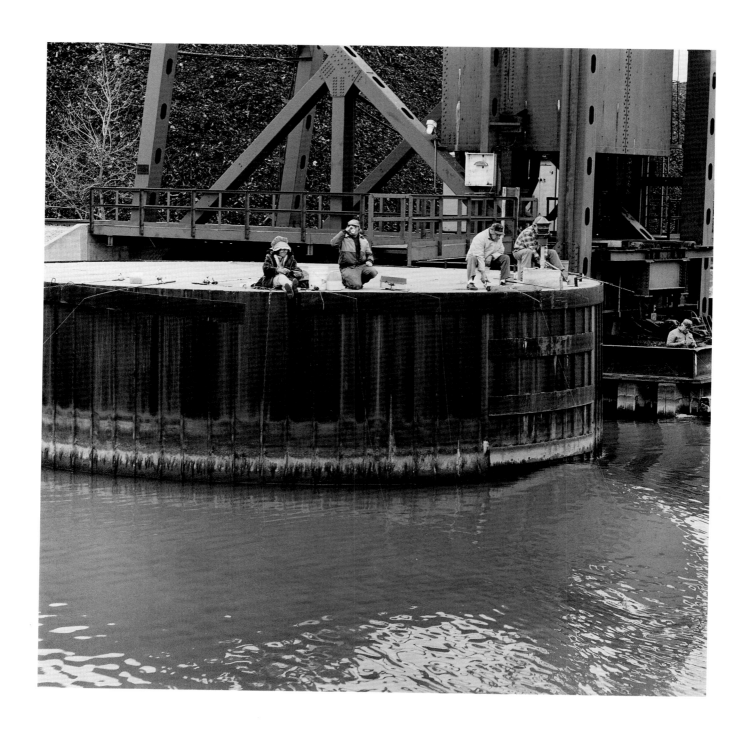

RON GORDON

Fishing for perch on the Calumet River, 1987

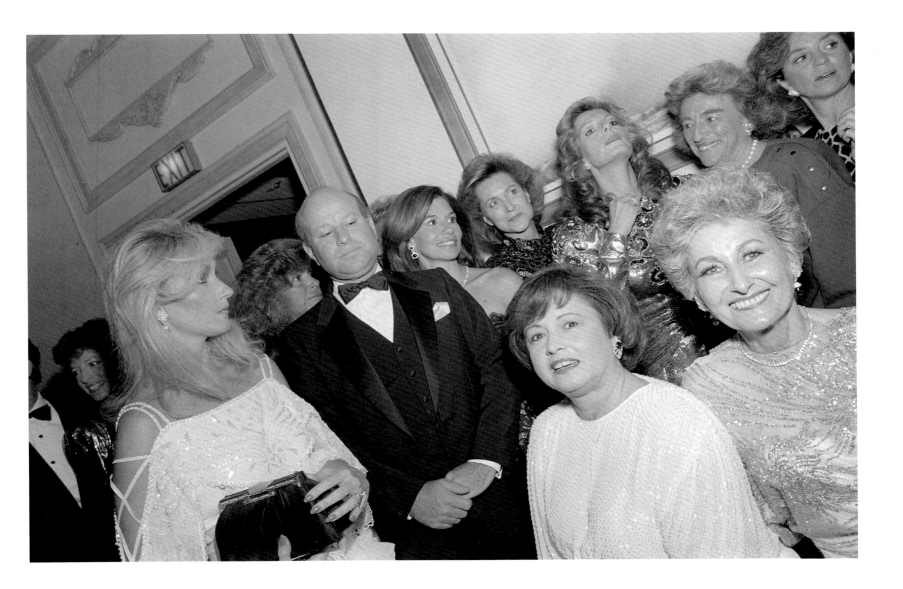

PETER HALES

Alzheimer's benefit, Conrad Hilton Hotel, 1987

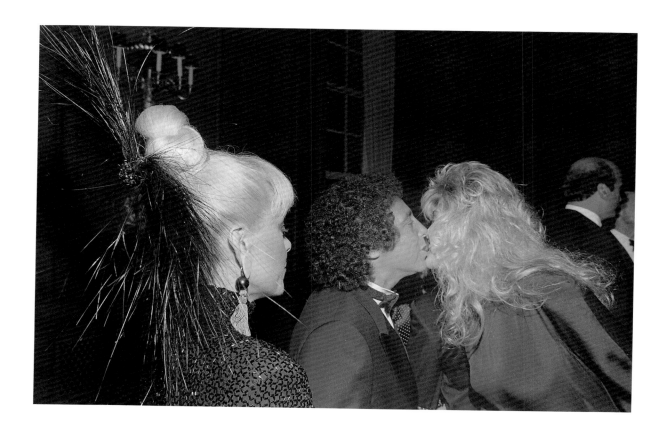

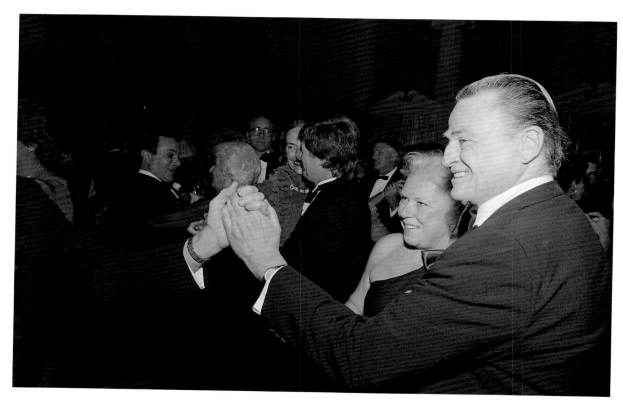

PETER HALES

Reception line at the Alzheimer's benefit, Conrad Hilton Hotel, 1987
Entrance to the Lyric Opera opening gala, 1987

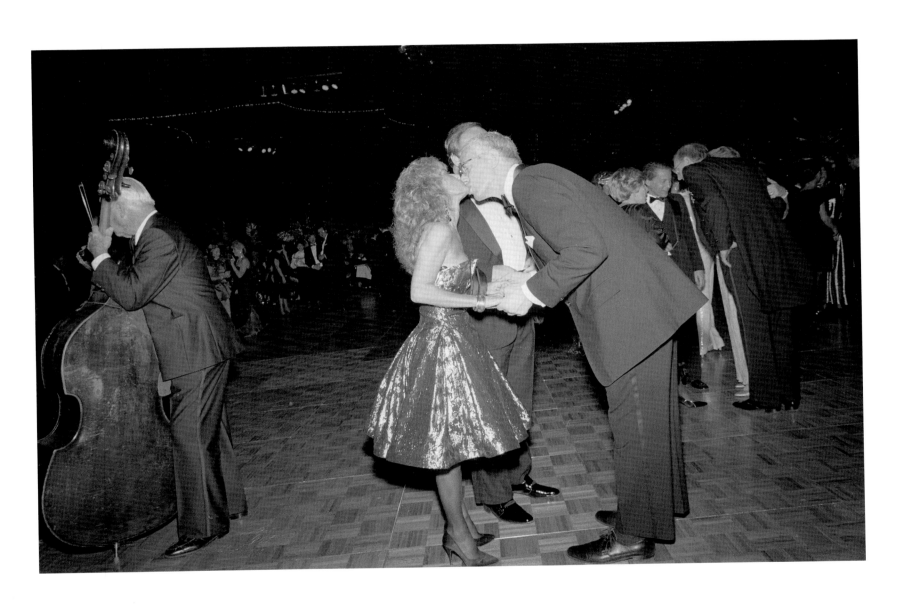

PETER HALES

The Crystal Ball Benefit for the Michael Reese Medical Research Fund, McCormick Place, 1987

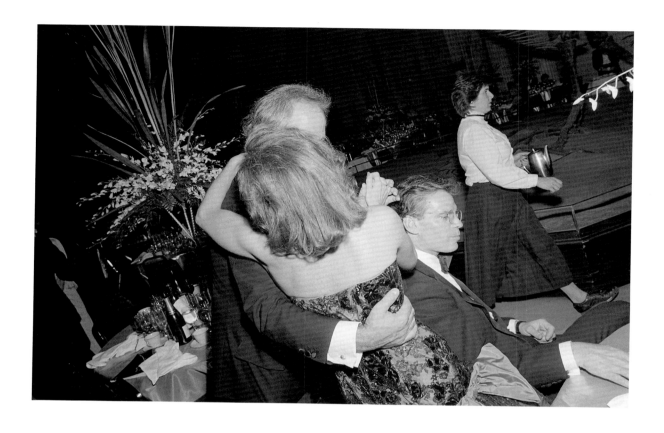

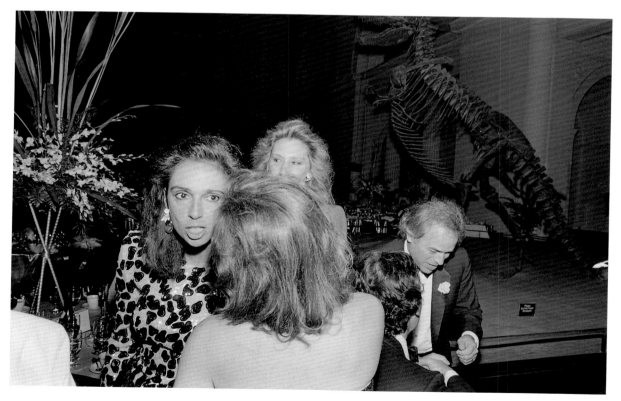

PETER HALES

The Crystal Ball Benefit for the Michael Reese Medical Research Fund, McCormick Place, 1987
The Tiffany Ball, Field Museum of Natural History, 1987

Tom Harney

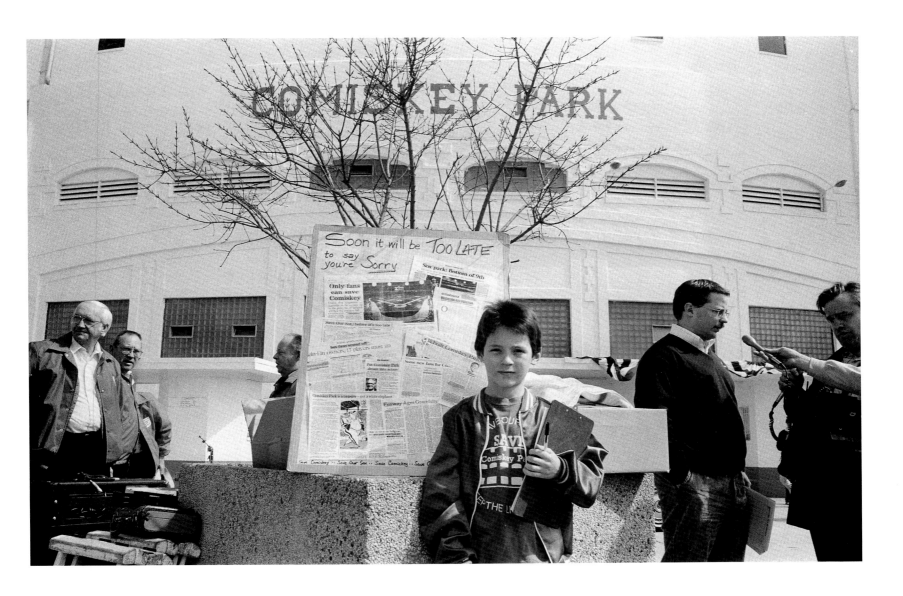

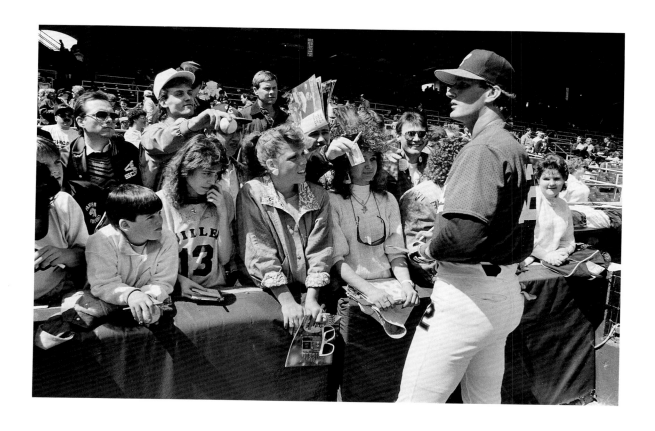

TOM HARNEY

Comiskey Park, 1988
Fans being photographed with players, Comiskey Park, 1988

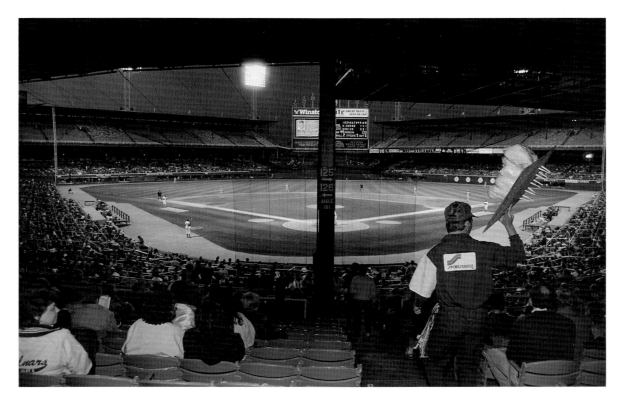

TOM HARNEY

Comiskey Park, 1988

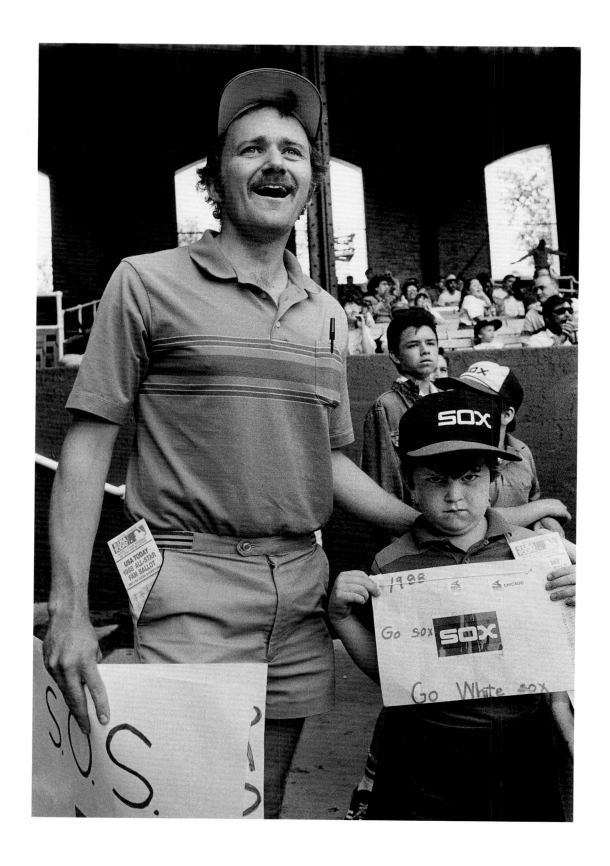

TOM HARNEY

Father and son, Comiskey Park, 1988

Tom Hocker

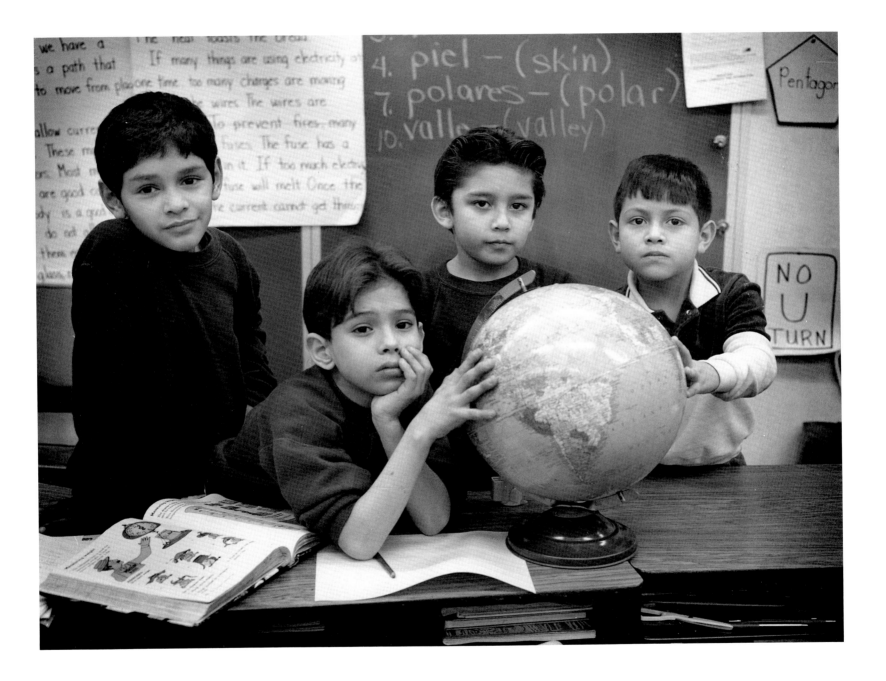

TOM HOCKER

Washington Elementary School, East Chicago, Indiana, 1988

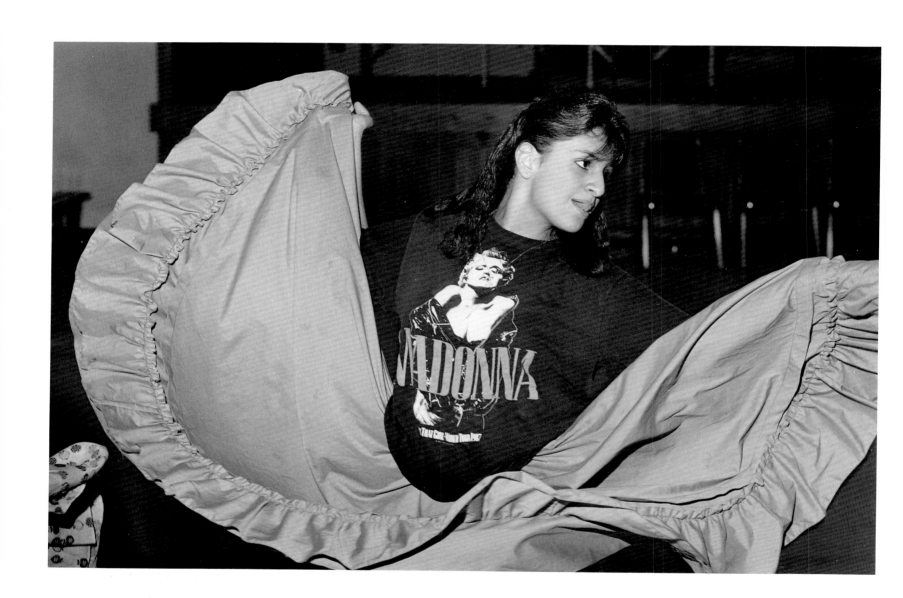

TOM HOCKER

Mexican dancer, East Chicago, Indiana, 1988

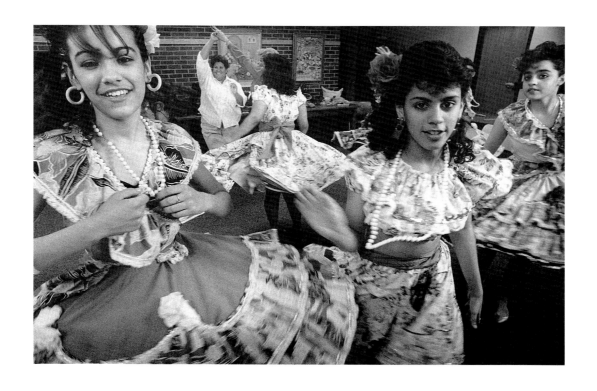

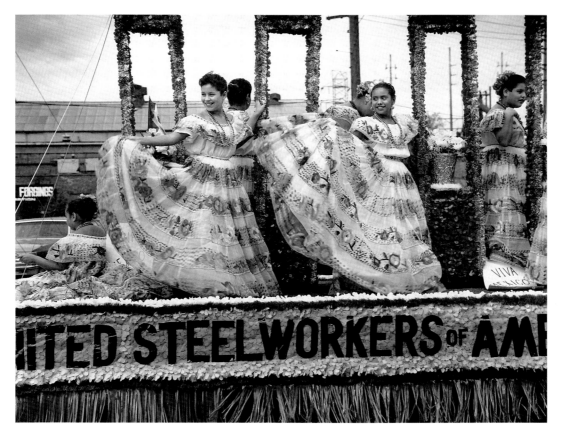

TOM HOCKER

Caribbean dance group, East Chicago, Indiana, 1988
Mexican Independence Day Parade, East Chicago, Indiana, 1987

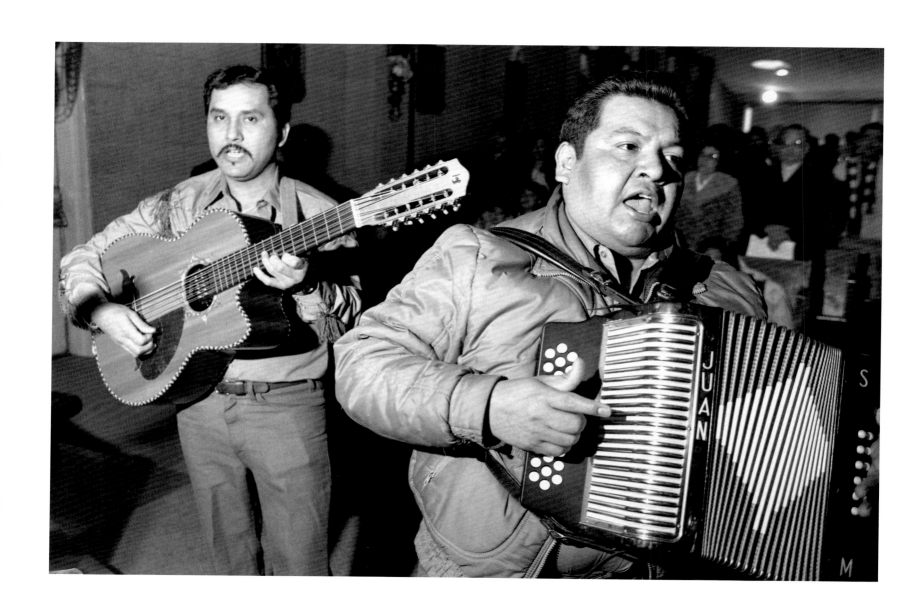

TOM HOCKER

Dueto los Rancheros del Palma, Our Lady of Guadalupe Church, East Chicago, Indiana, 1987

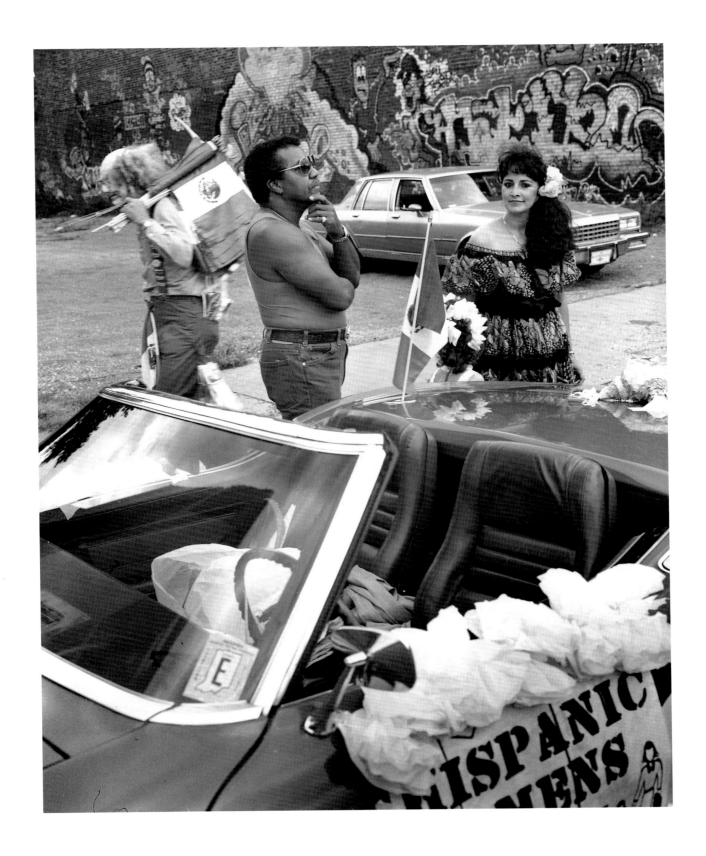

TOM HOCKER

Mexican Independence Day Parade, East Chicago, Indiana, 1987

James Iska

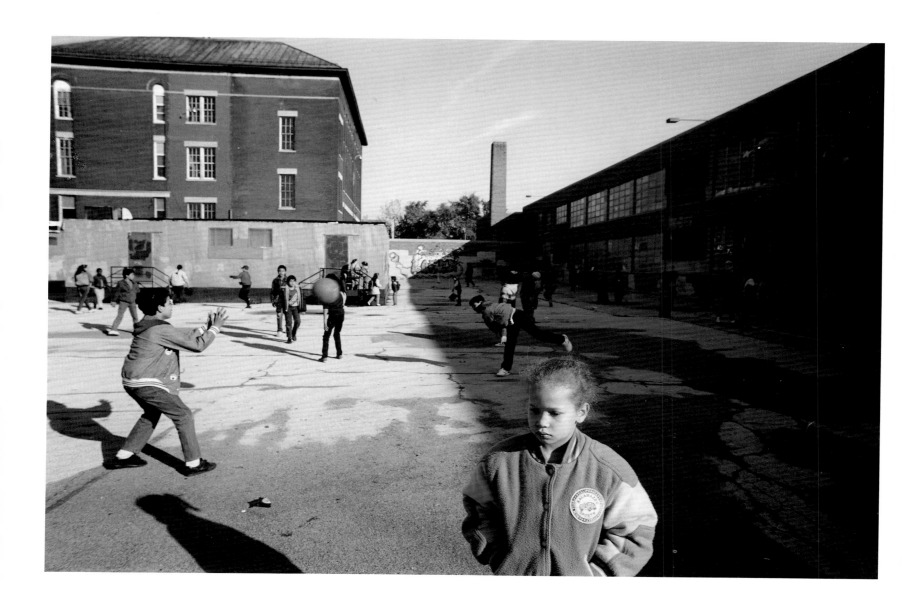

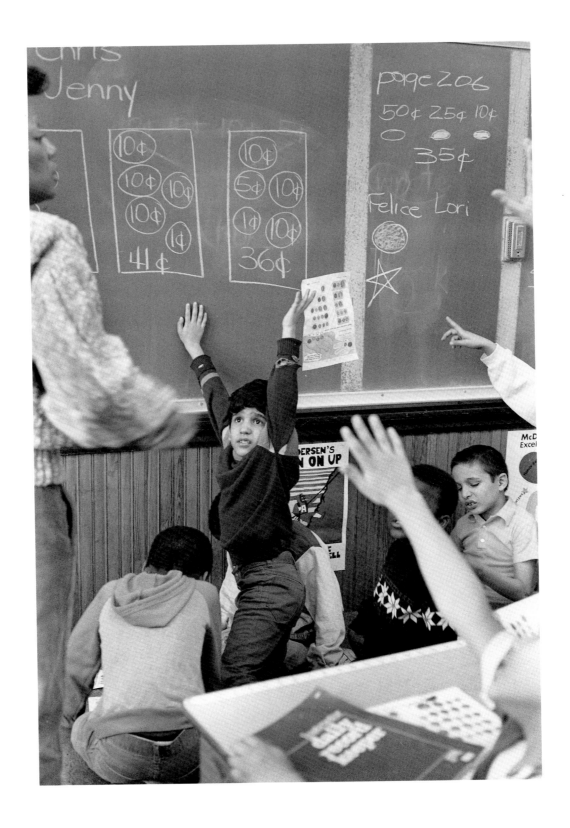

JAMES ISKA

Harry and other students at "auction," Hans Christian Andersen School, 1988

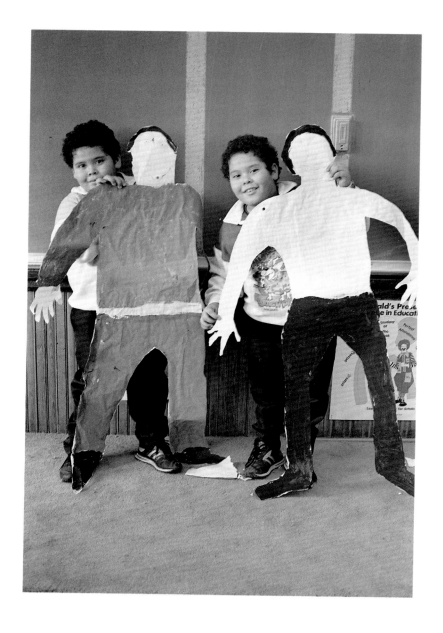

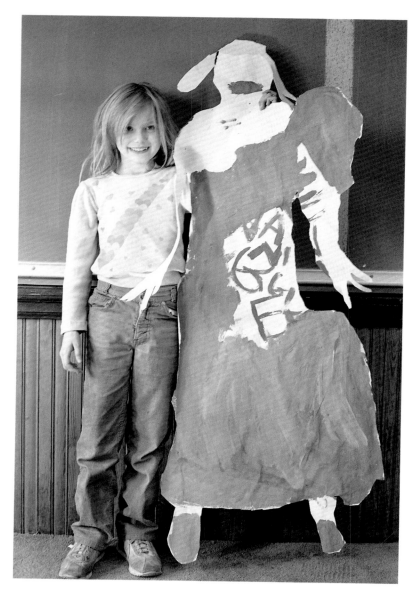

JAMES ISKA

Children with self-portraits, Hans Christian Andersen School, 1988

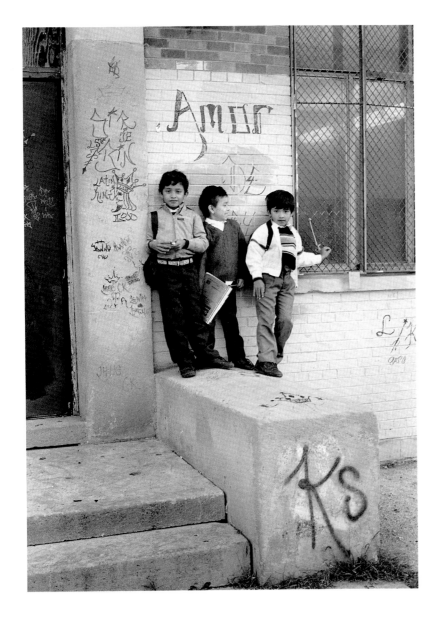
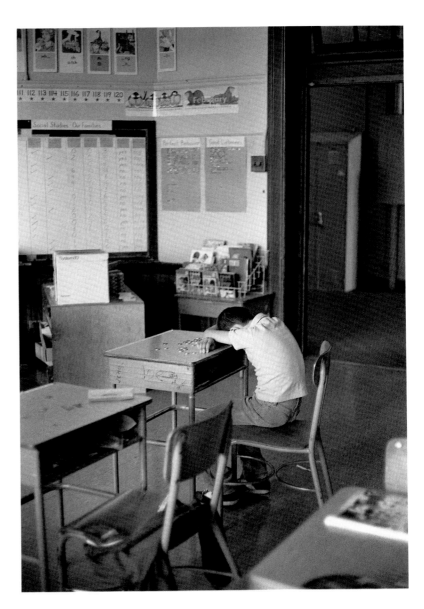

JAMES ISKA

Calixto, Eudocio and Alviel, Hans Christian Andersen School, 1987

Abel at his desk, Hans Christian Andersen School, 1988

103

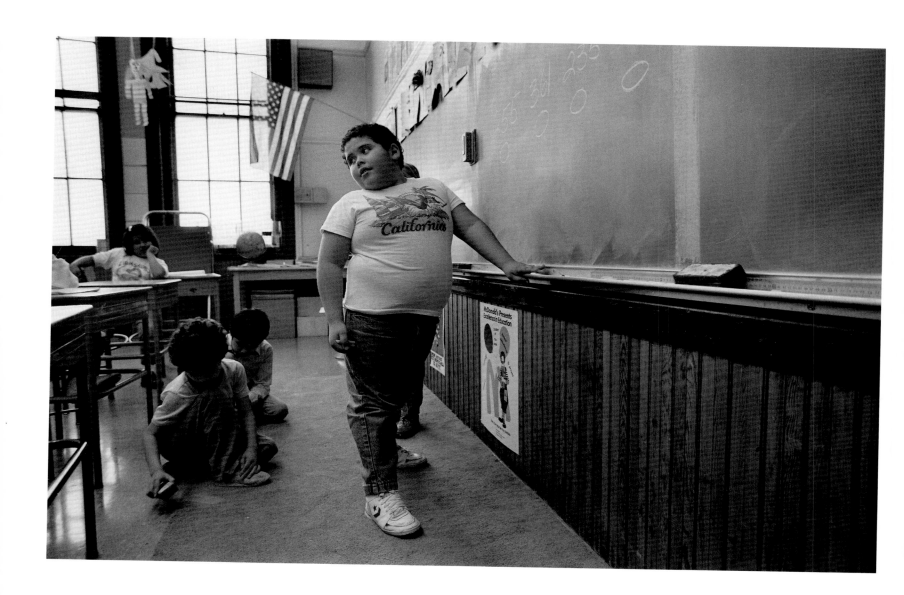

JAMES ISKA

Luis at chalkboard, Hans Christian Andersen School, 1988

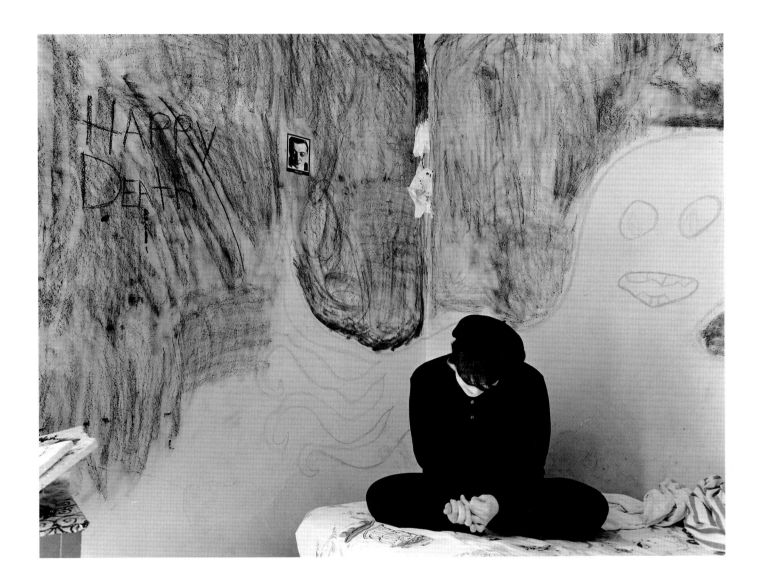

ANGELA KELLY

Monica in her bedroom, 1986

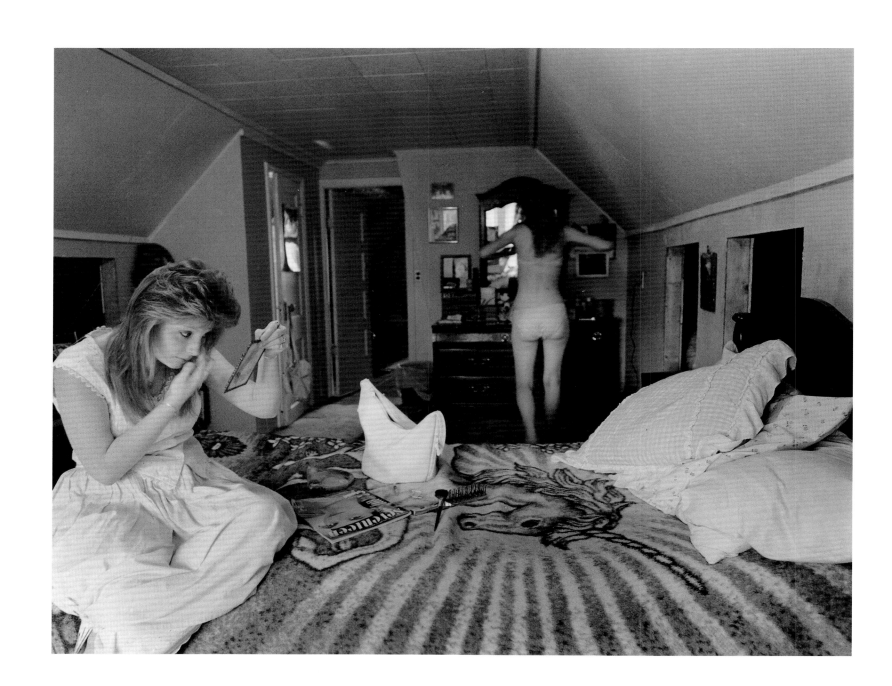

ANGELA KELLY

Trilby and Julie in Julie's bedroom, 1987

106

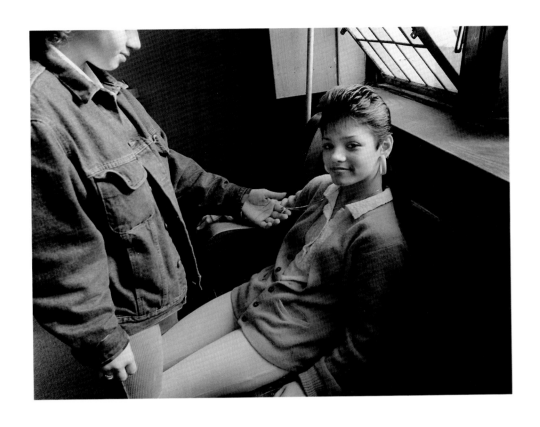

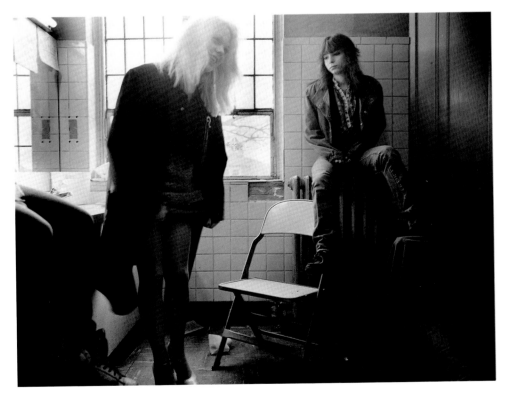

ANGELA KELLY

Mona and Jackie during lunch break, 1987
Diane and Nina in the smokers' bathroom, 1987

107

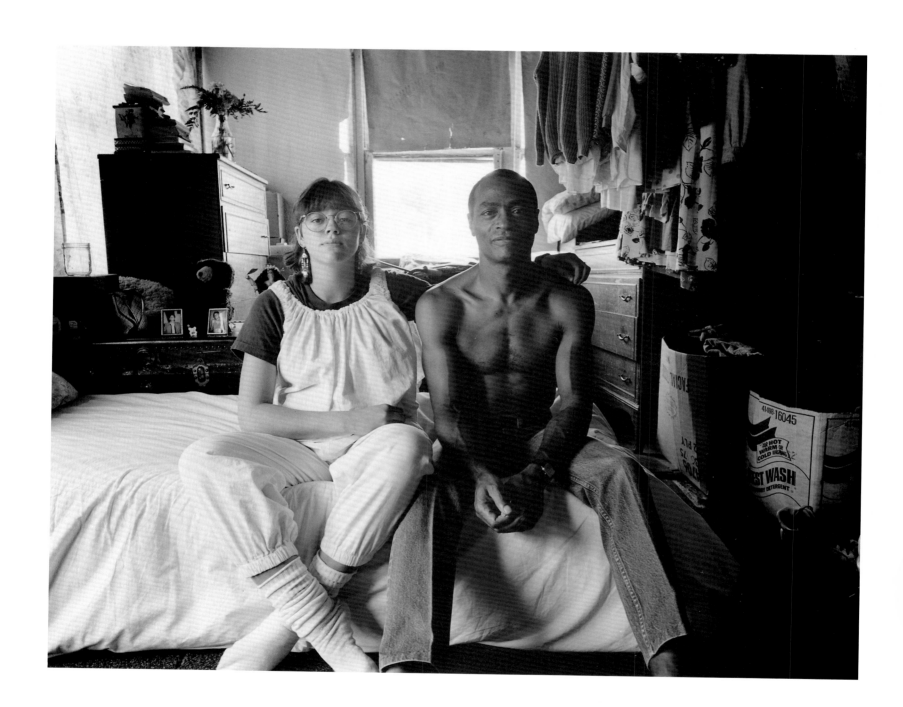

ANGELA KELLY

Tammy and her father, John, at home, 1987

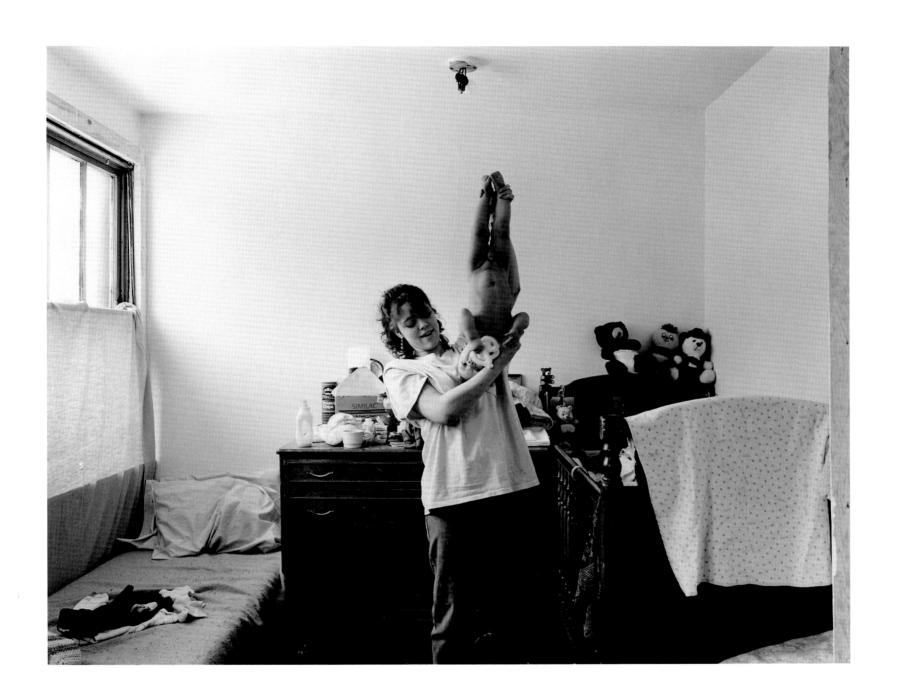

ANGELA KELLY

Tammy shows off her son, Sean, 1988

109

John Kimmich

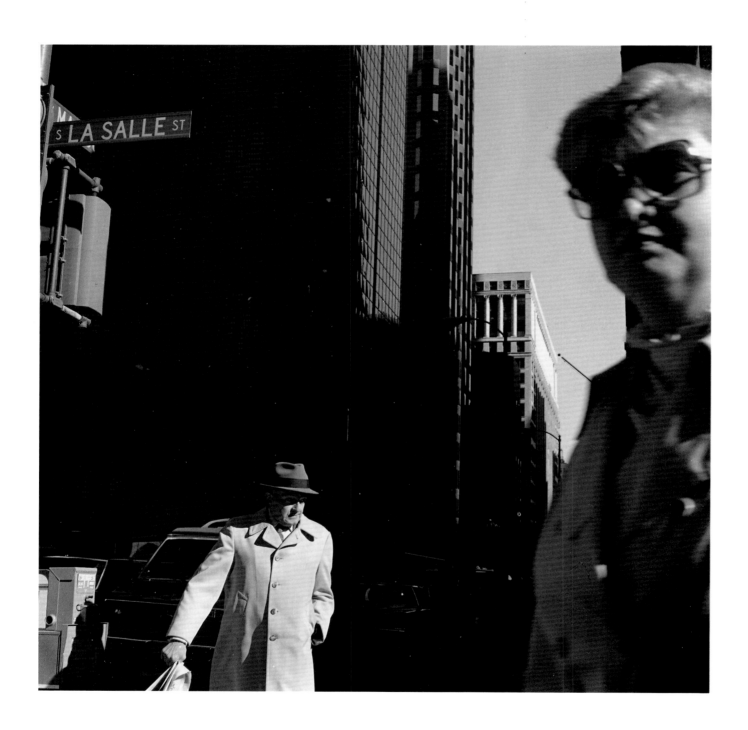

JOHN KIMMICH

LaSalle and Madison streets, 1988

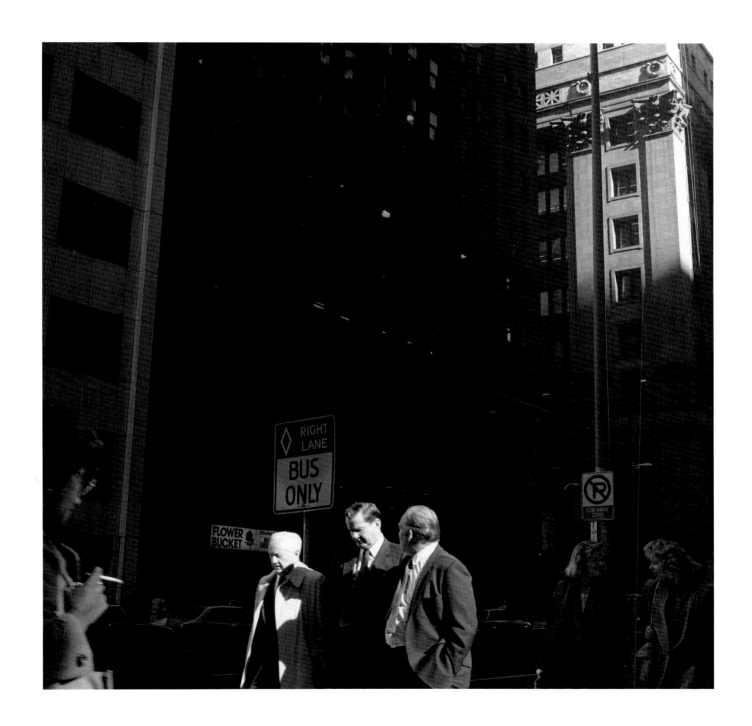

JOHN KIMMICH

Lunchtime, near City Hall, 1987

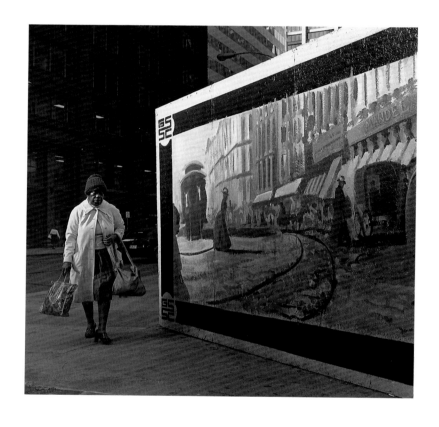 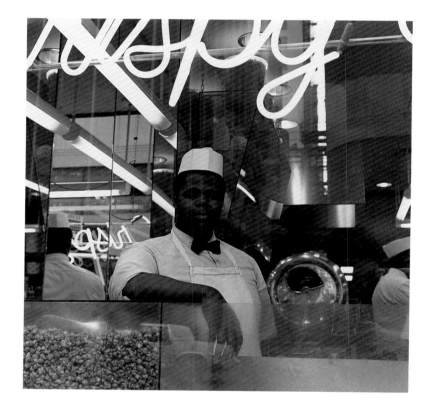

JOHN KIMMICH

Adams and Dearborn streets, 1987
Crispy Corn popper, Adams Street, 1988

112

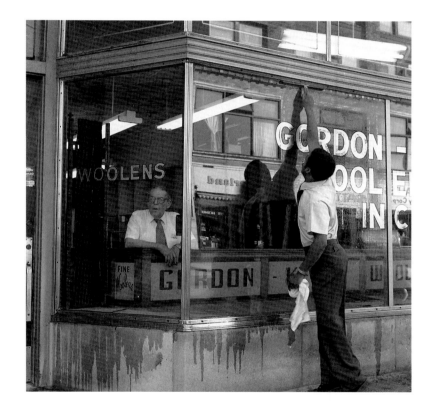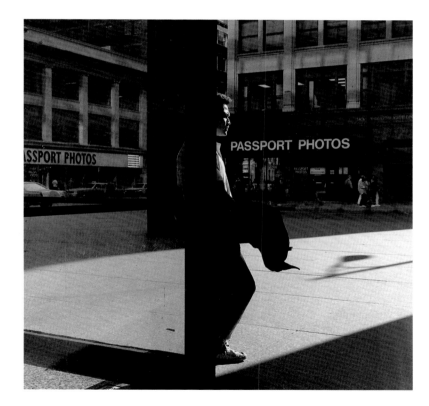

JOHN KIMMICH

Window washer, near Wells and Van Buren streets, 1987
Dearborn Street and Jackson Boulevard, 1987

113

Jay King

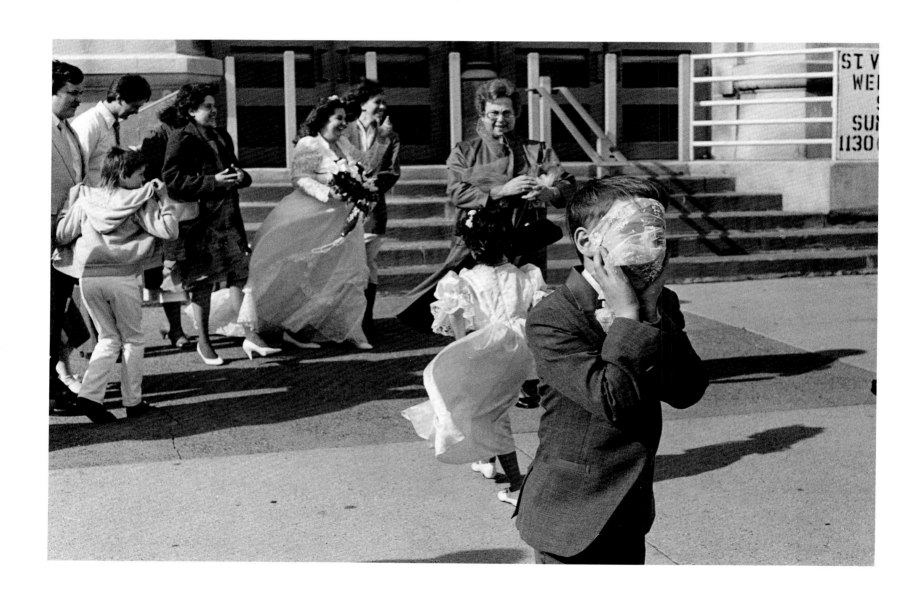

Boy at wedding, Webster and Sheffield avenues, 1988

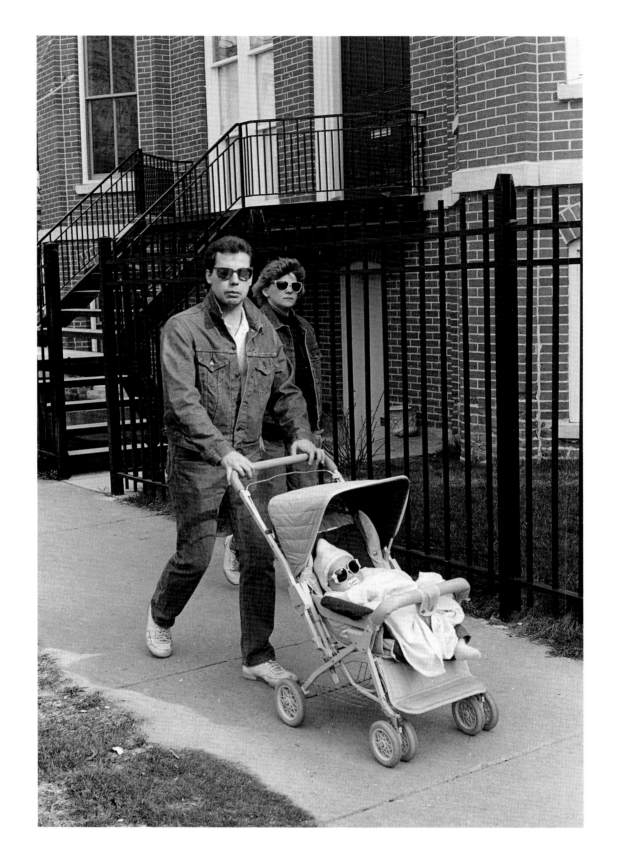

JAY KING

Family wearing sunglasses, Webster and Magnolia avenues, 1988

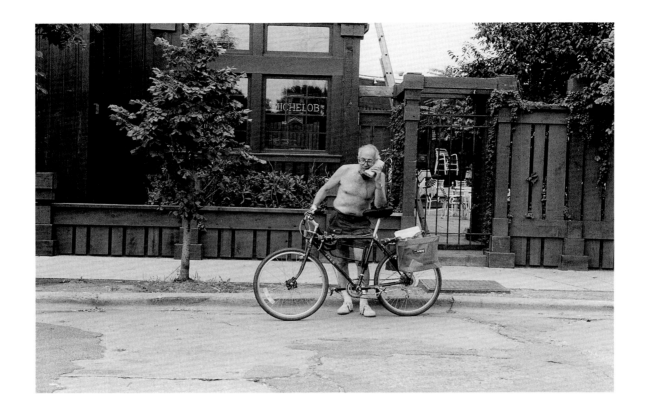

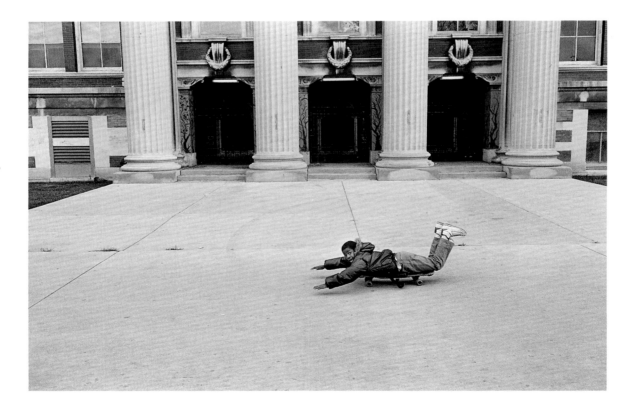

JAY KING

Man on telephone, Racine and Armitage avenues, 1987
Boy on skateboard, Orchard Street and Armitage Avenue, 1987

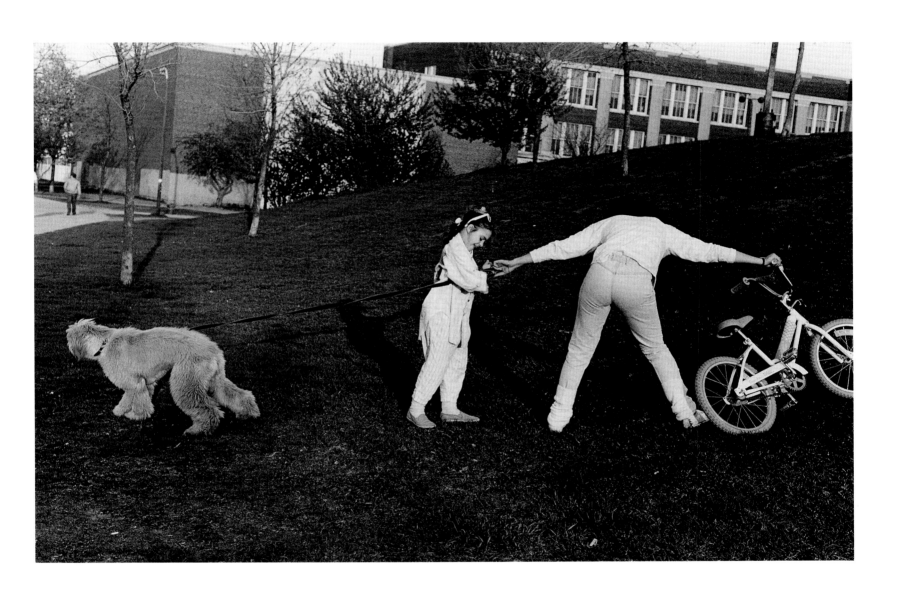

JAY KING

Mother and daughter with bicycle, near Lincoln Park High School, 1988

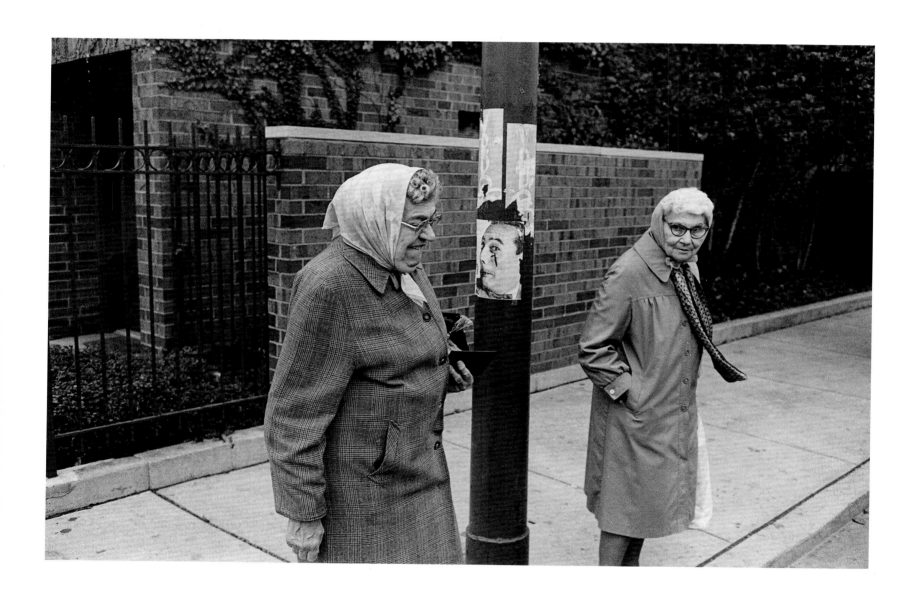

JAY KING

Two women, Halsted Street near Dickens Avenue, 1987

118

Stephen Marc

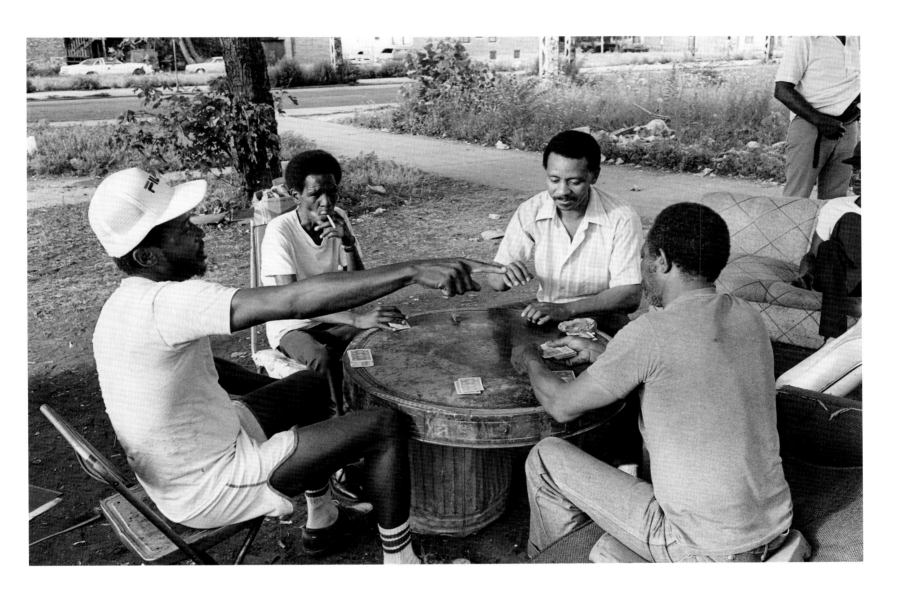

Sidewalk "living room" card game, 63rd Street and Greenwood Avenue, 1987

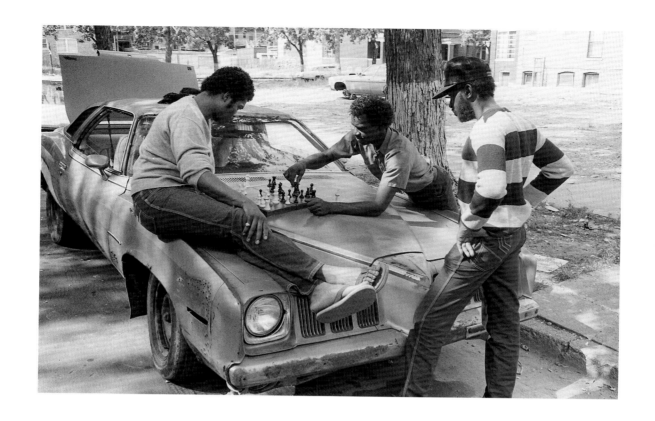

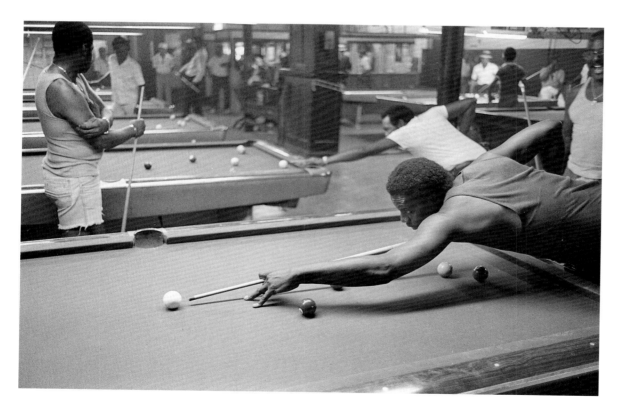

STEPHEN MARC

Chess game on car hood, 62nd Street between Langley and Champlain avenues, 1987
Pool hall, 64th Street and Cottage Grove Avenue, 1987

120

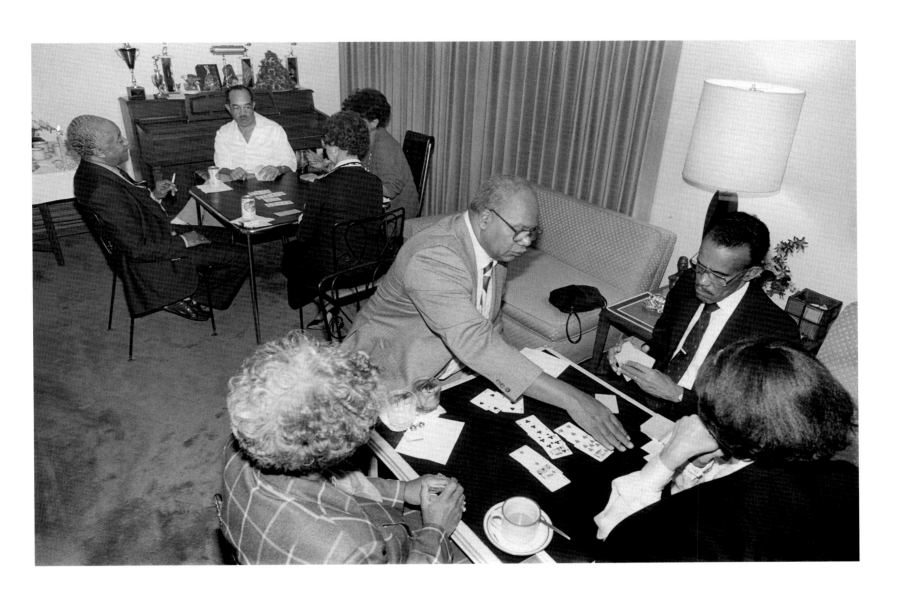

STEPHEN MARC

Fourth Saturday Night Bridge Club, 87th Street and Dorchester Avenue, 1987

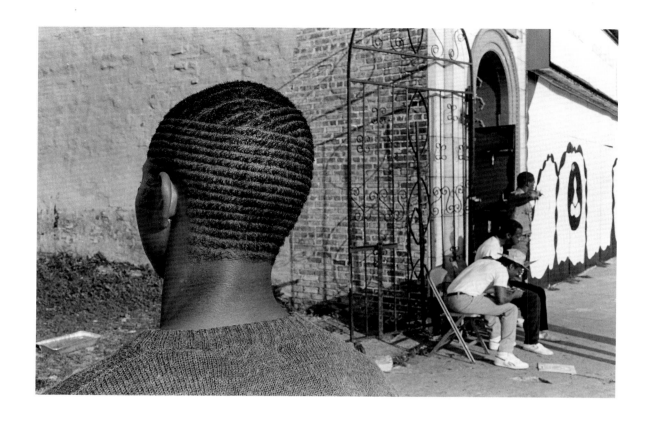

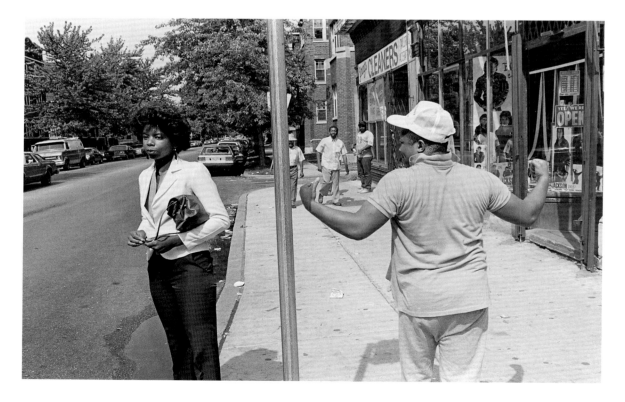

STEPHEN MARC

Multipart hairstyle, 39th Street and Drexel Avenue, 1987
Man showing muscles, 63rd Steet and Martin Luther King Drive, 1987

Rhondal McKinney

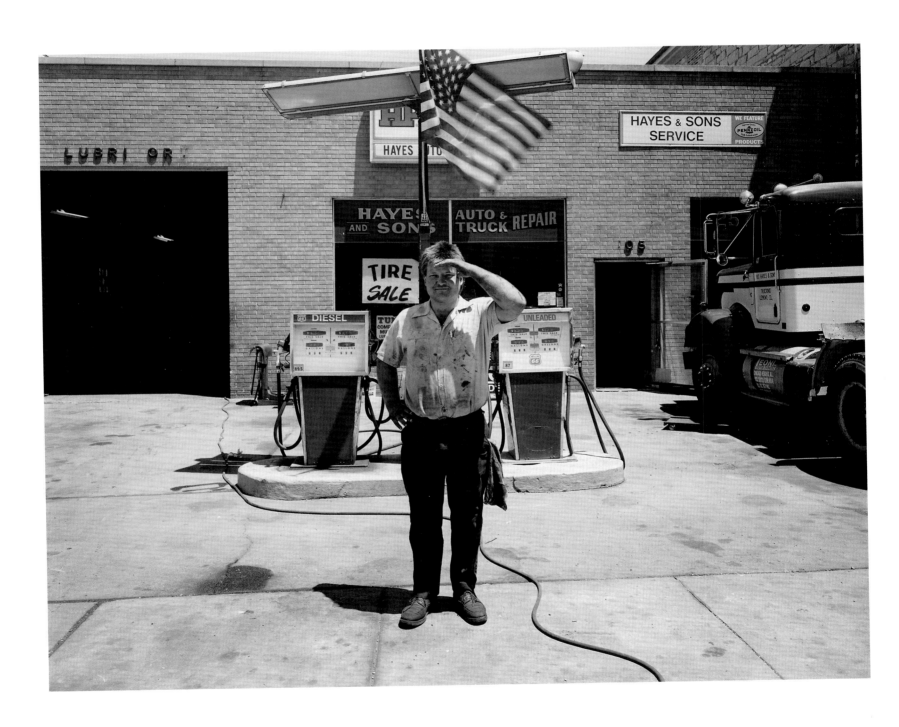

RHONDAL MCKINNEY

Gas station attendant, Lemont, 1986

123

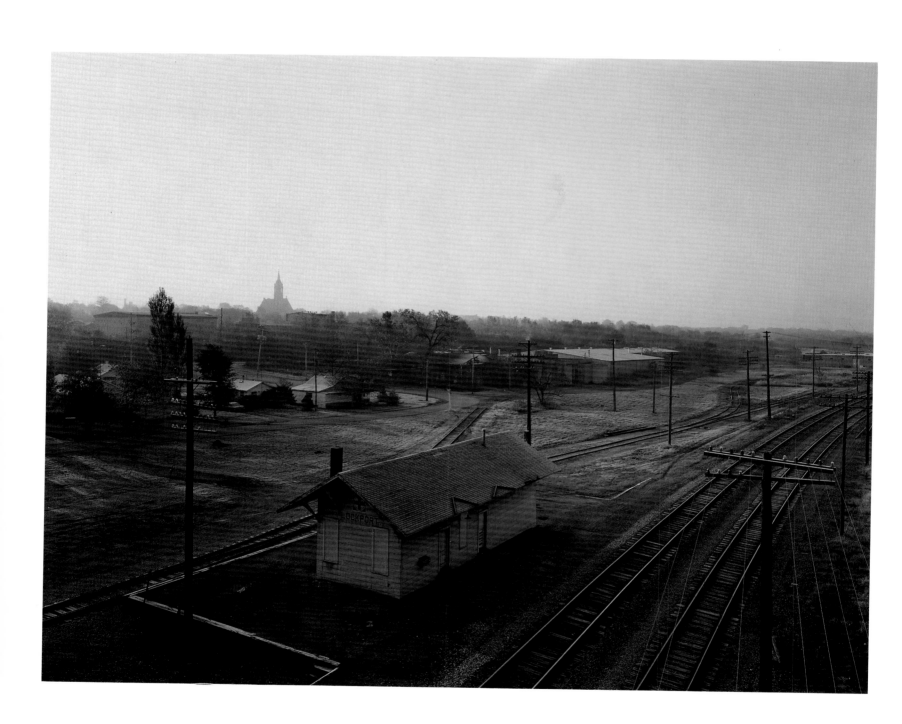

RHONDAL MCKINNEY

Lockport Railroad Station, from Route 7 bridge over canal, 1985

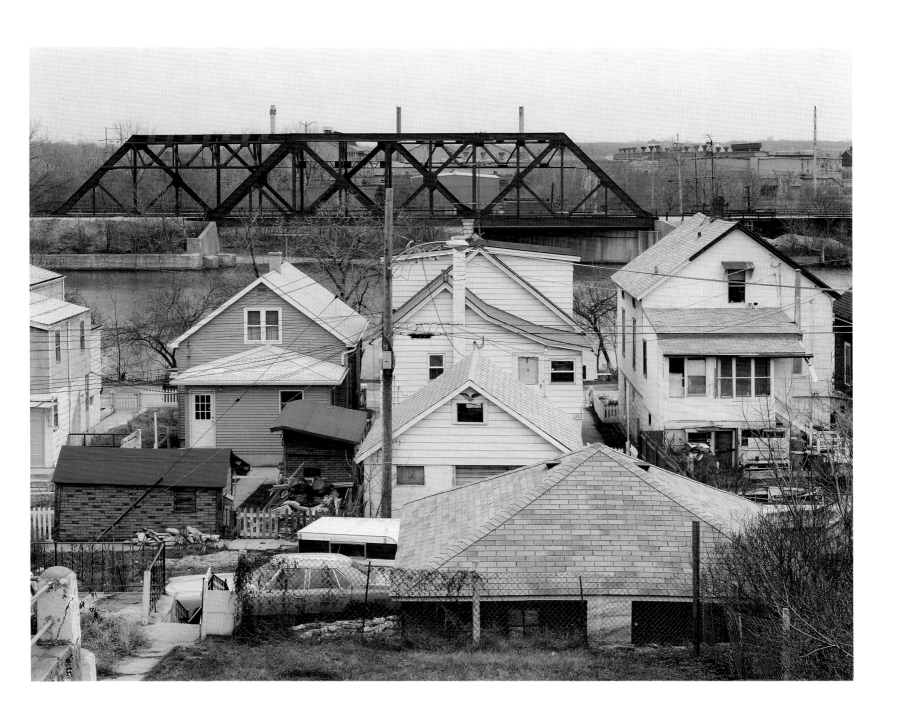

RHONDAL MCKINNEY

Looking toward the canal, Joliet, 1987

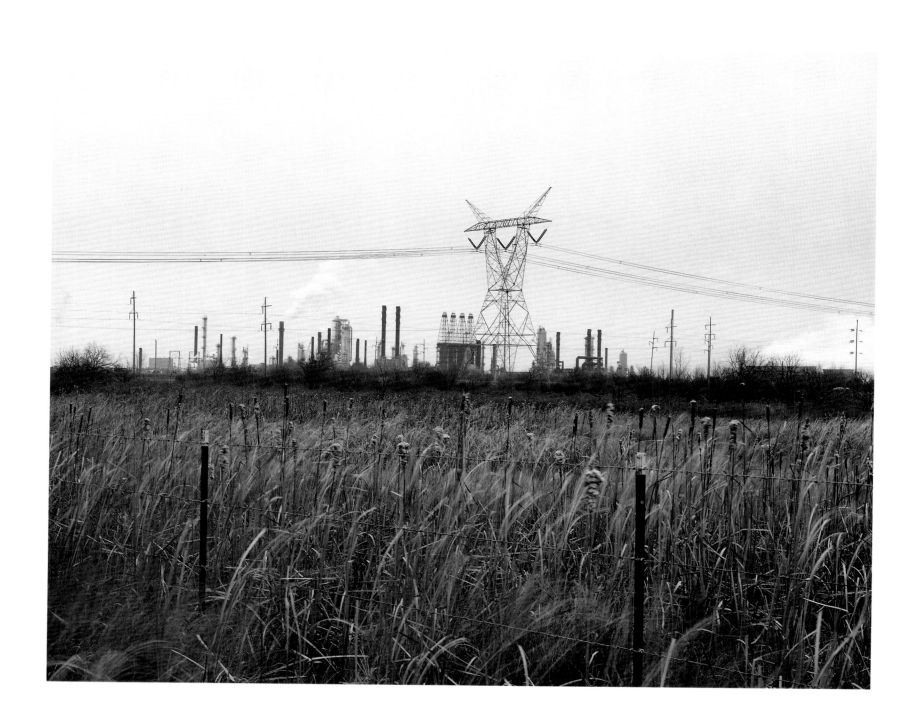

RHONDAL MCKINNEY

Refinery, south of Joliet, 1987

RHONDAL MCKINNEY

920 State Street, Lockport, 1986
State Street, Lockport, 1985

James Newberry

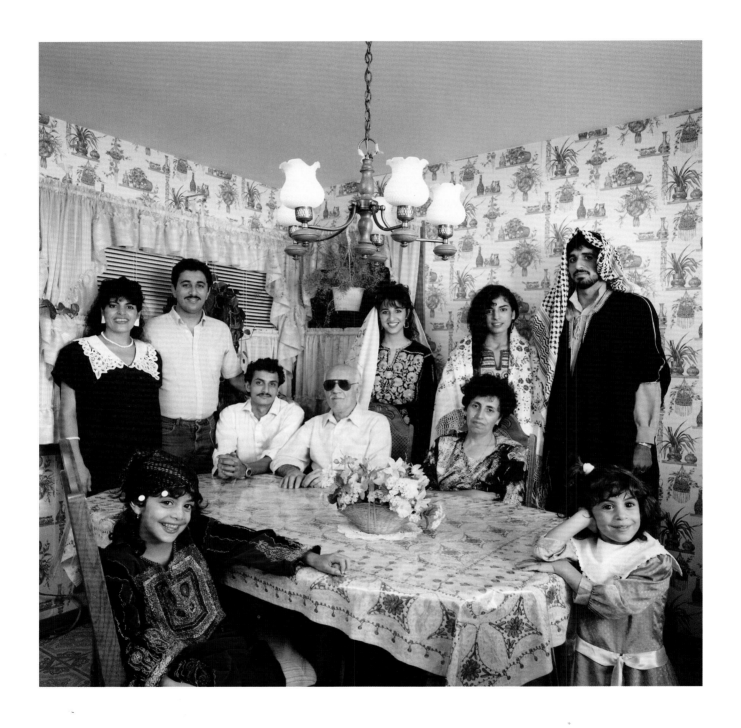

Palestinian-American family in their home. W. 79th Street, 1987

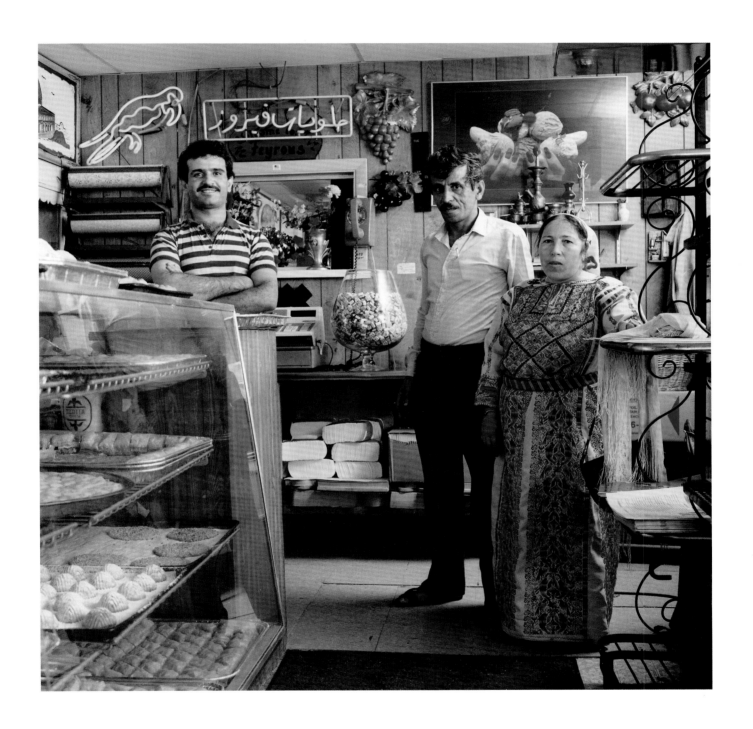

JAMES NEWBERRY

Bakery manager and friends, Feyrous Pastries, N. Kedzie Avenue, 1987

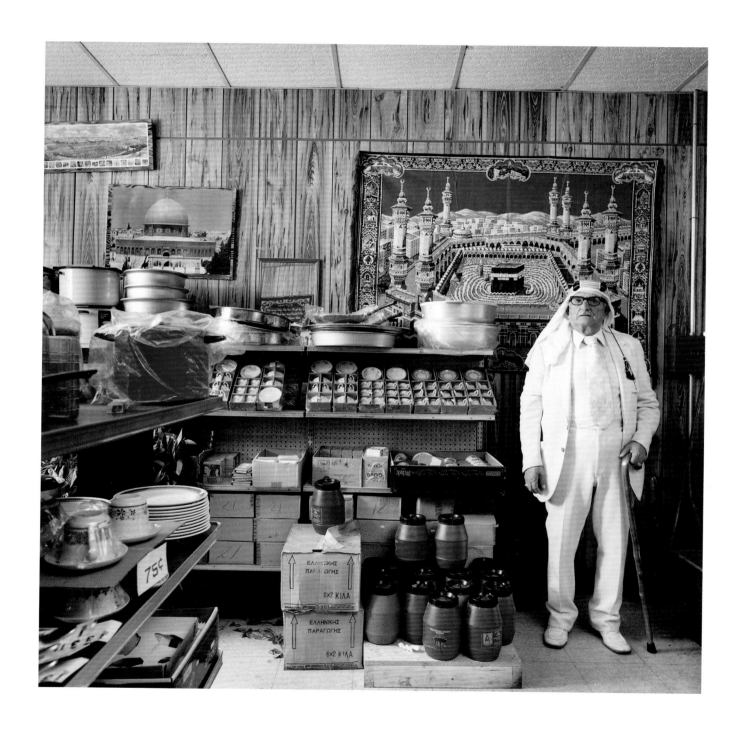

JAMES NEWBERRY

Al-Rasheed Bakery, W. 63rd Street, 1987

130

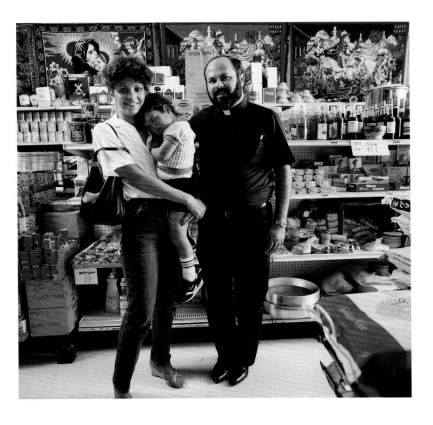
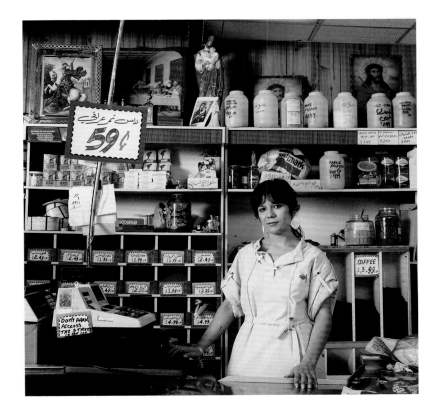

JAMES NEWBERRY

Antiochian Orthodox priest with wife and child, 1987.
Store clerk at Saba Cash-and-Carry, N. Kedzie Avenue, 1987

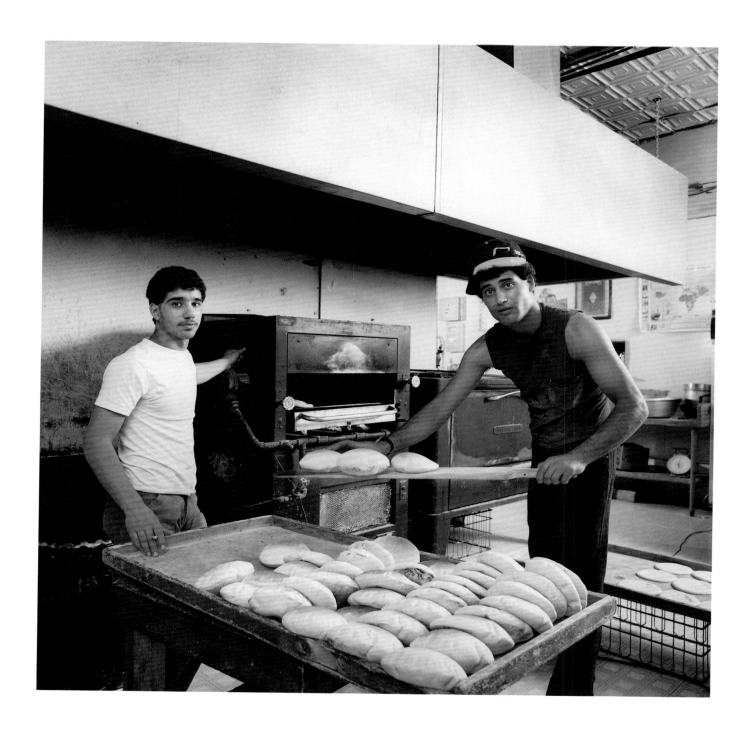

JAMES NEWBERRY

Two bakers, Al Ahram Bakery, 1987

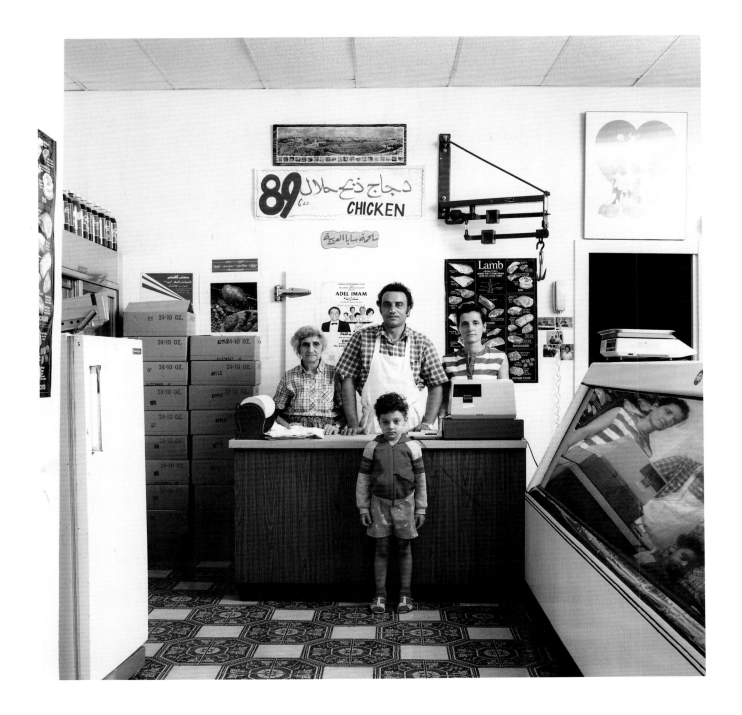

JAMES NEWBERRY

Greek Orthodox Palestinian-American family, owners of Saba Meat Market, N. Kedzie Avenue, 1987

Antonio Perez

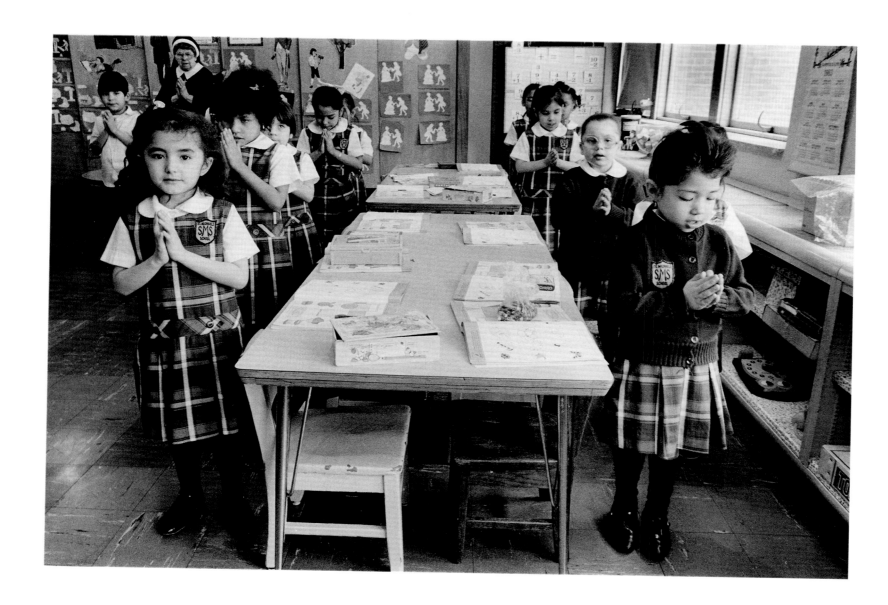

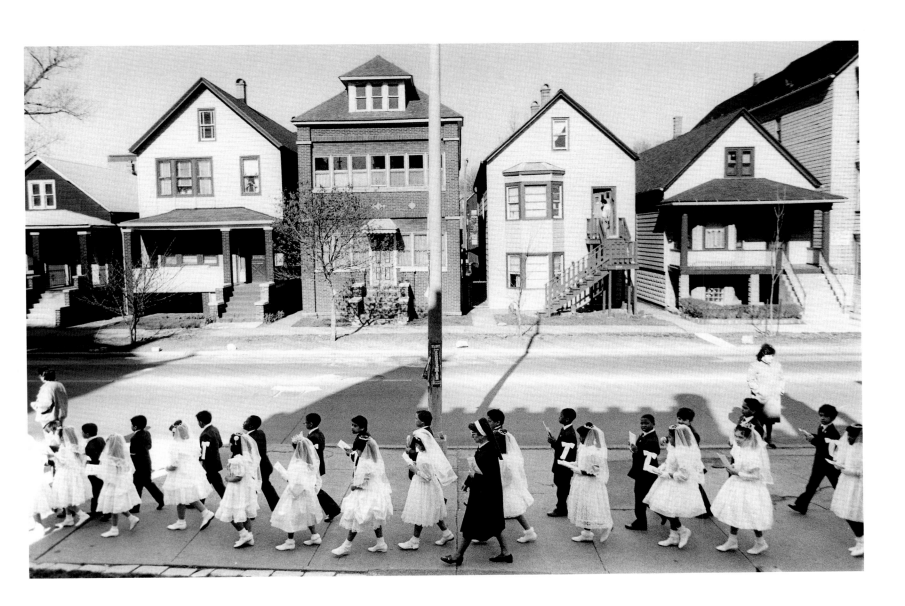

ANTONIO PEREZ

First Holy Communion at St. Michael's Church, 82nd Street and South Shore Drive, 1988

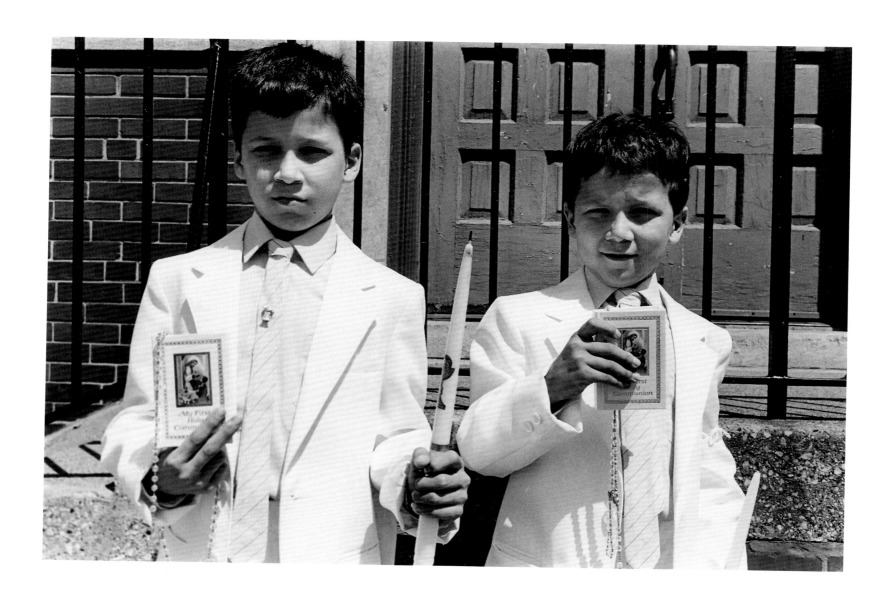

ANTONIO PEREZ

First Holy Communion, 3200 E. 91st Street, 1987

136

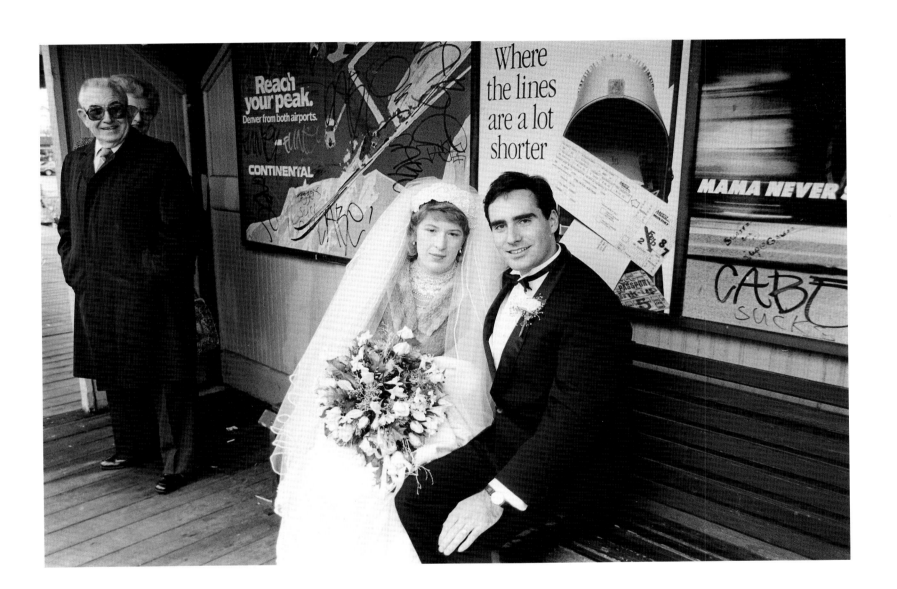

ANTONIO PEREZ

Newlyweds waiting for a train at the 83rd Street station, 1987

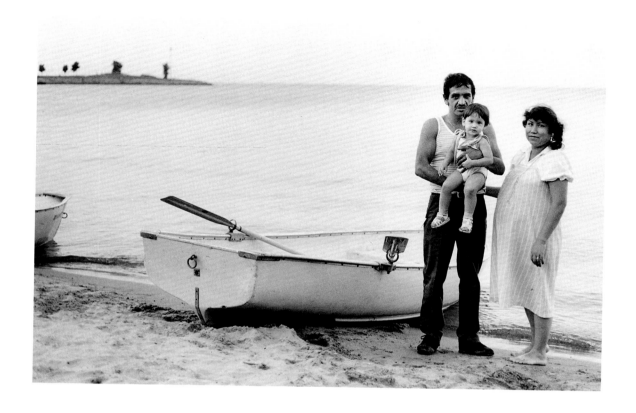

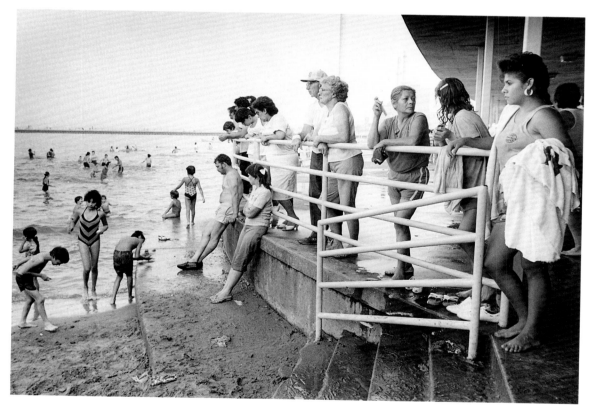

ANTONIO PEREZ

Couple and baby in Calumet Park, 1987
People watching swimmers at Calumet Park, 1987

138

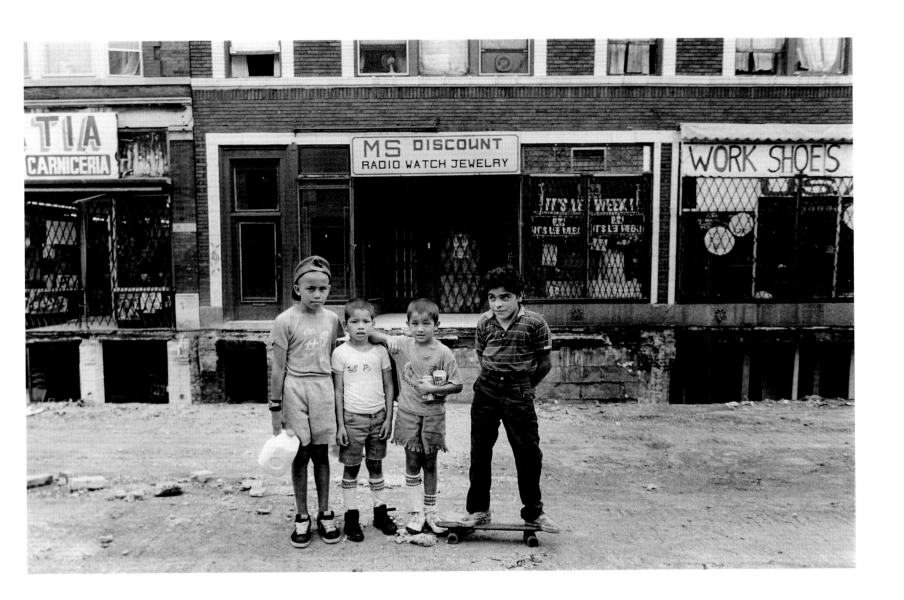

ANTONIO PEREZ

Four boys on their way home from shopping, 1987

Tom Petrillo

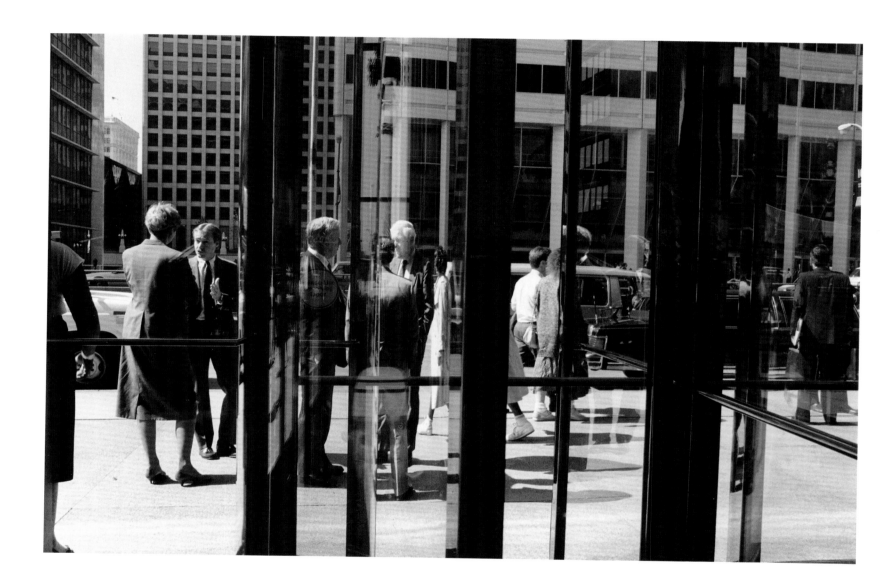

Lunch conversations, Sears Tower, 1987

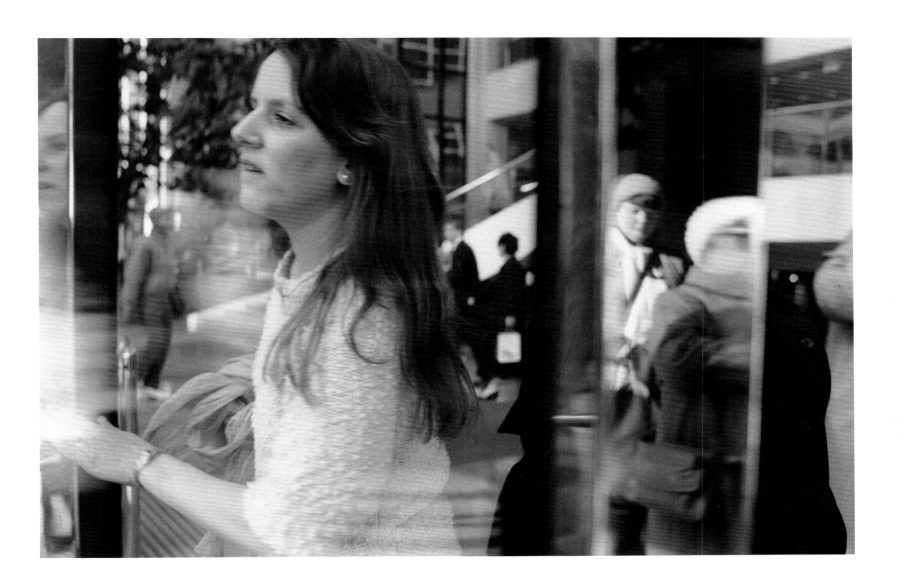

TOM PETRILLO

Revolving door, Wacker Drive lobby, Sears Tower, 1987

141

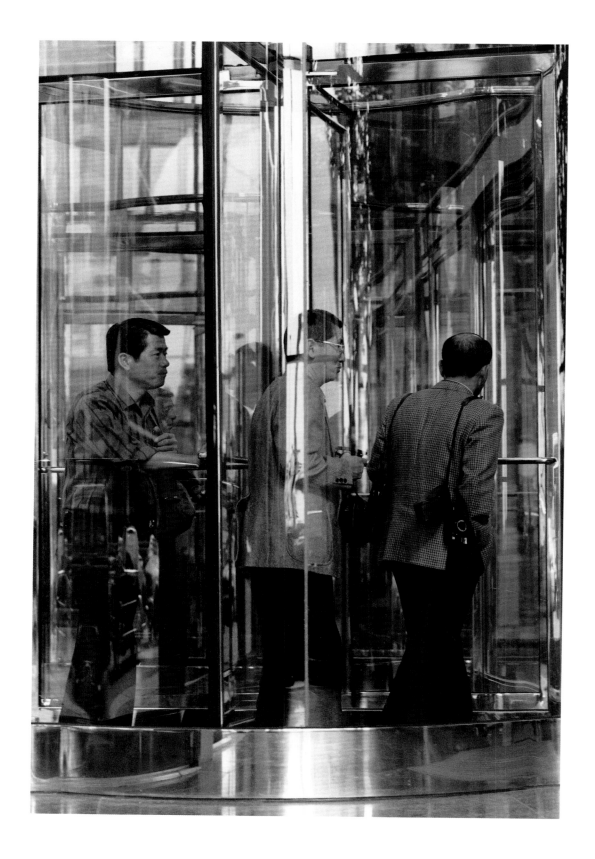

TOM PETRILLO

Entering through revolving doors, Sears Tower, 1987

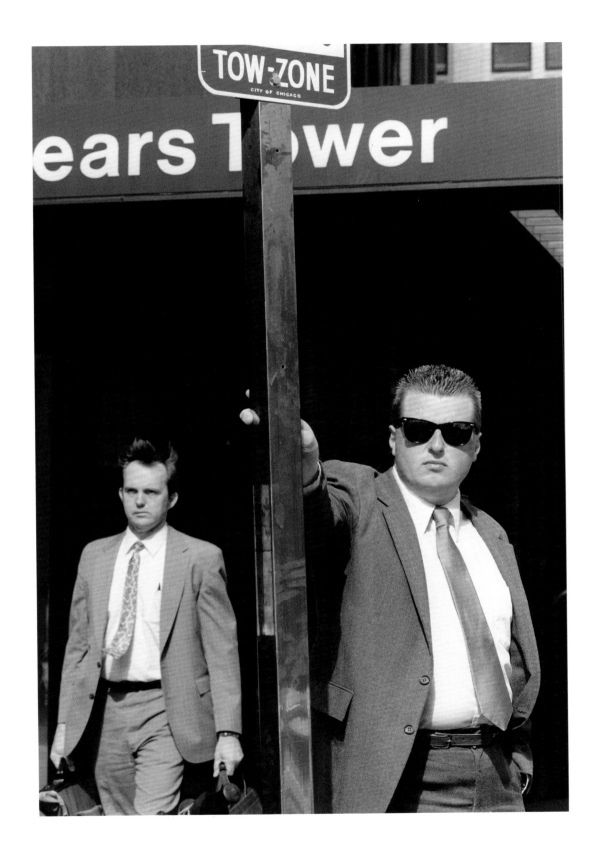

TOM PETRILLO

Man waiting at Franklin Street entrance, Sears Tower, 1987

143

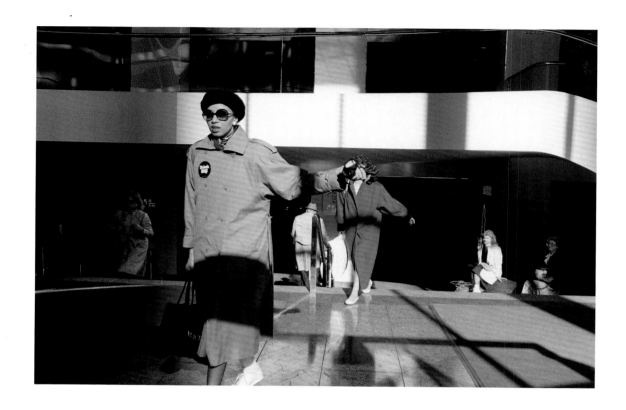

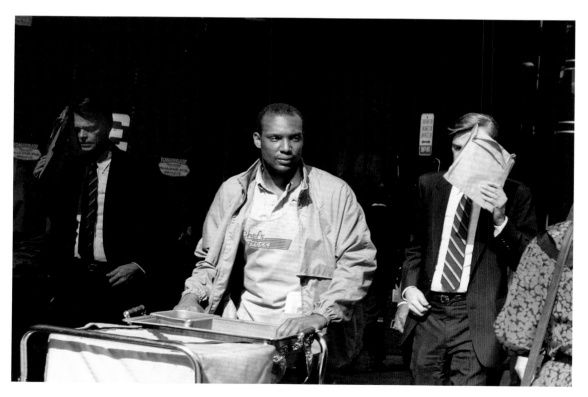

TOM PETRILLO

"Think Big" model, Wacker Drive lobby, Sears Tower, 1988
Chef Express, food delivery to corporate floors, Sears Tower, 1987

Russell Phillips

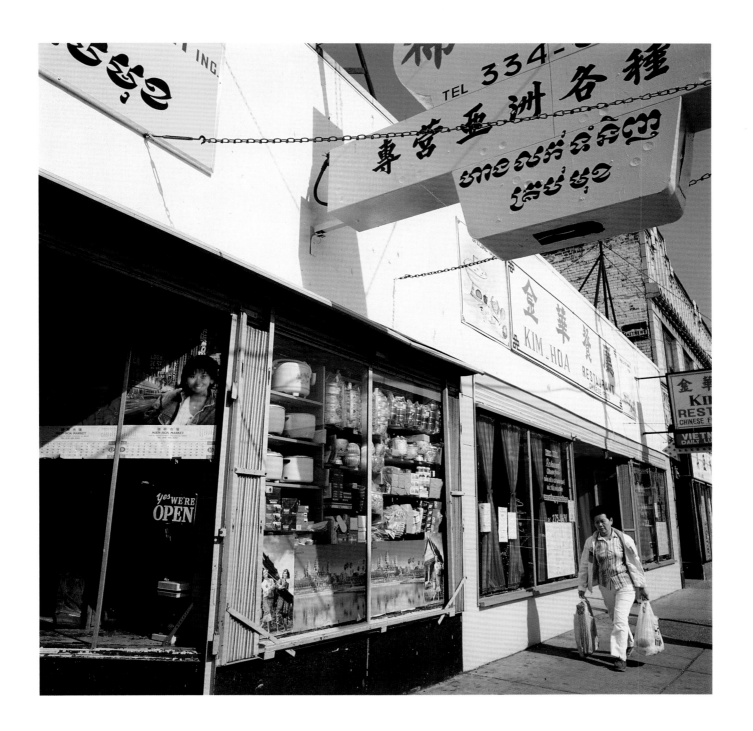

Argyle Street, 1987

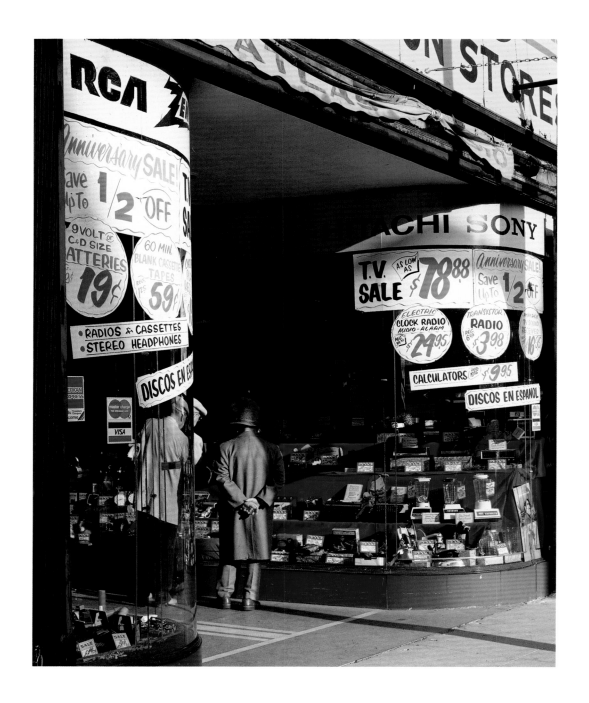

RUSSELL PHILLIPS

Two men looking in window, N. Lincoln Avenue, 1984

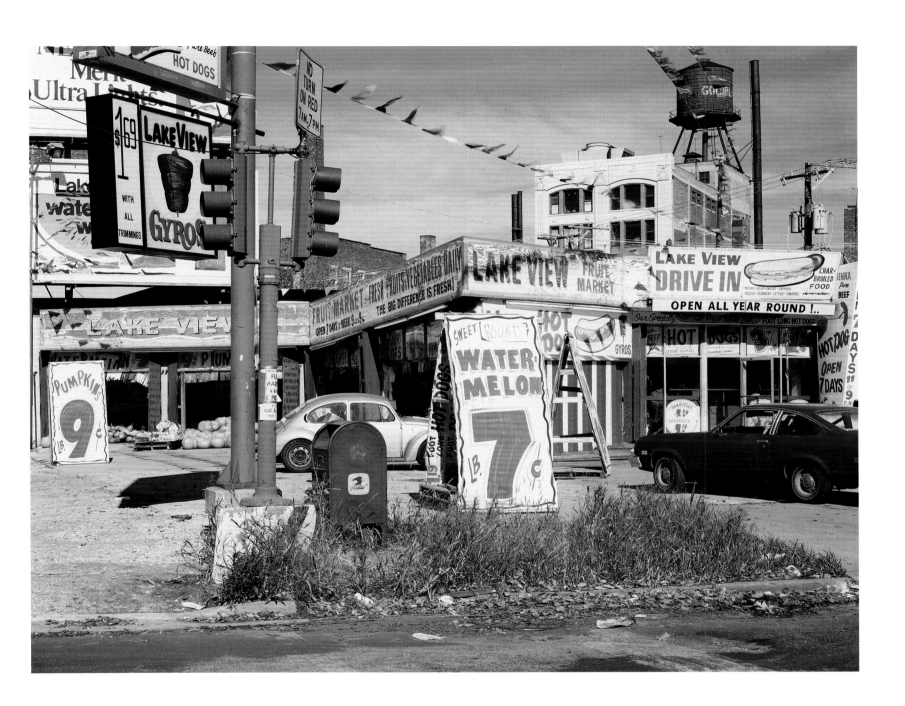

RUSSELL PHILLIPS

Lakeview fruit stand, N. Ashland Avenue, 1985

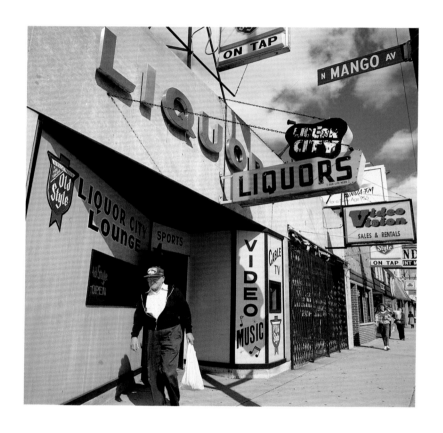
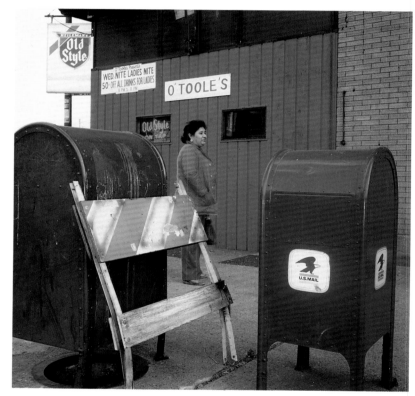

RUSSELL PHILLIPS

Liquor City Lounge, W. Belmont Avenue, 1987
O'Toole's, N. Clark Street, 1984

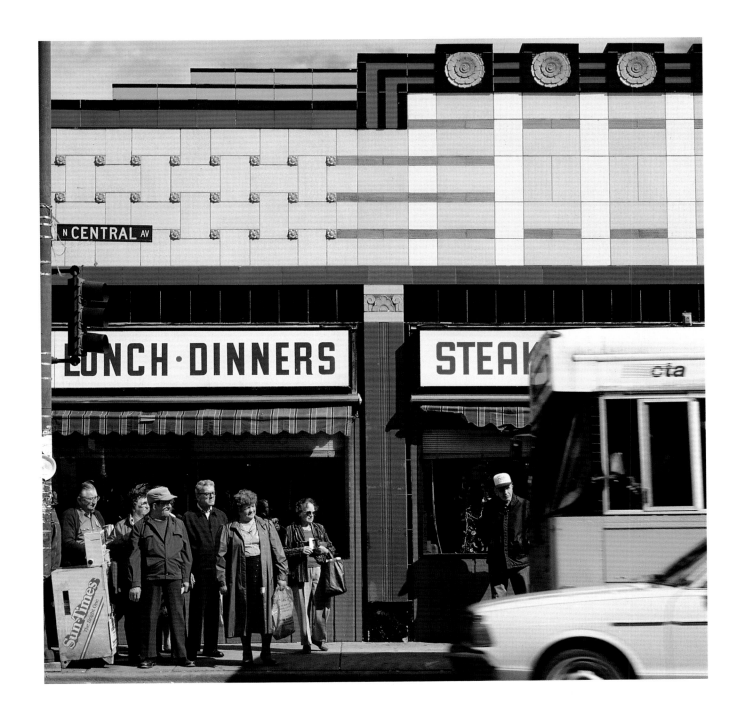

RUSSELL PHILLIPS

Bus stop, Belmont and Central avenues, 1987

Melissa Ann Pinney

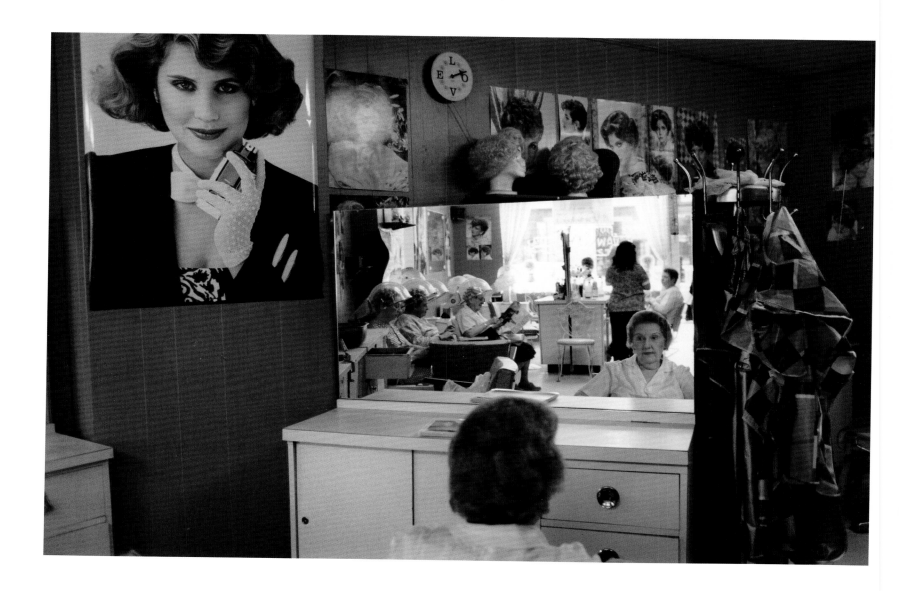

MELISSA ANN PINNEY

Waiting for a shampoo, Barbara's Beauty Salon, N. Lincoln Avenue, 1988

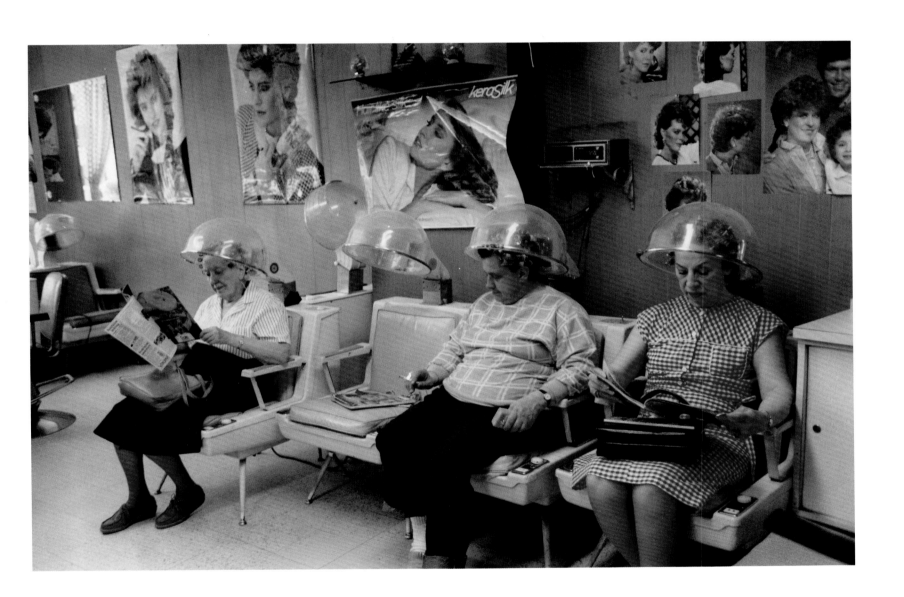

MELISSA ANN PINNEY

Under the dryers, Barbara's Beauty Salon, N. Lincon Avenue, 1988

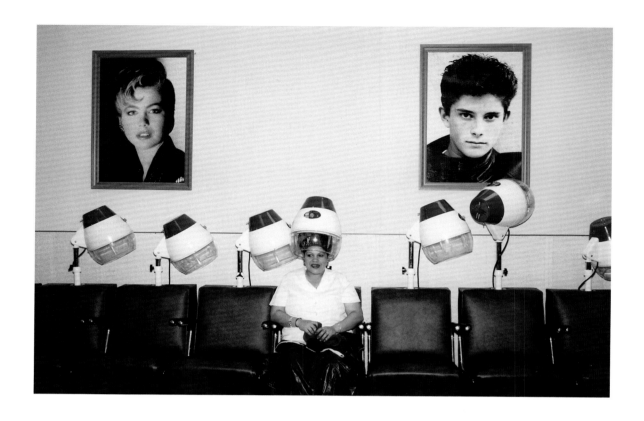

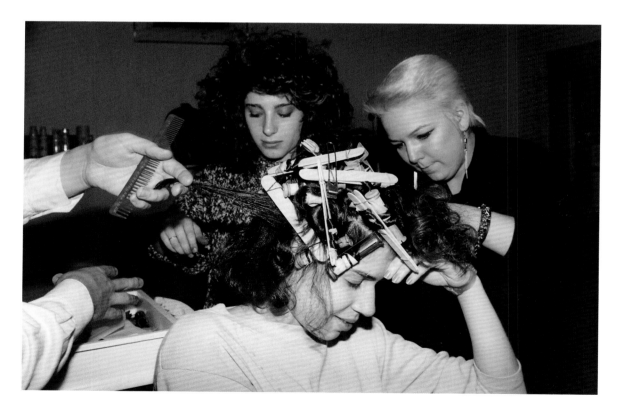

MELISSA ANN PINNEY

Canella School of Hair Design, N. Broadway, 1987
Sunday night workshop—cluster-spiral set, Di Capelli Hair Studio, N. Sheffield Avenue, 1987

152

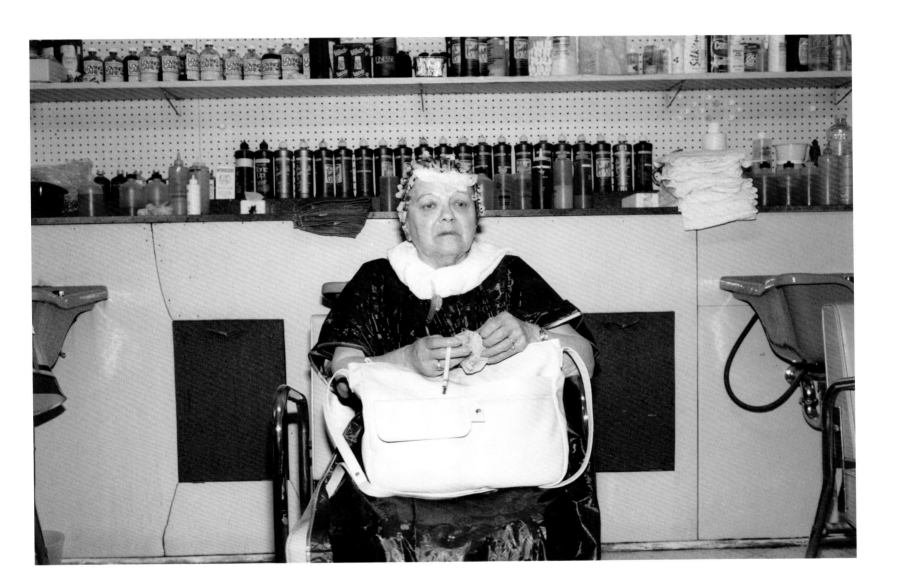

MELISSA ANN PINNEY

Waiting to be rinsed out, Barbara's Beauty Salon, N. Lincoln Avenue, 1988

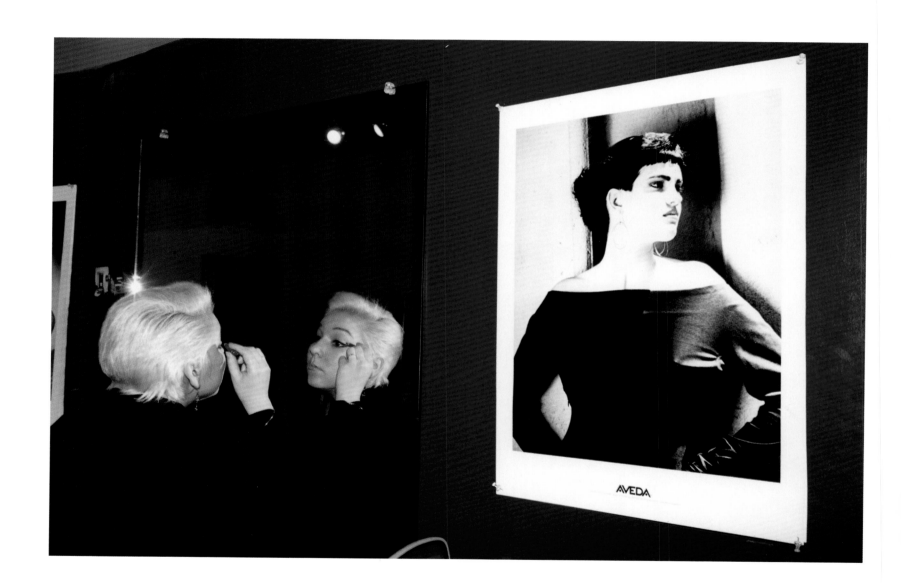

MELISSA ANN PINNEY

Sunday night workshop, Di Capelli Hair Studio, N. Sheffield Avenue, 1987

Marc PoKempner

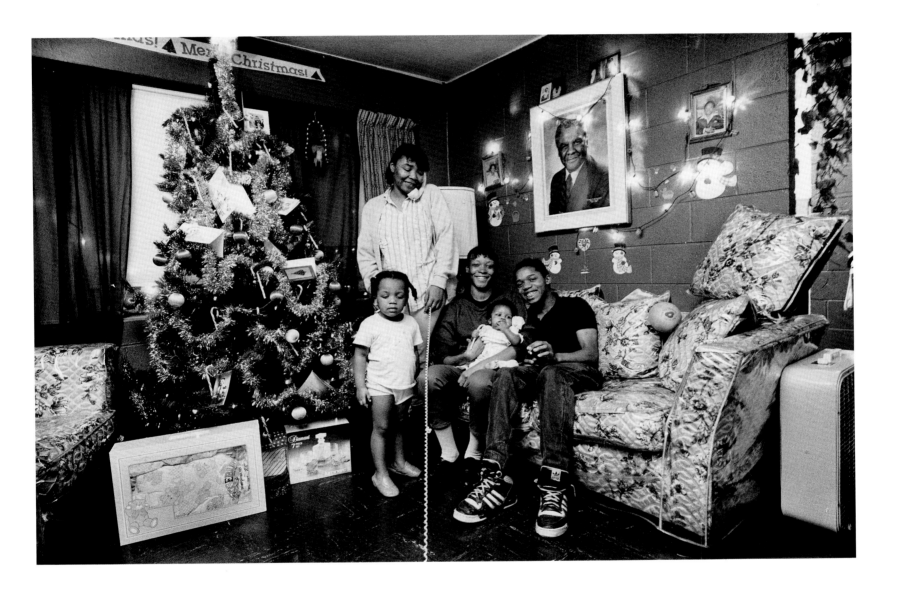

MARC POKEMPNER

Linda, Latrice, and Mario, Cabrini Green, 1987

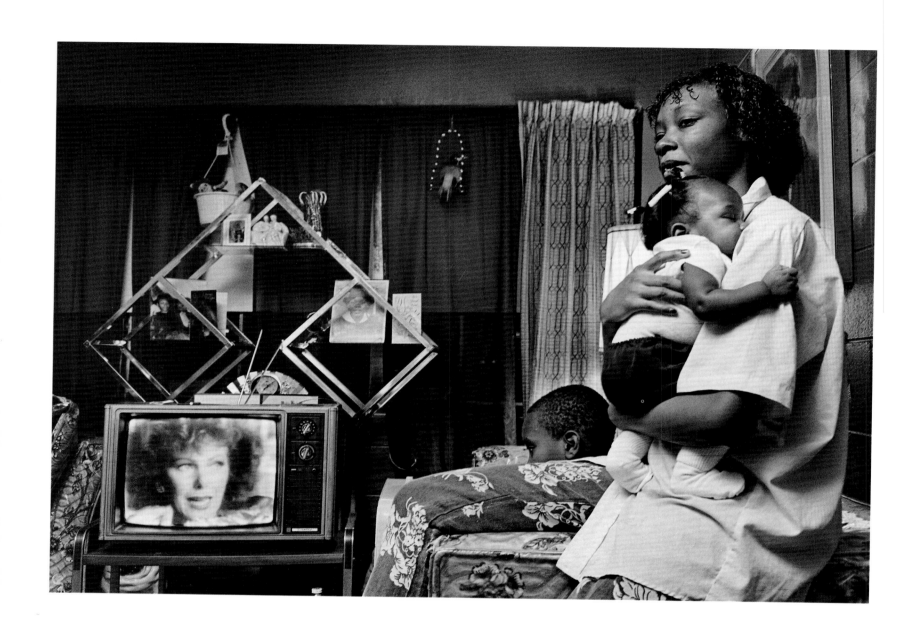

MARC POKEMPNER

Latrice with her baby, Chiquita, Cabrini Green, 1988

156

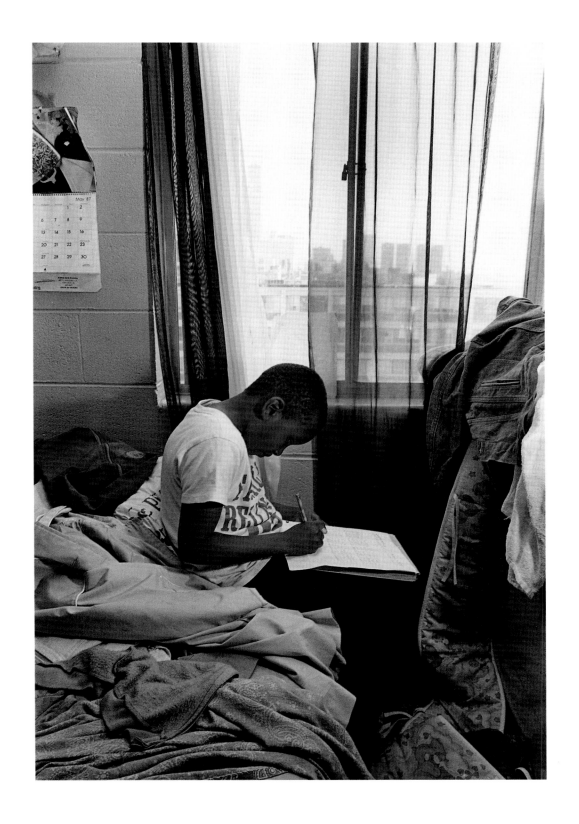

MARC POKEMPNER

Dwayne doing his homework, Cabrini Green, 1988

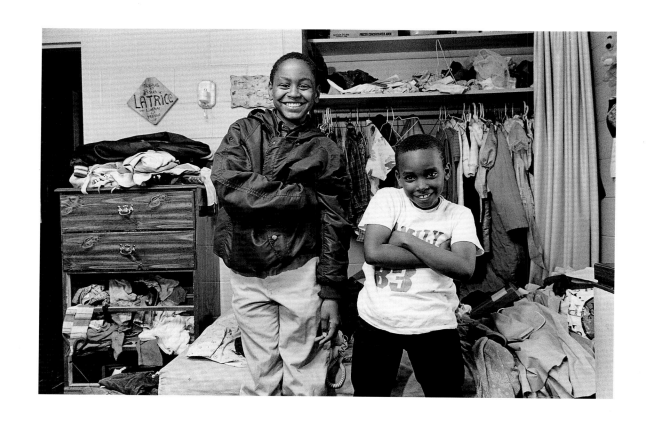

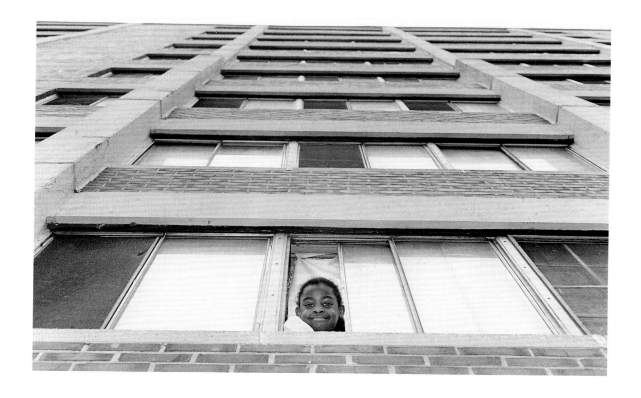

MARC POKEMPNER

Keith and Dwayne in the bedroom, Cabrini Green, 1988
Little girl looking out a window, Cabrini Green, 1987

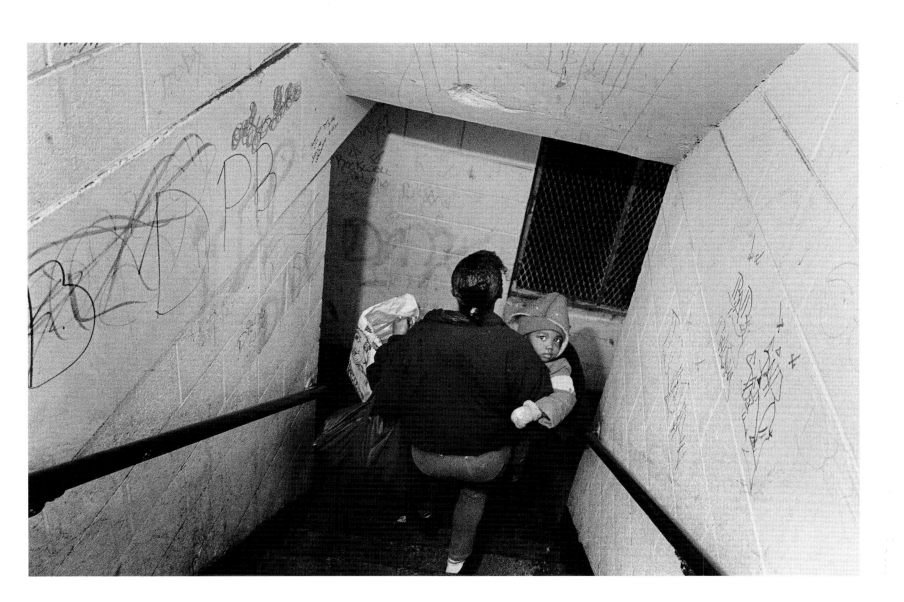

MARC POKEMPNER

Woman with child and groceries, Cabrini Green, 1987

Bob Thall

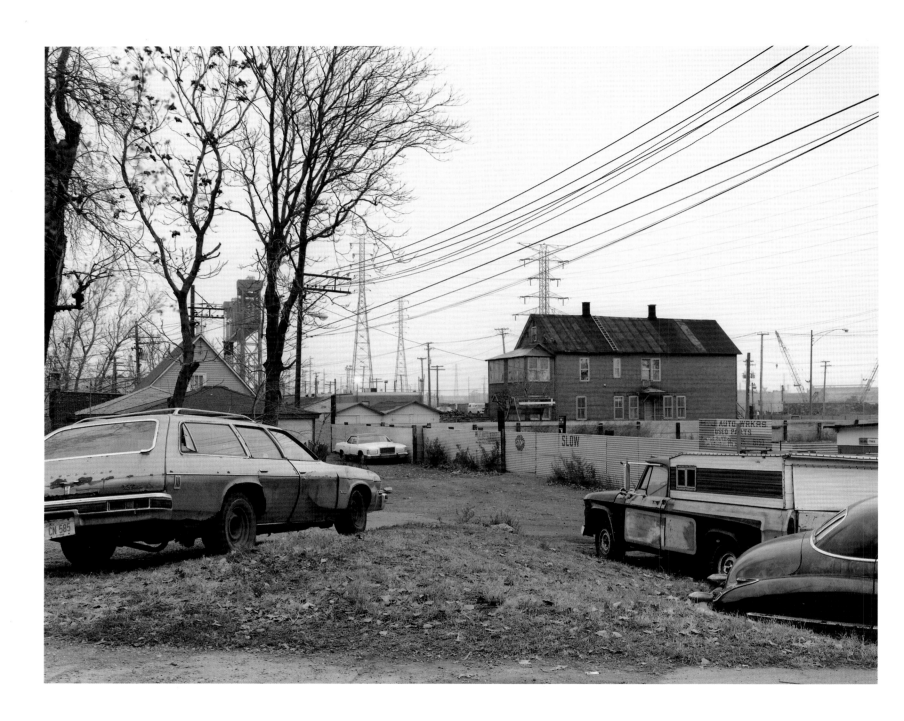

BOB THALL

East of Ewing Avenue, near 94th Street, 1987

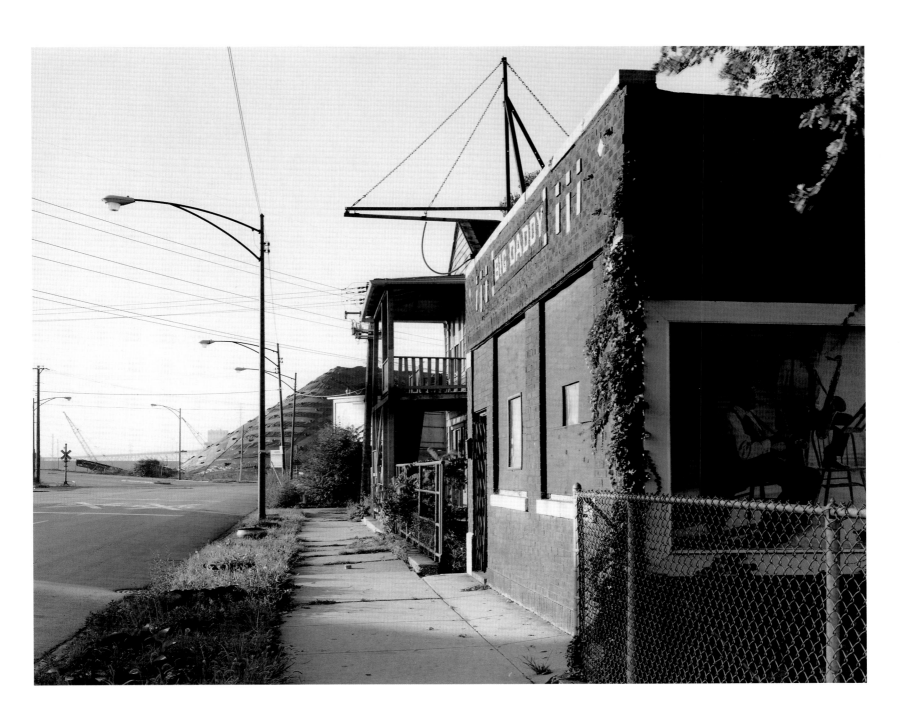

BOB THALL

Mackinaw Avenue, near 93rd Street, 1987

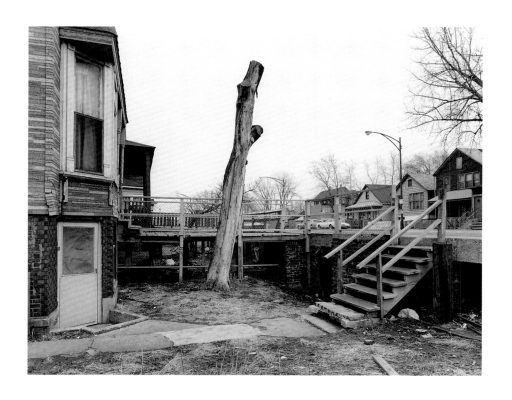

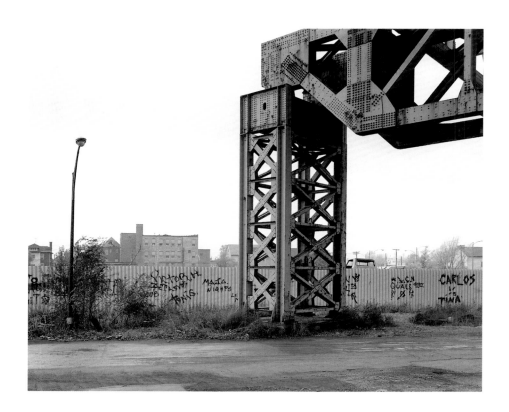

BOB THALL

Burley Avenue, near 88th Street, 1988
At the base of the Skyway, near 95th Street, 1987

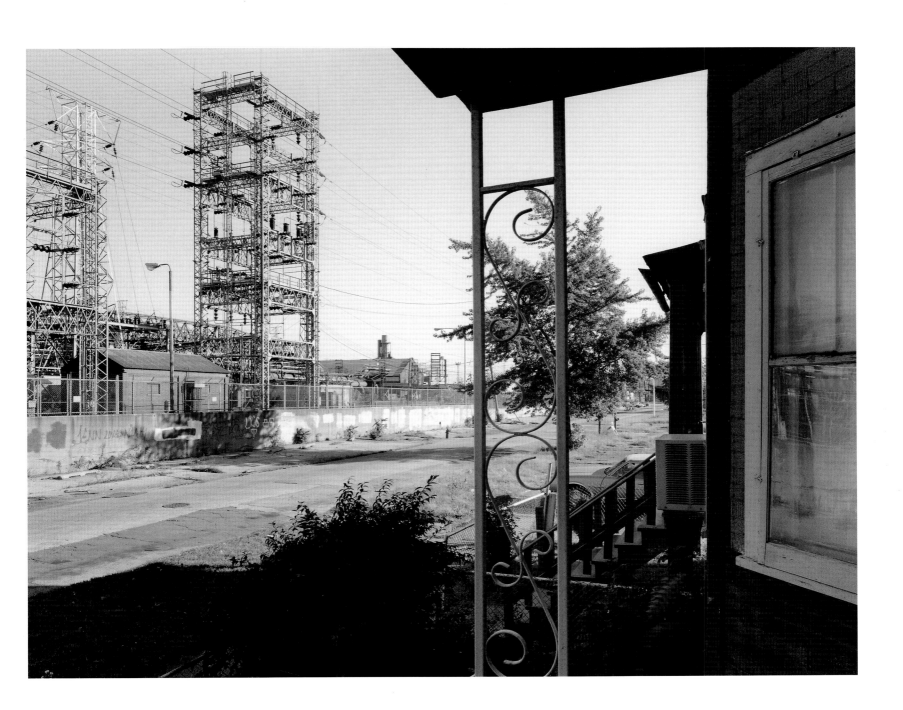

BOB THALL

U.S. Steel South Works, near Mackinaw Avenue and 84th Street, 1987

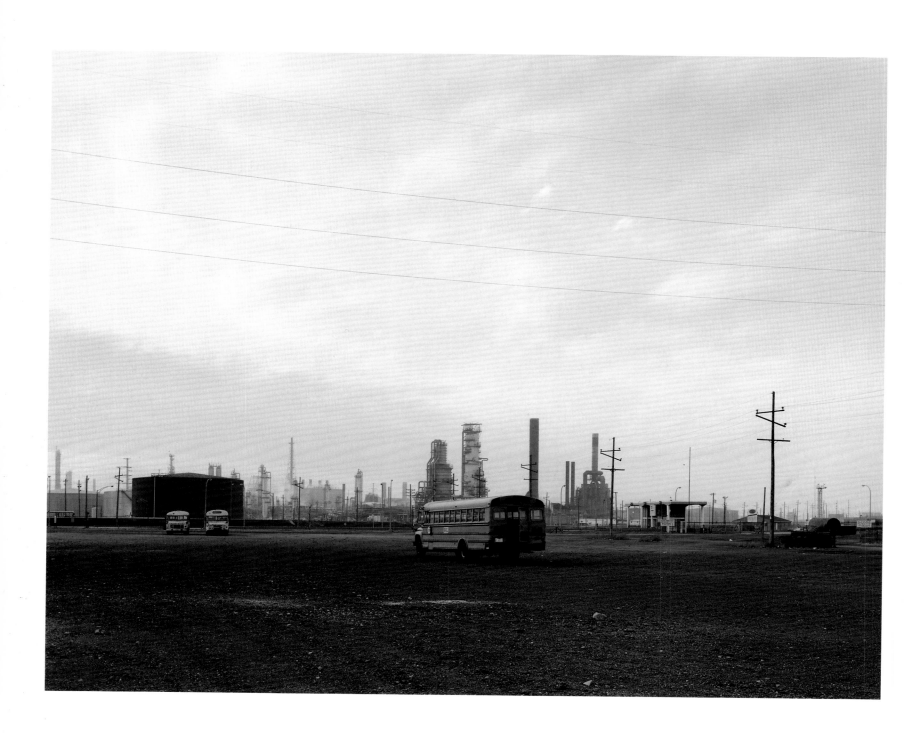

BOB THALL

In the vicinity of Route 912 and 130th Street, East Chicago, Indiana, 1988

164

Jay Wolke

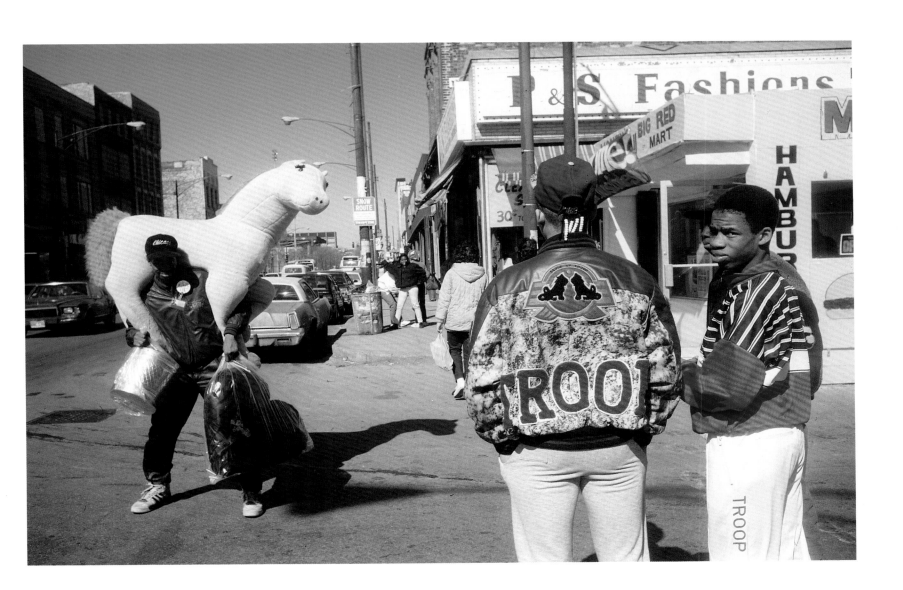

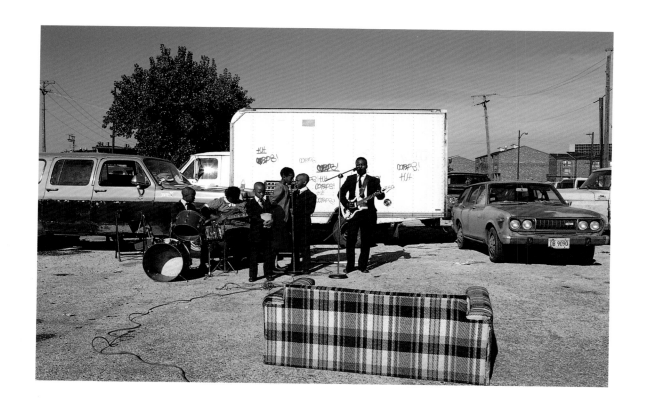

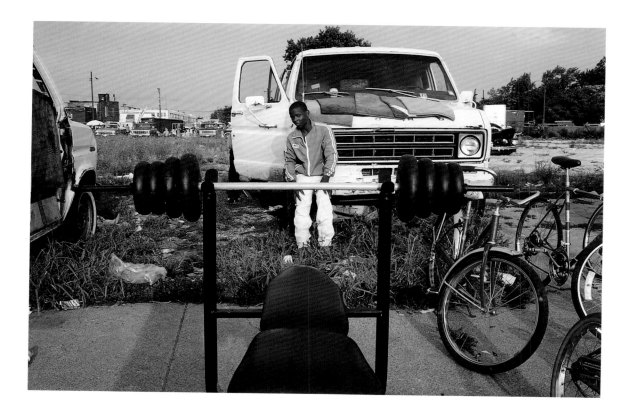

JAY WOLKE

Family blues band, Maxwell Street, 1987
Boy with weights, Maxwell Street, 1987

166

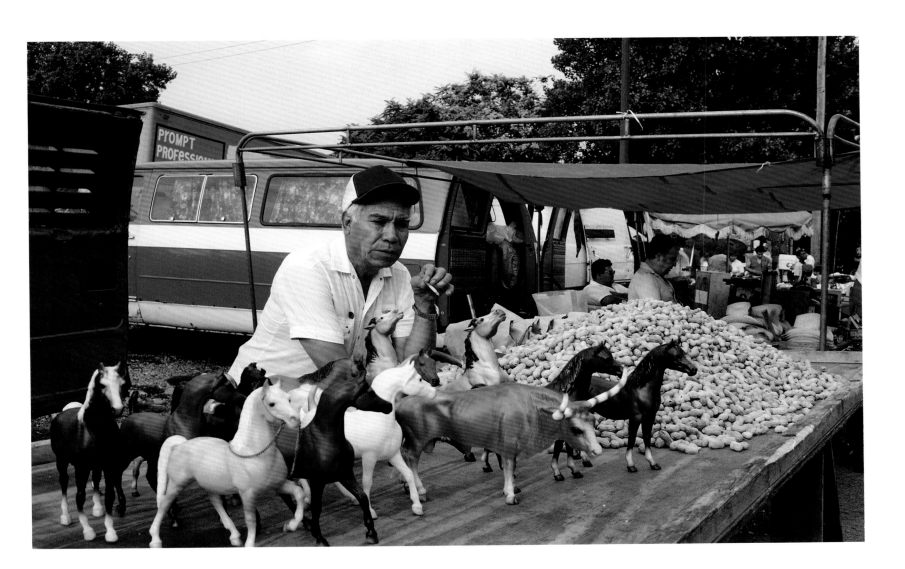

JAY WOLKE

Seller with horses and nuts, Maxwell Street, 1988

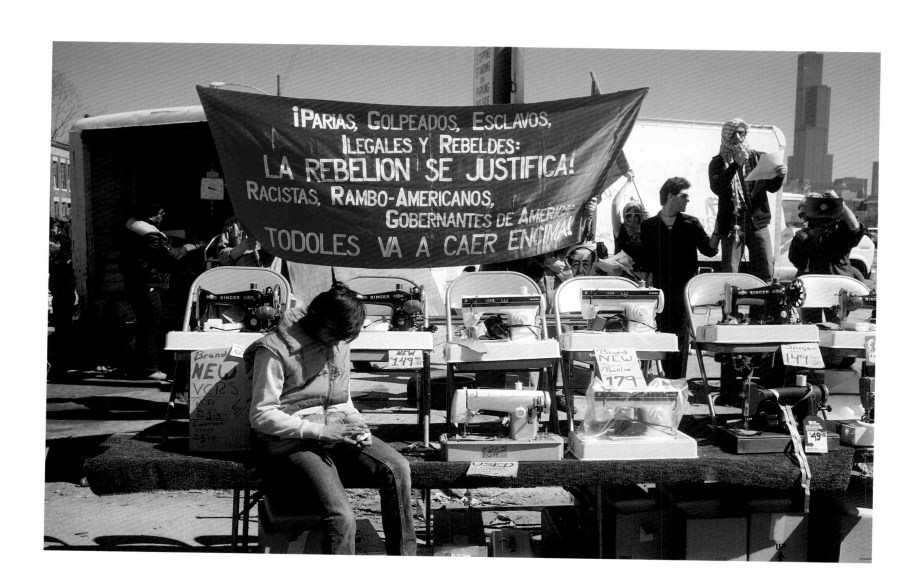

JAY WOLKE

May Day, Maxwell Street, 1987

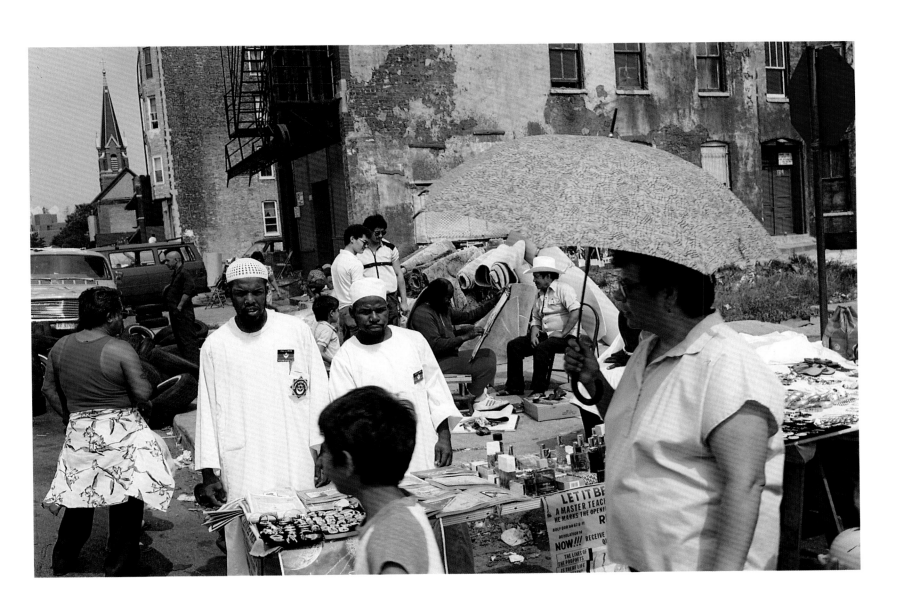

JAY WOLKE

Lives of the prophets, Maxwell Street, 1987

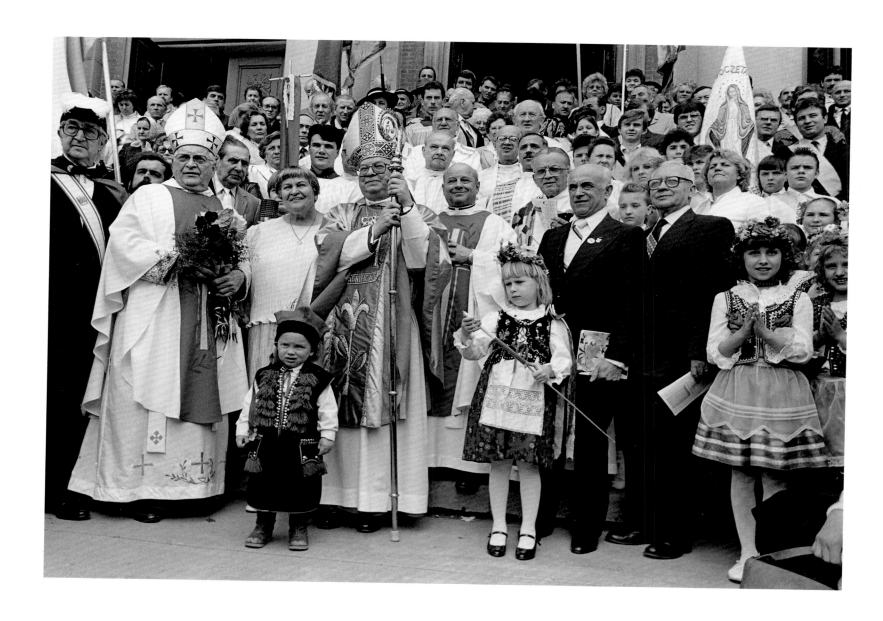

Visiting cardinal from Poland, with crowd at 1112 N. Noble Street, 1988

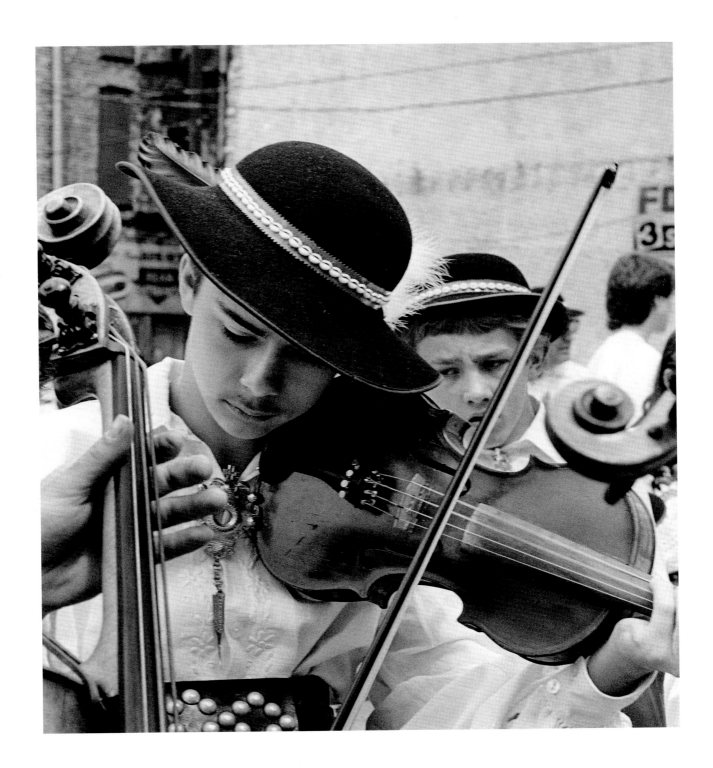

RICHARD YOUNKER

Highland fiddler at Kinzie and Clark streets, Polish Day Parade, 1988

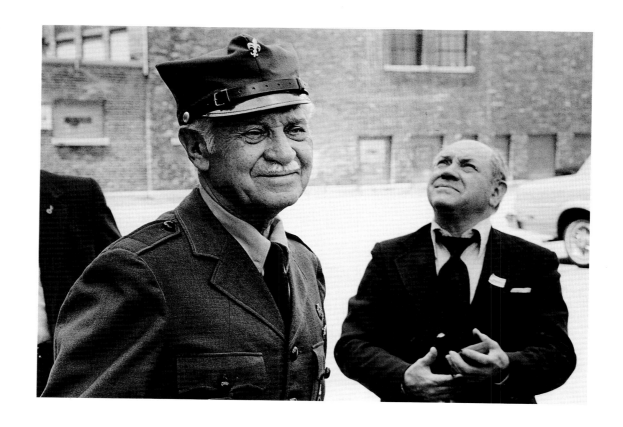

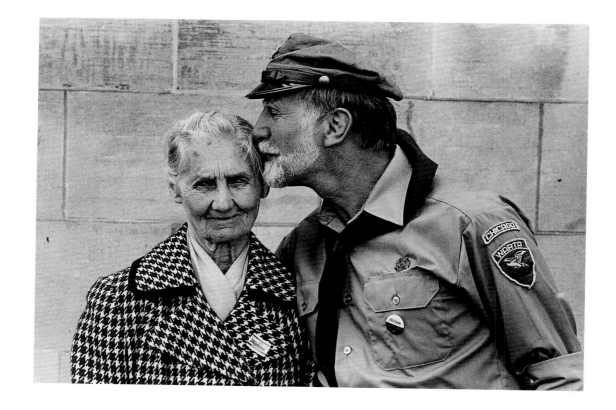

RICHARD YOUNKER

Polish scout officers at 1112 N. Noble Street, 1988
Mother and son at 1112 N. Noble Street, 1988

172

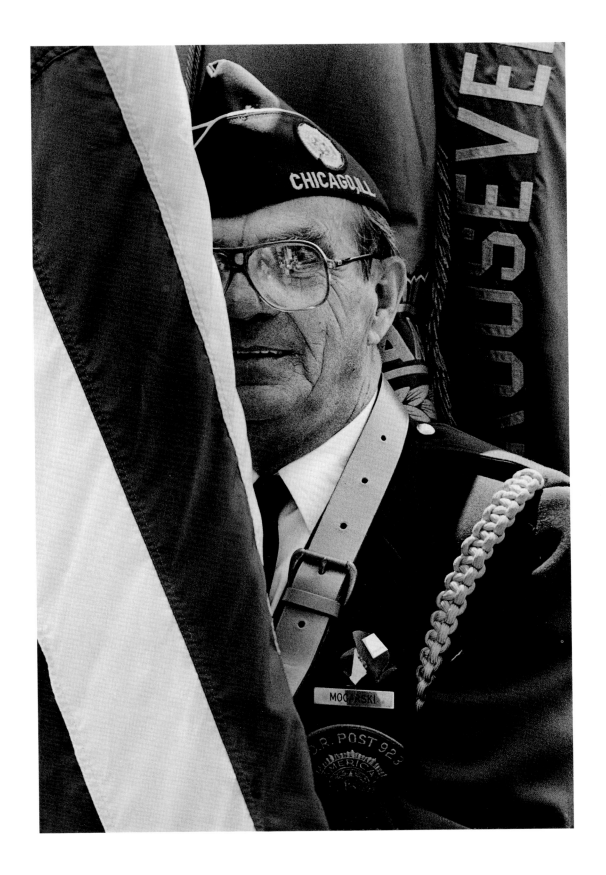

RICHARD YOUNKER

Patriot at the corner of Honore and Cortland streets, Memorial Day 1988

The Photographers

Biographical and career data were provided by the photographers or their representatives and compiled by Kathleen Lamb. A selection of one-person exhibitions is included, with titles of individual exhibitions omitted in most cases. Publications are limited to books written by the photographer and monographs or catalogs for one-person exhibitions, as well as selected articles by the photographer or articles that rely solely on his or her work for illustration. Brief project descriptions were also provided by most photographers and are included here.

Abbreviations used in biographies

AIC	Art Institute of Chicago
CC	Columbia College, Chicago
CCFA	Chicago Council on Fine Arts
CHS	Chicago Historical Society
CPLCC	Chicago Public Library Cultural Center
FMNH	Field Museum of Natural History, Chicago
GSU	Governors State University, University Park, Ill.
IAC	Illinois Arts Council, Chicago
ID/IIT	Institute of Design, Illinois Institute of Technology, Chicago
MCA	Museum of Contemporary Art, Chicago
MCP/CC	Museum of Contemporary Photography of Columbia College
MIT	Massachusetts Institute of Technology, Cambridge
MOMA	Museum of Modern Art, New York City
NEA	National Endowment for the Arts, Washington, D.C.
NEH	National Endowment for the Humanities, Washington, D.C.
NIU	Northern Illinois University, DeKalb
PSCC	Prairie State Community College, Chicago Heights
PUC	Purdue University–Calumet, Hammond, Ind.
RISD	Rhode Island School of Design, Providence
RIT	Rochester Institute of Technology, Rochester, N.Y.
SAIC	School of the Art Institute of Chicago
UC	University of Chicago
UI	University of Illinois at Urbana-Champaign
UIC	University of Illinois at Chicago
UM	University of Michigan, Ann Arbor

Born: Minneapolis, Minn., 1944
Residence: Minneapolis, Minn.

Education: Minneapolis College of Art and Design (B.F.A., 1968); University of Minnesota (graduate study, 1969-71). *Grants and awards:* Minnesota State Arts Board, 1973, 1983; "Farm Families" commission, Focus/Infinity Fund, 1985; Regents Park Artist-in-Residence Fellowship, Chicago, 1986. *Selected exhibitions:* Walker Art Center, Minneapolis, 1974; Louisiana State University, New Orleans, 1975; Minneapolis Institute of Art, 1984; "Men in America," First Bank, Minneapolis–St. Paul, 1988. *Publications:* David Travis, *Men in America, Photographs 1973-1987* (Minneapolis–St. Paul: First Bank, 1988).

The most interesting aspect of Chicago is, for me, the effect a confining urban context has on the human interaction of the various subcultures that co-exist, living, working, and playing together. I have an agenda for photographing in Chicago. Attending parades, neighborhood festivals, political demonstrations, going to church, sitting in cafes, walking the streets, and riding the El are some of the ways I come into contact with the people who daily go through urban rituals that comprise a Chicago life-style. This group of photographs was selected from a continuing series that attempts to trace my physical and emotional involvement with the people of Chicago.

DAVID AVISON

Born: Harrisonburg, Va., 1937
Residence: Chicago

Education: Brown University (Ph.D., physics, 1966); ID/IIT (M.S., photography, 1974). *Professional experience:* instructor of physics, Brown University, 1959-66; instructor of physics, Purdue University, 1967-69; instructor of photography, CC, 1970-86. *Grants and awards:* NEA, 1977; Midwest Museum of American Art, Elkhart, Ind., 1980; IAC, 1984. *Selected exhibitions:* AIC, 1977; Merwin Gallery, Illinois Wesleyan University, Bloomington, 1978; Silver Image Gallery, Ohio State University, Columbus, 1978; Odessa College, Odessa, Tex., 1980; Swen Parson Gallery, NIU, 1982.

Chicago has several extraordinary beaches, each with its own flavor: Montrose Beach is populated mainly by Hispanics and some Asians; North Avenue Beach caters to "assimilated Americans," both in families and in groups; at Oak Street Beach much primping and display are in evidence among young adults. I find the energies in each of these distinctive worlds to be captivating, especially on the ethnic beaches because of the strong sense of family. Not to be neglected are the artifacts and paraphernalia that are brought almost ritualistically to these public places, in many cases providing a rare glimpse into the important symbols and preoccupations of otherwise private Chicagoans. The beach is an ideal place for viewing the continuing human drama, and as I look through my photographs of people, I find persistent evidence of a search for play, for abandon, for innocence. In my City Beach Series, children are more exuberantly childlike, and adults shed some of their adult roles. Joy, anger, fear, and even terror find a more nearly transparent expression.

Born: New York City, 1943
Residence: Milwaukee, Wisc.

Education: Yale University (Ph.D., American studies, 1973); self-taught in photography. *Professional experience:* associate professor, American studies, SUNY at Buffalo; chair and associate professor, Department of Film, University of Wisconsin at Milwaukee. *Grants and awards:* Fulbright Fellowship, 1965-66; Woodrow Wilson Fellowship, 1966-69; Wisconsin Arts Board Fellowship, 1978, 1980; University of Wisconsin at Milwaukee Foundation Research Award, 1985. *Selected exhibitions:* DeSaisset Art Gallery and Museum, University of Santa Clara, Santa Clara, Calif., 1975; CEPA Gallery, Buffalo, N.Y., 1975; Perihelion Galleries, Milwaukee, Wisc., 1983. *Publications:* Dick Blau, "Polka Soul," *Insight Magazine*, Dec. 18, 1977.

These pictures were made over the last five years in the dance halls, bars, and motels where Chicago-style polka music is played. Unlike other, more folkloric expressions of national culture, this popular art form, with roots still deep in the hill country of southern Poland, from which so much of Chicago's Polish population has come, has adapted to and embraced the sounds of contemporary America. It contains the elements of many important musical traditions, including country and western, rock, and blues. Part of the popularity of Chicago-style polka music comes from the party that is an inseparable accompaniment. The polka party is a kind of carnival and can last as long as three days, filled with the breathtaking whirl of the dance—which is nothing like the "South Side gallop" we usually associate with the polka—and a special sort of euphoric play that unites performers and audience in a mass improvisation on a set of comic themes central to Polish-American life. I see this exuberant music as a kind of secular communion, as a moment in which connections are made to the past, to the present, and to one another, as a celebration of this people's capacity to thrive despite what has been (and remains) a very hard experience.

JAY BOERSMA

Born: Chicago, 1947
Residence: Homewood, Ill.

Education: CC (B.A., photography, 1974); RISD (M.F.A., photography, 1976). *Professional experience:* instructor of photography, Bradley University, Peoria, Ill., 1978-79; visiting assistant professor of photography, UI, 1979-81; professor of photography, GSU, 1982-present. *Selected exhibitions:* Benson Hall Gallery, RISD, 1974, 1976; Bradley University, 1977, 1979; School of Art, University of Denver, 1982; Mitchell Museum, Mount Vernon, Ill., 1982; Infinity Gallery, GSU, 1983; Pittsburgh Filmmakers Gallery, 1983; Southern Light Gallery, Amarillo, Tex., 1984; Gallery 2-D, PSCC, 1985.

Buildings, signage, properties, and other street details of Chicago's southern suburbs are the subject of this group of photographs. Socially, economically, and politically, the suburbs are an extremely important part of contemporary American life, but they are seldom explored by documentary photographers. The key visual characteristics of this area are, as one might expect, an array of similar fast-

food restaurants, discount stores, and various forms of the shopping mall, combined with absolute dependence on the automobile and the correlative lack of pedestrian street traffic. The specific subjects I photograph are those in transition, generally from some successful commercial use to neglected disuse. The result is an admittedly subjective view of the area and a portfolio that romanticizes the mundane while creating a landscape of loss and failure.

WAYNE CABLE

Born: Highland Park, Ill., 1957
Residence: Chicago

Education: SAIC, 1975; Cranbrook Writers' Guild, Bloomfield Hills, Mich., 1977; UM (B.A., English literature, 1979). *Professional experience:* staff photographer, *The Michigan Daily,* Ann Arbor, 1977-79; apprentice, Hedrich-Blessing, Chicago, 1980-82; owner of Cable Studios, 1982-present. *Grants and awards: Industrial Photography Magazine,* 1984, 1985. *Selected group exhibitions:* Hyde Park Art Center, Chicago, 1982; "Chicago: The Architectural City," AIC, 1983.

The Arlington House, located at 616 West Arlington Place in an area of Chicago known as Lincoln Park, may be the last vestige of another era. The world inside is far different from the environment immediately outside. Calling itself a "retirement club," it is home to approximately 120 people who for various reasons are apart from the external. Old age is an immediately apparent situation. I first photographed the Arlington House in 1981, and I was amazed to find that it was still intact when I returned in 1988 and that some of the people from seven years before were still there and remembered me. I have valued my exploration with them, opening up in each person a different world and attempting to understand how people in general get to be the way they are. It is probably only a matter of time before this valuable property is sold to real estate developers. Then the Arlington House will be no more, and what will happen to the residents is uncertain.

PATTY CARROLL

Born: Chicago, 1946
Residence: Chicago

Education: UI (B.F.A., graphic design, 1968); ID/IIT (M.S., photography, 1972). *Professional experience:* instructor of photography and drawing, Pennsylvania State University, University Park, Pa., 1973-74; instructor of photography and graphic design, UM, 1974-76; studio professor of photography, ID/IIT, 1977-present; visiting artist, SAIC, 1979, 1980, 1984, 1986, 1987; free-lance graphic design, Chicago, 1977-present. *Grants and awards:* IAC, 1977, 1981, 1984, 1987; Polaroid Corporation Materials Grant, 1981; IIT Faculty Research Fellowship, 1981. *Selected exhibitions:* CEPA Gallery, Buffalo, N.Y., 1980; RISD, 1981, 1984; CC Galleries, 1982; BC Space, Laguna Beach, Calif., 1983; Rush Rhees Fine Arts Gallery, University of Rochester, Rochester, N.Y., 1984; PUC, 1985; Artemesia Gallery, Chicago, 1985; "Nightworks," PSCC, 1986.

Hot dog stands are a business as well as a cultural phenomenon in a city that evolved with the growth of the meat-packing industry and an abundance of ethnic groups (especially German and Eastern European) that preferred sausages and other spiced meats. There are over 2,000 hot dog stands in Chicago, all of which seem to be popular places in their particular neighborhood and which seem to make money. Unlike New York and other places where pushcarts are the vendor style of selling hot dogs, Chicago has small, cheaply built structures or storefronts which may or may not include a place to sit down. The stands I have picked to photograph have some peculiar aesthetic or raw quality that distinguishes them as unique. I am interested in the vernacular architecture as well as the hand-painted, crazy decoration and signage that seems to be the expected naive style in Chicago. These mom-and-pop places have a dazzling charm that reflects the owner's personality and are as central to the casual life-style in Chicago as the neighborhood bar, providing not just affordable food but often a warm, fun, and very non-threatening atmosphere. I was seduced, too, by the bright colors, the humorous names of many of the stands, and the cheap food. I began the project in my mind, during a gray winter many years ago, when I noticed that the only cheery colors I ever saw (mostly yellow, red, or orange) were on hot dogs stands around the city and especially in the more ethnic neighborhoods. It was a mini visual vacation.

BARBARA CIUREJ — LINDSAY LOCHMAN

Barbara Ciurej
Born: Chicago, 1957
Residence: Chicago

Education: ID/IIT (B.S., visual design, 1978). *Professional experience:* photography and graphic design partnership with Lindsay Lochman, 1983-present. *Selected exhibitions:* "Prime Locations" (with Lindsay Lochman), CPLCC, 1987.

Lindsay Lochman
Born: Chicago, 1952
Residence: Chicago

Education: American University, Washington, D.C. (B.A., fine arts and history, 1973); ID/IIT (M.S., visual design, 1977). *Professional experience:* photography and graphic design partnership with Barbara Ciurej, 1983-present. *Selected exhibitions:* "Prime Locations" (with Barbara Ciurej), CPLCC, 1987.

These photographs explore the farthest outliers of Chicago, the distant rings of suburban growth that emanate from the city. After completing a collection of photographs on the older suburbs surrounding the city, we followed the highways to the suburban frontiers. From Oakbrook to the Naperville corridor, up the Tri-state to Deerfield and down to Orland Park, from O'Hare west to Schaumburg, we traveled along miles of strip architecture, subdivisions, and corporate corridors. In the unintentional minimalism and enforced uniformity, we saw a newly planted culture with its fundamental interests bared. To look at these landscapes is to contemplate suburban life.

Born: Chicago, 1945
Residence: Rochester, N.Y.

Education: Stanford University, Stanford, Calif. (B.A., psychology, 1967); RIT (M.A., fine arts, 1978). *Professional experience:* lecturer, instructor, assistant professor, and associate professor, School of Photographic Arts and Sciences, RIT, 1974-present; chair, Applied Photography Department, RIT, 1984-87. *Grants and awards:* NEA, 1979; *Unicolor*, Dexter, Mich., 1983. *Selected exhibitions:* "Inside State Street: Building Interiors by Kathleen Collins," CHS, 1982; "Interior Views, State Street, Chicago," RIT Photo Gallery, 1983; School of Fine Arts Gallery, Indiana University, Bloomington, 1984; Village Gate Art Center, Rochester, 1986. *Publications:* Howard S. Becker, "Inside State Street: Photographs of Building Interiors by Kathleen Collins," *Chicago History*, 11, no. 2 (Summer 1982).

My original interest in photographing workers in Chicago industry grew out of a curiosity about the people who work the tools and drive the machines that make our products. The Clybourn Avenue area was one of many areas from which to choose. The long history of industry there and the fact that this history is being threatened by residential development made it an interesting choice. The additional fact that the Chicago Boiler Company was about to relocate to the suburbs in the wave of this new development gave me the incentive to concentrate on this location. The photographs I made are individual portraits that collectively begin to portray a more generalized view of the industrial workplace. While I found myself fascinated by what these men do, photographically I was interested in describing not the activity but the person. The details—expression and stance, how the clothes hang, the dirt and grime, and the elements of the immediate environment—reveal a personal history. Perhaps because it is foreign, the industrial environment evokes a sense of theater for me. In the midst of the repetitive activity of work, a remarkable drama is constantly unfolding. These photographs are meant to be not only a document but a description of that drama as expressed through each player.

KERRY COPPIN

Born: Peekskill, N.Y., 1953
Residence: Chicago

Education: Fashion Institute of Technology, New York City (A.A.S., fashion photography, 1973); RIT (B.F.A., photographic illustration, 1975); RISD (M.F.A., photography, 1977). *Professional experience:* professor of photography, CC, 1978-present; director, CC Workshop/ Lecture Program, 1978-present; assistant, The Friends of Photography Workshop, "The Photograph as Document," Carmel, Calif., 1983; visiting instructor, University of Hawaii at Manoa, Honolulu, 1984-85. *Grants and awards:* Artist-in-Residence, Lightwork, Syracuse, N.Y., 1986. *Selected exhibitions:* Gallery 417, PSCC, 1982; "East of Eden," The Art Loft Two, Honolulu, 1985.

Born: New York City, 1940
Residence: Chicago

Education: Briarcliff College, Briarcliff, N.Y., 1958-62. *Professional experience:* instructor of photography, Manhattanville College, Purchase, N.Y., 1974; CC, 1983-85. *Grants and awards:* Illinois State Museum Purchase Award, 1985; MCP/CC Purchase Award, 1985; IAC, 1985, 1986. *Selected exhibitions:* Illinois State Museum, Springfield, 1985.

While photographing the construction site at 900 N. Michigan Avenue, I became aware of the tough and dangerous trade of the ironworkers. In particular, I was spellbound by the group known as "the raising gang," those who perform the high-wire acrobatics to position the structural steel and fix it in place with bolts. Until now I had been photographing the visually exciting construction sites in Chicago's Loop. Suddenly, this human element grabbed my interest, and I set out to capture the intensity coupled with abandon that seemed to surround these "men of steel." A group of ironworkers from the raising gang moved on to a new construction site at 35 W. Wacker Drive, where the drama continued, as the members of Local #1 wrestled each beam of the steel structure into place. These men are tough, often crude, extremely fraternal, and, though assuming an air of machismo, not without a deep respect for the danger that is ever present in their work.

DAVID DAPOGNY

Born: Berwyn, Ill., 1945
Residence: Hempstead, N.Y.

Education: UI (B.A., English, 1967); RISD (M.F.A., photography, 1976). *Professional experience:* slide librarian, CC, 1978-80; audiovisual technician, University of Alaska at Juneau and Adelphi University, Garden City, N.Y., 1982-86; director, Audio-Visual Department, Hofstra University, Hempstead, N.Y., 1986-present. *Selected exhibitions:* Alaska State Museum, Juneau, 1984; Anchorage Historical and Fine Arts Museum, Anchorage, Alaska, 1985; Infinity Gallery, GSU, 1985; Student Union Gallery, South Dakota University, Brookings, 1986; Utah State University, Logan, 1987.

All of these photographs were taken at the McDonald's Christmas Parade, held on the first Sunday after Thanksgiving as a kickoff to the Christmas season. Despite its corporate sponsorship and obvious (though not from these photographs) commercial overtones, the parade remains what parades in Chicago have always been, a spectacle of equally good-natured participants and interested (and interesting) spectators (both of which were severely tested by this particular parade's unfortunate but not necessarily atypical weather) against the backdrop of the cityscape. The photographs attempt to portray something of these relationships: spectator to spectacle, spectacle to cityscape.

Born: Chicago, 1948
Residence: Chicago

Education: GSU (psychology and photography, 1978-80). *Professional experience:* free-lance photojournalist and documentary photographer. *Selected group exhibitions:* "New Horizons," CPLCC, 1982-84; "Illinois Photographers," State of Illinois Art Gallery, Chicago, 1985; "Small Works National," Zaner Gallery, Rochester, N.Y., 1982-85.

The photographs were made on the South Side of Chicago, its southern suburbs, and northwest Indiana, areas I know well and travel through almost every day. These people allowed me into their homes, and I thank them all. When I enter someone's private sanctuary, it's a spiritually awakening experience for me. I feel like a pilgrim in search of a sacred object; in this case the TV set is the guiding light, simultaneously shining in millions of homes throughout the world. I asked these people if I could "stop over" during their favorite TV program. I watched with them, for a while, then I stood up and walked around the room. I become the viewer of the TV watcher, and when the signal came in clear to me, I made my photograph.

MEG GERKEN

Born: Oelwin, Iowa, 1942
Residence: Chicago

Education: UC (B.A., literature and art, 1964; M.A., Russian literature, 1968); SAIC (M.F.A., photography, 1983). *Professional experience:* associate professor of photography, Wright College, Chicago, 1968-present; free-lance photographer, 1978-present. *Grants and awards:* IAC, 1981, 1986. *Selected exhibitions:* "Visual Gossip," Elmhurst College, Elmhurst, Ill., 1979, Il Torrione, Ferrara, Italy, 1980; "Celebration of the Human Family," John Hancock Center, Chicago, 1980; "Two Families," Palmer Square Arts Fair, Chicago, 1985; "Bedrooms," Dazibao Gallery, Montreal, 1986. *Publications:* Meg Gerken, "Two Families," *City,* Winter 1986.

The subject of these photographs is an extended family, the Weisingers, who for many years have lived in the Chicago Housing Authority's Henry Horner Homes, in the 1800 block of West Washington. Lorine is the matriarch, the focus of the family; her husband, Joe, moved out a few years ago, though he often comes by for holiday gatherings or to visit Lorine in the hospital. There are nine grown children, ten grandchildren, and one great-grandchild, several of whom live with Lorine. The family faces many overwhelming problems, among them Lorine's poor health due to diabetes and the increasingly oppressive environment of the housing project.

I came to know the family through my friendship with the eldest daughter, Jean, and first photographed them as part of a "Bedrooms" series in the early 1980s. The continual interaction and negotiation, the apparent lack of privacy in this large household, so different from the relative solitude of my home, has long fascinated and puzzled me.

My relationship with the Weisingers is crucial: I am a trusted outsider; they represent a faintly known but esteemed "other." It is the tension between belonging and looking in that has always attracted me, and I think the photographs sometimes reveal in the family members themselves a similar tension.

RON GORDON

Born: Chicago, 1942
Residence: Chicago

Education: UI (B.A., language and literature, 1965; M.A., literature, 1968; doctoral studies in language and literature with coursework in film and photography, 1969-71). *Professional experience:* owner of photography studio and custom printing lab, Chicago, 1974-present. *Grants and awards:* Fulbright Travel Grant, 1965-66. *Selected exhibitions:* Galerie Minaca, Paris, 1983; "Baseball Photographs," *The Chicago Journal* offices, 1983; American Institute of Architecture, 1988.

Even though I work in a medium called "still photography," I have never felt that photography is without movement. Each time I look, the city is different, constantly changing. It changes through natural movement of light and time and through human endeavor. I have always been fascinated with the change itself, and most of my photographs are an attempt to see and understand it. These photographs were taken on or near the Chicago waterways. The water is a perfect symbol both for the Changing Chicago Project and for the themes of movement and time. As if flows through the city, the river displays a rich diversity of backdrops for the people who live and work near it. Industry both flourishes and decays. The bridges span the history of human industrial achievement. People work on the river, live on it, travel on it, and play on it. Ironically, many of the pictures could have been taken at any period in this century. What emerges from this range of photographs is a single picture, one of universals. Through the river we are connected to our past and our future.

PETER HALES

Born: Pasadena, Calif., 1950
Residence: Evanston, Ill.

Education: Haverford College (B.A., English and American literature, 1972); University of Texas (M.A., American civilization, 1976; Ph.D., American civilization, 1981). *Professional experience:* Associated Press wirephoto photographer, 1976-79; curator, MoMing Gallery, Chicago, 1981-85; assistant and associate professor, History of Architecture and Art Department, UIC, 1980-present. *Grants and awards:* Rockefeller Foundation, 1977-78; IAC, 1983; UIC Silver Circle Teaching Award, 1984; Institute of Humanities Fellowship, 1985; NEH, 1985, 1987-88; UI University Scholar, 1985-87. *Selected exhibitions:* Fourth Street Photo Gallery, New York City, 1976; San Francisco Camerawork, 1981; "Gates of Eden: Americans and the Land," CPLCC, 1988.

Publications: (all by Peter Hales) *Silver Cities: The Photography of American Urbanization, 1839-1915* (Philadelphia: Temple University Press, 1984); *William Henry Jackson* (London: MacDonald and Co., 1984); *William Henry Jackson and the Transformation of the American Landscape, 1843-1942* (Philadelphia: Temple University Press, 1988).

A photographer who is also a cultural historian by profession, I am deeply committed to the documentary tradition and to its capacity to yield results in the hands of those who are aware of its histories, its possibilities, and its limitations. Good photographs are rich containers for information, not only about the subject of the photograph, but about the photographer and the relationship of the two to each other. My pictures are never "objective," but neither is any other work of investigation. Instead, I hope that my photographs are *interesting* in the original meaning of the word—that they interject the viewer into the midst of things, the most important of these being the confrontation between the culture of the photographer and the culture of the subject. My work for this project focuses on upper-class public rituals as a means to explore the issues of class structure and to look at the peculiar subculture of wealth. These are photographs of self-declared "high society" events in which public display is the primary product and in which subtle but crucially important matters of status, of style, of language, and of belief are negotiated—in the peculiar gazes of women at each other, in the varieties of the social kiss, in the rings a man might wear or the flowers that serve as a centerpiece for a banquet table. I don't pretend to organize or explain these phenomena. Instead, I aspire to what the anthropologist Clifford Geertz called "thick description": the presentation of my subject in such a way that clarity and richness do not become mutually contradictory terms.

TOM HARNEY

Born: Chicago, 1946
Residence: Chicago

Education: Michigan State University (B.A., business administration, 1968); self-taught in photography. *Professional experience:* staff photographer, *Suburban Week Magazine* (the *Chicago Sun-Times* supplement), 1973-74; free-lance photographer, 1981-present. *Selected exhibitions:* Madison Art Center, Madison, Wisc., 1979; ARC Gallery, Chicago, 1981; Truman Gallery, Truman College, Chicago, 1981.

I take photographs to see what I would have otherwise missed. I am photographing Comiskey Park because it may soon be gone and because to me it represents a place we can go to be part of something and, at the same time, to let ourselves go. With each visit I gladly accept the secrets of the ballpark's tradition. And with each visit the feeling of seeing Comiskey Park for the last time takes hold.

Born: Sherman, Tex., 1943
Residence: Hammond, Ind.

Education: Rice University, Houston, Tex. (B.A., history, 1966); ID/IIT (M.S., photography, 1969). *Professional experience:* photographer, United States Army, 1969-70; instructor of photography, PUC, 1971-present; photographer, Inland Steel Corporation, East Chicago, Ind., 1972-85. *Grants and awards:* Indiana Committtee for the Humanities, 1980, 1982, 1983. *Selected exhibitions:* Northern Indiana Art Association, Hammond, 1980; Lutheran Theological Seminary, Chicago, 1980; GSU, 1983; Lake County Court House, Crown Point, Ind., 1983; Gary Public Library, Gary, Ind., 1986; Michigan City Center for the Arts, Michigan City, Ind., 1987.

My work in documentary photography has been based on two fundamental impulses: the fascination of "being there" and the need to create a well-crafted object (i.e., the photograph). With the camera as my "passport," I participate vicariously in any manner of activity that fulfills for me the function of entertainment in the best sense—the human comedy as instruction. Given my reactions to life as a collection of thoughts and feelings—a combination of the rational and intuitive—I want to take one fragment of those reactions and express it in some tangible form. When I hand a photograph to someone, I disappear; he/she can experience my reactions only by way of the object I have created. My reactions to life enter the photographic process through a host of value judgments, many of which concern a sense of form. Line, balance, rhythm, contract: some features of a process that I care about in a passionate way. Basically, the impulse to create form derives from a sense of play and from the pleasure in endless variation.

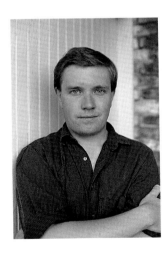

Born: Chicago, 1958
Residence: Chicago

Education: ID/IIT (B.S., photography, 1980). *Professional experience:* free-lance photographer, 1980-present; exhibition preparator, Photography Collection, AIC, 1982-present. *Selected exhibitions:* Kroch's and Brentano's Gallery, Chicago, 1986; "Children of the Inner City," Rizzoli Gallery, Chicago, 1987.

Hans Christian Andersen School is located on Division Street between Ashland and Damen avenues in the community of West Town on Chicago's near northwest side. The area has a history of being a predominantly working-class neighborhood with an ethnically diverse population. Although the community has recently been undergoing an influx of young professionals, it remains a neighborhood experiencing many of the problems typical to most inner city neighborhoods. For practically all of my life, my mother has been affiliated with Andersen, first as a teacher and now as principal. Naturally, the school has been a part of my life as well. My pictures are not an objective record of the triumphs and failures of the public school system. Rather, I see my work more as a personal document of specific people and a specific place, and the relationships between them, as well as a remembrance of my own childhood in the city.

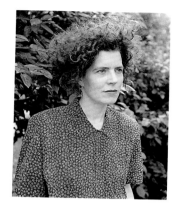

Born: Belfast, Northern Ireland, 1950
Residence: Chicago

Education: Mary Ward College, University of Nottingham, England (Diploma, education, 1972); Trent Polytechnic, Nottingham (B.A. Diploma, creative photography, 1975); CC (M.A., photography, 1987). *Professional experience:* member, photography subcommittee, Arts Council of Great Britain, 1979-80; co-curator, "Three Perspectives on Photography," Hayward Gallery, London, 1979; visiting artist, SAIC, 1980-82, 1986; instructor of photography, Loop College, Chicago, 1982-84; instructor, CC, 1985-87; instructor, SAIC, 1988-89. *Grants and awards:* Arts Council of Great Britain, 1977, 1978; CCFA, 1984; NEA, 1987. *Selected exhibitions:* Manchester Arts School, Manchester Polytechnic, England, 1980; Viewpoints Gallery, Salford Art Gallery and Museum, Salford, England, 1987. *Publications:* Angela Kelly, Paul Hill, and John Tagg, *Three Perspectives on Photography* (London: Arts Council of Great Britain, 1979).

These are photographs of teenage girls who attended the Chrysalis Learning Center in Chicago, a non-residential educational facility, which closed unexpectedly in 1987. Until then it had provided a safe learning environment for girls aged fifteen to eighteen who, for one reason or another, were not having their needs met through the traditional parochial and public school systems. Some of the students were already parents or mothers-to-be; others came from broken homes and needed a "home away from home." Chrysalis offered them the opportunity to learn in a supportive environment where they were encouraged to take responsibility for how and what they learned, guided by a small, dedicated female staff and a feminist curriculum. My relationship with these women developed over a period of two years, and I have continued to photograph a few of them since the school closed. Their input has been crucial in terms of how I have represented them and recorded this small part of their history.

JOHN KIMMICH

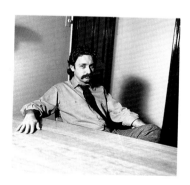

Born: Philadelphia, 1950
Residence: Chicago

Education: UI (B.S., architectural studies, 1973); PUC (M.A., photography, 1978). *Professional experience:* teaching assistant, PUC, 1976-78; instructor of photography, CC, 1978-86. *Grants and awards:* IAC, 1981, 1982, 1986, 1987; CCFA, 1982. *Selected exhibitions:* CPLCC, 1982, 1988; Purdue University Creative Arts Gallery, Hammond, Ind., 1984; Sol Mednick Gallery, Philadelphia College of Art, 1986; Gauss Fotografiskt Galleri, Stockholm, Sweden, 1986; Nueva Imagen Galery, Pamplona, Spain, 1987.

Since my arrival in Chicago, the Loop has been a source of constant fascination. The heart of the city, once leveled by the Great Fire of 1871, birthplace of the skyscraper, this area remains the site of some of the most exciting examples of twentieth-century architecture. Many of Chicago's promoters boast of the city's ethnic neighborhoods, but it is in the Loop, the city center, that all citizens gather: Hispanic, black, Oriental, Irish, and Polish Chicagoans cross paths; businessmen, tourists, construction workers, politicians, and beggars share the same sidewalk.

The photographic traditions of Eugene Atget, Charles Marville, John Thompson, Walker Evans, and Berenice Abbott have influenced my approach to the documentation of Chicago, just as the visions of Harry Callahan, Edward Hopper, Henri Cartier-Bresson, and Josef Koudelka have influenced my image of the city as the stage for a surrealist play. People, architecture, light, form, space, sound, and time all share equal importance in this work. It is this balance in the two-dimensional picture frame that is fascinating; it is magic. This is my vocabulary for documentation; these are moments of contemplation, some quiet and others noisy. At the simplest level the photographs are a record of passing time, a fraction of a second, in the ever-changing Chicago.

JAY KING

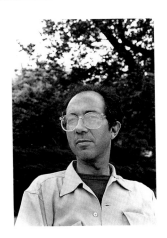

Born: Chicago, 1944
Residence: Chicago

Education: University of Wisconsin at Madison (B.A., history, 1966); self-taught in photography. *Professional experience:* free-lance commercial photographer, 1967-present. *Selected exhibitions:* CC Galleries, Chicago, 1982. *Publications:* Jay King and Steven Klindt, *Jay King, Chicago Photographer* (Chicago: CC, 1982).

With these photographs I have tried to capture the life-style of people in a particular area (DePaul) as it continues to evolve. I had been aware of rapid social and economic change and tried to show how it was manifesting itself in these people. One of the things I noticed was that much of what I saw was not radically different from any other time and place I had photographed. Activities such as bike riding, dog walking, being on the streets, shopping, and so on, were different in certain material ways: the kind of dog, type of bike, style of clothes gave a particular spin on things that were common occurrences. I also saw things that looked relatively unchanged, especially in the lives of older people. What I found was not an entirely new society but different people coexisting at the same time and place with widely varying life-styles.

RHONDAL MCKINNEY

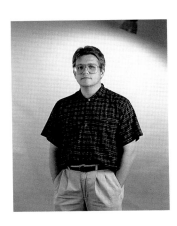

Born: Effingham, Ill., 1948
Residence: Normal, Ill.

Education: UI (B.S., 1970; M.F.A., 1981). *Professional experience:* guest curator, "An Open Land: Photographs of the Midwest 1852-1982," AIC, 1981-83; director, University Galleries, Illinois State University, Normal, 1986-87; assistant professor, Illinois State University, Normal, 1983-present. *Grants and awards:* "Farm Families" commission, Focus/Infinty Fund, 1985; Upper Illinois Valley Association commission, 1985-86; IAC, 1986, 1987. *Selected exhibitions:* Light Gallery, New York City, 1986; Blue Sky Gallery, Portland, Ore., 1987; University of Dayton, Dayton, Ohio, 1987; The Kalamazoo Institute of Art, Kalamazoo, Mich., 1988. *Publications:* Rhondal McKinney, "Midwestern Moods," *Aperture,* no. 91 (1983); Rhondal McKinney and Victoria Post Ranney, eds., *An Open Land: Photographs of the Midwest 1852-1982* (Chicago: Open Lands Project, in association with AIC and Aperture, 1983).

Since 1984 I have been photographing in and around towns along the historic Illinois and Michigan Canal, which was constructed in the 1840s and linked the Mississippi River to the cultural and commercial centers of the East by way of the Great Lakes and the St. Lawrence Seaway. Chicago was a town of 18,000 souls, without a single railroad, when the canal opened in 1848; before long, it was attracting the raw materials, manufactured goods, people, and ideas necessary to the opening of the West during the second half of the nineteenth century. From the end of the Civil War until only a generation ago, the towns along the canal boomed with mining, manufacturing, and transportation. With each immigrant wave to America the area became more richly and diversely ethnic, suffused with the spirit of these people, their traditions, and their efforts. I have tried to connect with this spirit, staying as close as possible to the canal itself. I feel that the clearest expression of the spirit and ideas I am looking for can be found in the places where they were first expressed.

STEPHEN MARC

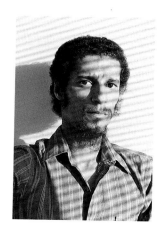

Born: Rantoul, Ill., 1954
Residence: Chicago

Education: Pomona College, Claremont, Calif. (B.A., art, 1976); Tyler School of Art, Temple University, Philadelphia (M.F.A., photography, 1978). *Professional experience:* instructor, CC, 1978-present; free-lance photographer, 1978-present. *Grants and awards:* Eli Weingard Chicago Grant, through The Friends of Photography, 1983. *Selected exhibitions:* "Urban Notations," MCP/CC, 1984; 2-D Photo Gallery, PSCC, 1985. *Publications:* Stephen Marc, *Urban Notations* (Chicago: Stephen Marc, 1983).

For this project I concentrated on Chicago's southside Afro-American community, where I was raised. I am primarily a street photographer concerned with visually exploring various cultural cues and social interactions, the character of everyday life as well as special events. It was important to tackle this place, so large and diverse, because I feel that the black community is seldom photographed from within and is often misunderstood and misrepresented. Although plagued by many "urban problems," in this area you can still find a strong element of identity, camaraderie, and even extended family, which I hope the viewer can sense in these photographs.

JAMES NEWBERRY

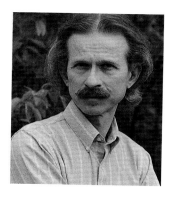

Born: Indianapolis, 1937
Residence: Commerce, Tex.

Education: ID/IIT (B.S., photography, 1967; M.S., 1973). *Professional experience:* founding chair, Department of Photography, CC, 1967-75; associate professor and professor, East Texas State University, Commerce, 1979-present. *Grants and awards:* Maryland Arts Council Artist Fellowship, 1977; East Texas State University Research Grant, 1981. *Selected exhibitions:* Church Street Photographic Center, Melbourne, Australia, 1978; Art Gallery, University of Wisconsin at Superior, 1981; "Maxwell Street: The Photographs of Nathan Lerner and James Newberry," CHS, 1983.

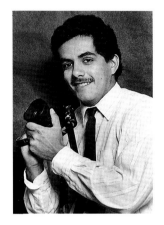

Born: Chicago, 1962
Residence: Chicago

Education: CC (B.A., photography, 1985). *Professional experience:* teaching assistant, CC, 1984-85; portrait photographer, Root Photographers, Chicago, 1985-86; staff photographer, *The Daily Calumet,* Lansing, Ill., 1984-86; staff photographer, Triton College publications, Chicago, 1985-present. *Grants and awards:* Presidential Purchase Award, MCP/CC, 1985; National Community College Publication Photography Award, 1987. *Selected exhibitions:* "Hispanic Festival of the Arts," Museum of Science and Industry, Chicago, 1983, 1984, 1985; MCP/CC, 1985. *Publications:* Antonio Perez, "Images of South Chicago," *The Daily Calumet,* November 30, 1985.

I chose to photograph the neighborhoods of south Chicago and the East Side, concentrating on the area between 7900 south to 130 south and 3600 on the west to the lake street beaches, southeast of the Loop. This area has been my home since birth and has a rich family and work-ethic history. Through my photographs I hope to show its many hidden treasures, seen in the expressions of the people. I tried to capture the life and times of southeast Chicago, an area that at one time provided thousands of jobs through its steel mills but is now silent. Gone are the noise and the smoke but not the community spirit, the strong family ties, the work ethic, the street life, which have survived against ever-increasing odds like unemployment, gangs, and crime.

Born: McKees Rocks, Pa., 1949
Residence: Chicago

Education: Temple University, Philadelphia (B.S., 1971); University of New Mexico, Albuquerque (M.F.A., 1973). *Professional experience:* visiting instructor and assistant professor, SAIC, 1974-present; assistant professor, Southern Illinois University at Carbondale, 1975-77; artist-in-residence, The Exploratorium, San Francisco, 1981; lecturer, Northwestern University, Evanston, Ill., 1981-present. *Selected exhibitions:* International Center of Photography, Education Gallery, New York City, 1981; University of Arkansas, Fayetteville 1981; The Exploratorium, San Francisco, 1981; CC Galleries, 1982; Tarrant County Junior College, Hurst, Tex., 1984; Evanston Art Center, Evanston, Ill., 1986.

During the planning and building of the Sears Tower the acronym QUEENI was used: quality, utility, economy, efficiency, no-nonsense image. The tower may embody all of these notions, but it is its image—of power, strength, and change—that is most clearly seen. It looms over other landmarks—monuments, church spires, manufacturing and industrial sites—both visually and economically. The clean, no-nonsense exterior contrasts with the hectic interior, through which 15,000 workers, tourists, delivery people, and transients pass daily. Like glass surfaces the occupants both reflect the aspiration and define the isolation of the tower.

Born: Oklahoma City, 1954
Residence: Chicago

Education: Kansas City Art Institute, Kansas City, Mo. (B.F.A., photography, 1977); ID/IIT (M.S., photography, 1985). *Professional experience:* assistant photographer, Hedrich-Blessing, Chicago, 1981; freelance photographer, 1981-present. *Selected exhibitions:* "Downtown Deco," CPLCC, 1982; "Chicago: The Architectural City," AIC, 1983; "Theater Interiors: Houses of Fantasy," CPLCC, 1984; "Moving Picture Palaces," CHS, 1986. *Publications:* Larry Viskochil, "Moving Picture Palaces: Color Photographs of Theater Interiors by Russell Phillips and Don DuBroff," *Chicago History,* 14, no. 3 (Fall 1985).

The focus of this work has been the diversity of Chicago's commercial districts. I have concentrated on the neighborhoods around such main streets as Clark, Ashland, Belmont, Lincoln, and Halsted, where the variety of ethnic, social, and economic groups is evident in the way merchants decorate their storefronts. The use of color in the environment is one of my main interests, and I am attracted to the way in which color is used by these merchants. In many cases they are not bound by a schooled application of color and design; they do not follow the same rules as Bloomingdale's and K mart, yet they all decorate with the intention of luring the consumer. Consequently, neighborhood storefronts reveal more about merchants and consumers than do the commercial chains.

MELISSA ANN PINNEY

Born: St. Louis, 1953
Residence: Chicago

Education: CC (B.A., photography, 1977); UIC (M.F.A., photography, 1988). *Professional experience:* instructor, Loyola University, Chicago, 1981-84; instructor, CC, 1984-present; free-lance photographer and set designer, 1980-present. *Grants and awards:* IAC, 1980, 1981, 1987; NEA, 1987; Community Arts Assistance Program, City of Chicago, 1987. *Selected exhibitions:* "Remembrances," CPLCC, 1982; Illinois State Museum, Springfield, 1983; "Recent Work," Artemesia Gallery, Chicago, 1985; "New Work," Artemesia Gallery, Chicago, 1986; "Sunshine and Other States," Artemesia Gallery, Chicago, 1988.

I came to the Changing Chicago Project with several years' experience photographing weddings. Among the many ideas gleaned from these events, I was drawn particularly to both the intense self-involvement and the camaraderie that constitute the communal work of women getting ready to present themselves among family and friends. Familiar, unnamed rituals performed by women while dressing or at the beauty salon make visible the ways we have been taught to build and exhibit feminine identity. This series of photographs focuses primarily on our dialogue with a feminine self: who we are and how we measure up to the current ideal displayed virtually everywhere we look. It documents how women struggle to define themselves in relation to one another, to their children, to men, and, most important, to themselves.

Born: Pottsville, Pa., 1948
Residence: Chicago

Education: UC (B.A., philosophical psychology, 1973); MIT (graduate study in photography, 1969-70). *Professional experience:* chief staff photographer, News Office, MIT, 1971; free-lance photojournalist, Chicago, 1973-present. *Selected exhibitions:* "Salvadoran Refugees," Peace Museum, Chicago, 1982; "Blues Ain't News," Pallas Gallery, Chicago, 1984; "Picture Cuba," CPLCC, 1986. Selected publications: (all articles feature Marc PoKempner's photographs) "Chicago Blues," *Popular Photography 35mm Photography Annual,* 1978; "Chicago," *New York Times Magazine,* April 10, 1983; "Blues der Chicago," *Merian,* 8, no. 39 (1986); "Playing the Blues Chicago Style," *New York Times Magazine,* January 18, 1987; "Chicago Blues," *Southwest Spirit,* February 1988.

Cabrini Green is a notoriously bad place, especially for the residents. The press is often full of stories of murders of young children, of rapes, of teenage pregnancies, of unemployment and drug-related gang wars. I've worked on these stories for local and national magazines and seen them perpetuate the negative stereotype of the irresponsible, incorrigible underclass criminal lowlifes living off public aid and ill-gotten gains. I took the Changing Chicago Project as an opportunity to document the normalcy I found in everyday life in Cabrini—the birthday parties and holiday celebrations I saw as reflective of the middle-class values and aspirations of the families there. After trying unsuccessfully to gain access through institutional channels, I simply approached some residents, took photos of them and their kids, and brought them back. I established myself as their "picture man," was invited to some family events, and was welcomed back on ordinary days to deliver prints and make more snaps. I looked for the relatively good situations I had noticed but passed over on my other assignments. I tried to provide some balance to the illustrations of "problems" I had done for my editors by showing clean apartments with pictures of high school graduates on the walls, but I also tried to evoke the context of the residents lives—the graffiti on the outside and the television imagery on the inside of each home.

BOB THALL

Born: Evanston, Ill., 1948
Residence: Chicago

Education: UIC (B.A., design-photography, 1972; M.F.A., photography, 1986). *Professional experience:* professor of photography, CC, 1976-present; free-lance architectural photographer, 1975-present. *Grants and awards:* IAC, 1980. *Selected exhibitions:* "Landscape-Cityscape," MoMing Art and Dance Center, Chicago, 1981; Swen Parson Gallery, NIU, 1982; CC Galleries, 1983; Tarrant College Gallery, Fort Worth, Tex., 1984; University of Kansas Gallery, Lawrence, 1984; Loyola University Gallery, Chicago, 1984; Illinois State Museum, Springfield, 1984.

The heavily industrialized crescent of land that runs along the shore of Lake Michigan from 79th Street south and east to Gary, Indiana, is

a region as distinct from the Chicago Loop as it is from the Indiana farm towns. It is undeniably an area with severe problems: heavy air and water pollution, high unemployment, decay, and racial tension; yet it may also be the most interesting landscape in the Midwest. Before U.S. Steel created Gary as the site of one of its huge plants, southeast Chicago/northwest Indiana was a place of pristine marshes and exceptional sand dunes. Once Inland Steel, Wisconsin Steel, Standard Oil, and Mobil also moved in, only ironic fragments of nature escaped the flood of heavy industry. Some company towns were built, but all the homes and neighborhoods existed in the shadows of the mills and refineries. The tight relationship between home and factory (with a few bars located on the cusp) seems almost feudal, yet people of the region remember a golden age of prosperity and security. Now there is economic regression and physical decay: mills abandoned, dismantled; bridges rusted; neighborhoods ragged with empty lots, burned houses, embroidered with gang graffiti. The thoughtlessness of the boom and the chaos of the region's bust have the force of a natural disaster.

JAY WOLKE

Born: Chicago, 1954
Residence: Chicago

Education: Washington University, St. Louis (B.F.A., printmaking and illustration, 1976); ID/IIT (M.S., photography, 1980). *Professional experience:* instructor, ID/IIT, 1982-83, 1987-88; instructor, CC, 1980-87; visiting artist, SAIC, 1985-86. *Grants and awards:* Illinois State Museum Purchase Award, 1985; Society for Contemporary Photography, Kansas City, Purchase Award, 1985; IAC, 1985-86; NEA, 1985-86. *Selected exhibitions:* "New Work," Popular Photography Photo Gallery, New York City, 1985; "The Dan Ryan Expressway Project," CHS, 1985; University of Notre Dame, South Bend, Ind., 1986; "Vegas," MCP/CC, 1987. *Publications:* Larry Viskochil, "At the Society," *Chicago History,* 14, no. 1 (Spring 1985).

As the port of entry for various ethnic populations that came to Chicago, Maxwell Street was renowned as a cacophonous, hustle-ridden, open-air market where absolutely anything could be bought and sold. Germans and Irish in the mid-1800s were succeeded by a huge wave of Jewish immigrants. By the 1940s and 1950s the second and third generations of Jews had left and a large black population surged in. In the 1960s the area was decimated by Dan Ryan Expressway construction, University of Illinois expansion, and public housing projects. The remaining buildings on the streets surrounding Maxwell and Halsted crumble from disrepair and neglect. However, the vital and almost ritualistic market survives, albeit limited to a weekly assembly on Sundays. Where once pushcarts swelled the streets, now every form of vehicle invades the urban wasteland. A new breed of itinerant vendor, including an influx of Asians and Hispanics, offers up a mix of staples and treasures.

My approach toward documenting this institution allowed for the integration of subtle, human dramas played out within a complex, multifaceted backdrop. To create intimate portraiture, many visits

and long aquaintanceship with my subjects were necessary. There were times, though, when I allowed myself to be swallowed up by the tumultuous street and created images reflecting its spontaneity and flow. The density of visual information, symbols, and activity reveals Maxwell Street as a microcosm of the history and vitality of the culture at large.

RICHARD YOUNKER

Born: Chicago, 1945
Residence: Chicago

Education: UC (B.A., psychology, 1964); self-taught in photography.
Professional experience: free-lance photojournalist, 1974-present.
Publications: Richard Younker, *On Site* (New York: Thomas Y. Crowell, 1980); Charles Bowden and Lew Kreinberg, *Street Signs Chicago* (Chicago: Chicago Review Press, 1984); Richard Younker, *Our Chicago: Faces and Voices of the City* (Chicago: Chicago Review Press, 1987); "The Sport That Just Won't Die," *The Chicago Tribune Magazine,* March 5, 1978; "Building," *The Reader,* July 18, 1980; "Richard Younker's Chicago," *The Reader,* February 5, 1988.

The Authors

Jack Jaffe is the founder and president of the Focus/Infinity Fund of Chicago, a not-for-profit corporation whose purpose is to produce film and still photography projects of social, artistic, and educational significance, with special emphasis on midwestern subjects.

Walter Rosenblum is professor emeritus of art at Brooklyn College. His photographs are in the permanent collections of many institutions, including the Metropolitan Museum of Art and the Museum of Modern Art. He is the co-author of *America and Lewis Hine* and has published articles in numerous photography journals. A retrospective of his work is in preparation for publication in Europe.

Naomi Rosenblum is adjunct professor of art history and the history of photography at Parsons School of Design in New York City. She is the co-author of *America and Lewis Hine* and *American Art,* the author of *A World History of Photography,* as well as numerous museum catalogs and journal articles.

Larry Heinemann is a novelist and a native Chicagoan. In 1987 he received a National Book Award for *Paco's Story.*

Portrait credits, provided by the photographers:
Susan Crocker (Arndt); Mark Krastof (Avison);
Tom Bamberger (Blau); Cable Studios (Cable);
Gordon Quinn (Gerken); Ron Gordon (Gordon);
Barbara L. Monier (Hales); T. A. Hocker
(Hocker); Ruth Jongsma (Iska); Bernie Hasken
(Kelly); Leslie Schwartz (Kimmich); Stephen
Marc (Marc); Judy Allen-Newberry (Newberry);
Pat Borowiak (Perez); Tom Petrillo Photography
(Petrillo); Kate Friedman (Pinney); Carrie
Bruggers (PoKempner); M. Pinney (Thall); Larry
Zambello (Wolke).

Designed by Michael Glass Design, Inc.,
Chicago, Illinois.
Typeset by AnzoGraphics Computer
Typographers, Chicago, Illinois.
Color separated film by Andromeda Printing
and Graphic Art, Champaign, Illinois.
Printed by Eastern Press, Inc., New Haven,
Connecticut.
Bound by Riverside Book Bindery, Rochester,
New York.